Victoria & Albert Museum

JEWISH RITUAL ART

in the Victoria & Albert Museum

MICHAEL E KEEN

London: HMSO

ISBN 0 11 290449 1

In memory of
Joseph Jacobs (1854–1916)
and
Lucien Wolf (1857–1930),
authors of the
catalogue of the 1887
Anglo-Jewish Historical Exhibition,
in acknowledgement of the part
they played in establishing
an awareness of Jewish art

HMSO publications are available from:

HMSO Publications Centre
(Mail and telephone orders only)
PO Box 276, London, SW8 5DT
Telephone orders 071–873 9090
General enquiries 071–873 0011
(queuing system in operation for both numbers)

HMSO Bookshops
49 High Holborn, London, WC1V 6HB 071–873 0011 (counter service only)
258 Broad Street, Birmingham, B1 2HE 021–643 3740
Southey House, 33 Wine Street, Bristol, BS1 2BQ 0272–264306
9–21 Princess Street, Manchester, M60 8AS 061–834 7201
80 Chichester Street, Belfast, BT1 4JY 0232–238451
71 Lothian Road, Edinburgh, EH3 9AZ 031–228 4181

HMSO's Accredited Agents
(see Yellow Pages)

and through good booksellers

Printed in the UK for HMSO
Dd 289393 C28 7/91 CCN 3735

CONTENTS

PREFACE

When I began the task of compiling this catalogue I intended that my approach should be entirely functional; all the objects to be included had to be capable of being defined as having been made by, or for, Jews for specifically Jewish social or religious purposes. This definition seemed sufficiently flexible to allow the inclusion of ritual objects such as *Kiddush* cups and *Ḥanukkah* lamps on the one hand, and everyday objects such as slippers and gowns on the other. The original aim has been slightly modified in that I have also included articles which have been made by Jews for non-Jewish purposes, like the small glass bowl made by Isaac Jacobs (cat. no. 102), and items such as the dummy board figure of a Jewish pedlar (see cat. no. 104) which throws some light upon attitudes towards Jews and the way in which Jews have been perceived by non-Jews.

My views and observations have been conditioned by the fact that I am not Jewish and have approached the study of Judaica from the outside. The Hebrew language and Jewish liturgy, history and social customs were strange and unknown to me at first, but as my journey of exploration into this *terra incognita* continued I became aware of familiar landmarks which form part of the common ground between Christianity and Judaism, based on the belief in one God and on the shared literature of the Old Testament. It is my intention that this work shall provide all its readers with a list of the Victoria & Albert Museum's Jewish holdings, and that non-Jewish readers will obtain from it some insight into, and explanation of, Jewish customs and observances. I believe that knowledge can in some measure counteract prejudice and that in these ecumenical times people who, like myself, have been brought up in the Christian tradition will be interested to see the many parallels between the two faiths. They will find that many Christian festivals and ritual objects are based upon Jewish precedents and models; for example the autumnal festival of *Sukkot* (Feast of Tabernacles) is the basis of the Harvest Thanksgiving, and the *Kiddush* cup is linked with the Communion chalice, just as the *Purim* plate is with the collection plate.

The impetus to compile this catalogue sprang initially from my own desire to know what Jewish artefacts were held by the V&A, and from the need to answer enquiries from outside the museum. I trust that this publication will prove to be useful to all students of Judaica. Its layout is based on the excellent pattern established by the Jewish Museum of London in their fine exhibition publication of 1974.[1] The first section is devoted to public

[1] Barnett, R D, *Catalogue of the permanent and loan collections* [etc.]. London, Jewish Museum, 1974.

worship, the second to festivals and holy days, and the third to domestic worship. There are two additional divisions which list Jewish costume and miscellaneous items; the final section also includes some objects which have been listed as being Jewish but about which there is some doubt, or which are obviously not Jewish.

It has taken a long time to catalogue a relatively small number of objects because of the way in which the museum has been organised. There are at the time of writing 11 curatorial departments arranged according to material of manufacture rather than according to area of origin (with the special exception of the two Asian departments).[2] None of these departments is specifically empowered to collect Jewish objects, and as a consequence of this arrangement, Jewish artefacts are spread throughout the various departments. This has made the job of locating, identifying and describing the pieces both time consuming and complicated. This work was undertaken in my own time and in addition to my official duties. It could not have been achieved without the unstinted assistance and goodwill of colleagues in my own and other departments. The search for Judaica in the Textiles and Dress Department proved to be a simple task because Natalie Rothstein, its keeper, who has considerable expertise in the field of Jewish textiles,[3] had already drawn up a list of relevant items in her department and this required slight amendment only. In other departments I had to depend upon serendipity and on my own ability to recognise Jewish artefacts in store-rooms crammed with items of every conceivable type and from every period. Serendipity also played a part when, early in January 1988, a *Kiddush* cup (cat. no. 47) which I had missed was pointed out to me by Ezra Kahn, librarian of the Jews' College in London, while I was showing him the ritual objects on display in the museum galleries.

The absence of a Judaica department has led to the V&A amassing a heterogenous group of objects rather than a well-balanced and representative collection illustrating every field of Jewish ritual requirement and aesthetic endeavour. On the other hand, each piece of Judaica accumulated by the museum has been acquired because it is, for example, a fine piece of embroidery or a typical example of central European filigree silver rather than because it is a *parochet* (Ark curtain) or *b'samim* (spice box). So while the V&A holdings cannot compare in quantitative terms with the major collections – such as may be found in the Israel Museum or the Jewish museums of London and New York – many of its objects are of excellent quality, and one or two may be considered unique.

[2] These departments are, in alphabetical sequence: the Bethnal Green Museum of Childhood; Ceramics; Far Eastern; Furniture and Interior Design; Indian; Metalwork; the National Art Library; Prints, Drawings and Photographs and Paintings; Sculpture; Textiles and Dress; and the Theatre Museum.

[3] Barnett, *op. cit.* pp. xxi–xxiv (Textiles, N Rothstein).

The biblical quotations used throughout the text have been taken from the Authorised King James Version, and translations of Hebrew prayers have been taken from the *Authorised Daily Prayer Book of the United Hebrew Congregations of the British Empire* (8th edn 5668/1908). These two versions were chosen because I prefer the form of English they employ, not because they are necessarily the best translations.

ACKNOWLEDGEMENTS

Many friends and colleagues have encouraged me throughout the years spent compiling this work. There are far too many for me to name them all individually; to those who feel that their names should have been included and are not, I offer my special gratitude and my apologies for a faulty memory. Of those who are named, I thank first my wife and my children for putting up with me while this work was under way. Next I thank my friends outside Britain for all their help and encouragement: Bezalel Narkiss and Ziva Amishai-Maisels of the Hebrew University, the late Edith Varga-Biro (formerly of the Haifa Ethnographical Museum), Batsheva Ita of the Iraqi Jews Traditional Cultural Center, Yona Yapou and Chaya Benjamin of the Israel Museum, Arthur Feldman (former director of the Maurice Spertus Museum of Judaica, Chicago), Joseph Gutmann of Wayne State University and Vivien Mann of the New York Jewish Museum. In the V&A my thanks have to be extended to a large number of people, including Elizabeth Esteve-Coll, director of the V&A and formerly of the National Art Library; Pip Barnard and Richard Davies of the Photographic Studio; Duncan Haldane, Michael Wilson and the late Gerald MacPherson of the National Art Library; Ronald Lightbown, Philippa Glanville, Anthony North and Miranda Poliakoff of the Metalwork Department; Santina Levy, Natalie Rothstein and Alyson Bradley of Textiles and Dress; Michael Kauffman and Caroline Oppenheimer, formerly of the Prints, Drawings and Photographs and Paintings Department; Anna Somers-Cocks, Jennifer Opie and Amanda Fielding of Ceramics; Jane Rick of Furniture and Interior Design; and Anthony Burton, Vera Kaden and the staff of the Bethnal Green Museum of Childhood for mounting the Judaica exhibition in the summer of 1987. Finally, I give my very grateful thanks to Lesley Burton, the V&A's publications officer.

INTRODUCTION
The Victoria & Albert Museum and Jewish Art

The Victoria & Albert Museum, or the V&A as it is popularly known, took its name from Queen Victoria and her consort, its spirit from the Industrial Revolution and its inspiration from the radical politics and ideas to which industrialism had given rise. The museum's genesis, however, lay in the Report of the House of Commons Select Committee on Arts and Manufactures, issued in 1835, which urged the application of ingenuity and excellence in industrial production, and emphasised the need for proper and expert art education, qualities deemed to be lacking in the early 19th century. From its inception, following the Great Exhibition of 1851, until its recent separation under a Board of Trustees, there was a direct link between the museum and central government under the aegis of the Ministry (later Department) of Education. The collection of art and industrial exhibits from the Great Exhibition, which formed the nucleus of the early collection, was first housed at Marlborough House before moving to the site in South Kensington where it is still contained.[1]

Jewish art history is a new field of study: as an area of academic endeavour it is not much older than the V&A.[2] But when the Anglo-Jewish historical exhibition was staged at the newly opened Royal Albert Hall, London, in 1887, the de-luxe edition of the exhibition catalogue, in the section devoted to Jewish ecclesiastical art, implied that there was no such discipline as Jewish art history:

> Unfortunately this branch of study has no very distinct existence, and it would be extremely difficult to trace its history in any detail. It is more correct to speak of a geography than of a history of Jewish Ecclesiastical Art; for like their customs, their superstitions and other phenomena of their social life, their art is little more than a composite of the contrastful impression of their geographic dispersion, and of a varied and chequered history.[3]

[1] For a full account of the formation of the Victoria & Albert Museum and the growth of its collections, see Somers-Cocks, A, *The Victoria and Albert Museum: the making of a collection*, London, Victoria & Albert Museum, 1980.

[2] 'The systematic investigation of early mediaeval Jewish art may be said to have begun with the publication in 1778 by the German Christian hebraist Claus Gerhard Tychsen of his important monograph, Von den mit kuenstlish geschreiben Randfiguren gezierten hebraeischen Biblischen Handscriften.' Cecil Roth's entry in: *Encyclopaedia Judaica*, 1971, III, cols 593–4.

[3] Royal Albert Hall, *Catalogue of the Anglo-Jewish historical exhibition*. Publications of the Exhibition Committee IV. London, Royal Albert Hall, de-luxe ed., 1888, p. 83.

The history of collecting Jewish art would seem to predate the 1887 exhibition by a little over a century. During the 18th century David Alexander, a Jew employed at the court of the Duke of Brunswick, is known to have amassed a collection of ceremonial objects which he bequeathed to the local Jewish community.[4] But it was not until 1878 when the private collection of Isaac Strauss, *chef d'orchestre* to Napoleon III, was displayed at the Galeries du Trocadéro as part of the Exposition Universelle that a catalogue of any sort was produced. This display at the Trocadéro is the first known exhibition of Jewish Art,[5] but the Paris exhibition consisted of only 82 pieces of Judaica, whereas the London exhibition contained 2945 exhibits, was spread over four sites[6] and included the Sassoon collection[7] in addition to that of Isaac Strauss. The Strauss collection was not broken up after the musician's death but was acquired for the Musée Cluny by Baron Nathaniel de Rothschild, so that the French museum, unlike the V&A, obtained a collection accumulated as the result of a coherent policy, albeit that of a private individual.

The growth of interest in the appurtenances of the Jewish faith as well as in its spiritual and intellectual values seems to have developed as an extension of the emancipation of Jews in western Europe. In France this movement had begun during the First Republic and gained momentum during Napoleon Bonaparte's reign. In England it had taken a little more time, but by 1887 British Jewry had at last achieved full emancipation,[8] thanks to the efforts of leading members of the Jewish community and their Christian political allies. As a consequence of these achievements there was an air of self-confidence abroad which found expression in the Royal Albert Hall exhibition. The Report to the Members of the General Committee of the Anglo-Jewish Historical Exhibition reveals that one of the aims of the Albert Hall exhibition was 'to create interest in the History of the Jewish race in Britain'.[9] The organisers seem only to have discovered Jewish art when collecting together the exhibits, if the following sentence is to be taken at its face value:

[4] Barnett, R D, *Catalogue of the permanent and loan collections* [etc.]. London, Jewish Museum, 1974, p. xiii (Introduction, C Roth).

[5] Gross, W L, 'Catalogue of catalogues: bibliographical survey of a century of temporary exhibitions of Jewish art'. In: Journal of Jewish Art, 1978, VI, p. 133.

[6] The Royal Albert Hall (site of the main exhibition), the Public Record Office, the British Museum and the South Kensington (now the Victoria & Albert) Museum.

[7] Reuben Sassoon had acquired this collection following the death of the man who first brought it together, Philip Salomon of Brighton. It afterwards passed to David Solomon Sassoon (1882–1942), who also owned a famous collection of Hebrew manuscripts which he described in his catalogue: *Ohel Dawid*, Oxford, Oxford University Press, 1932.

[8] During the course of the 19th century full religious and civil rights were extended to all dissenting groups, including the Jews, but it was not until 1885 – when the Liberal prime minister, William Ewart Gladstone, created Sir Nathaniel Rothschild a peer – that a British Jew finally entered the House of Lords.

[9] Royal Albert Hall, *op. cit.*, p. 207.

Besides the main [historical] objects of the exhibition, a subsidiary one soon presented itself in the collection of interesting articles of Jewish ecclesiastical art, which formed one of the main attractions of the Exhibition, and added the charm of artistic beauty, which could not be secured by the display of objects interesting only for their historical associations.[10]

One is left with the impression that Jewish ritual art was added almost as an afterthought, but it would be wrong to criticise the organising officials for allocating a subsidiary role to Jewish art in what was essentially perceived as an exhibition of social history; on the contrary, they deserved to be congratulated on recognising it as being worthy of consideration when it appeared before them.

The dual importance of the 1887 exhibition was emphasised by Cecil Roth when he wrote: 'We are accustomed to think of this [exhibition] as marking a milestone in Anglo-Jewish historiography. But at the same time it marked an epoch in the history of Jewish collecting and the development of the study of Jewish ritual art.'[11] These developments were, however, more marked in Europe than in Britain during the rest of the 19th century.

At the time of the Royal Albert Hall exhibition, there were no Jewish museums, very few private collections of Jewish art and hardly any evidence of the Jews as a distinct social entity in the newly created ethnographical museums and collections. The impact of the exhibition, coinciding with the growth of national consciousness and the birth of Zionism among Middle and eastern European Jewry, brought about a marked change in this state of affairs. Six years after the London exhibition, the Gesellschaft für Sammlung und Conservierung von Kunst und historischen Denkmaelern des Judentums was held in Vienna, and two years later, in 1895, the first specifically Jewish museum was opened in that city. This advance was followed in another two years by the foundation of the Gesellschaft zur Erforschung jüdischer Kunstdenkmaler by Heinrich Frauberger, a non-Jew who had become interested in Judaica. It published illustrated volumes concentrating upon this new area of intellectual and aesthetic interest. In the early years of the present century Albert Wolf began to amass a private collection of ritual art objects and to produce a series of articles on Jewish art of the Middle Ages, adding both to the corpus of knowledge on the subject and providing the basis for yet another Jewish museum; his collection was used to found the Berlin Jewish Museum.

[10] *ibid.*

[11] Barnett, *op. cit.* p. xiii.

The anti-Semitic attacks, or pogroms, instituted and organised by the imperial authorities throughout the western provinces of the Russian Empire during the last decades of the 19th century, produced mass Jewish emigration to countries such as the United States of America and Great Britain, but it also encouraged the growth of Zionism and hastened the development of modern Jewish settlement in Palestine. In 1906 Boris Schatz, himself an immigrant product of these social upheavals, founded the Bezalel Art Institute and Museum in Jerusalem, thereby creating the institution that was the forerunner of the Israel Museum. He also produced a new school of Jewish design in which Jewish ritual objects were produced by Jewish craftsmen and women who adapted traditional items to accord with contemporary taste.[12]

Coinciding with this rebirth of Jewish ritual art came a rapid increase in the number of Jewish museums. By the outbreak of the First World War collections of Judaica had been assembled in Danzig (1903) Prague (1906; a venture founded by S H Lieben) and Warsaw (1910). Despite the enormous social, economic and democratic changes wrought by the Great War, the growth of interest in Judaica continued unabated during the inter-war years. In Germany the Jewish Museum in Berlin was complemented by others in Breslau, Kassel and Mainz as German Jewry indulged in its final flowering before the onset of the Nazi catastrophe.

Eventually even British Jewry obtained its own museum with the inauguration, in 1932, of the London Jewish Museum. This seeming tardiness on the part of British Jews to found their own museum after they had done so much to inspire their Continental co-religionists with the magnificent exhibition of 1887 was commented on by the late Cecil Roth: 'It was curious that England – the home of the most memorable Jewish libraries and of the most important Hebrew illuminated MSS. – should have remained almost indifferent [to public collections of Jewish art]'.[13] Cecil Roth, of course, was one of the prime movers in the foundation of the London Jewish Museum. Its contents, comprising items from the long-established English synagogues, together with an admixture of generous gifts and shrewd and timely purchases,[14] constitute one of the finest collections in the world, despite the fact that its present cramped quarters do less than justice to the collection and do not allow it to be displayed to advantage. Nevertheless, the publication of the museum's excellent exhibition cata-

[12] For a fuller account of the Bezalel Art Institute, see: Israel Museum, *Bezalel, 1906–1929* Exhibition Catalogue 232, Jerusalem, Israel Museum, 1983.

[13] Barnett, *op. cit.* p. xiv.

[14] *ibid.* Cecil Roth noted that many fine pieces of ritual silver were obtained from the sale of the Howitt collection at Christies early in 1932, the year in which the London Jewish Museum was founded.

logue in 1974 did a great service to Jewish art scholarship, and has made its unique holdings known to an international audience.

In its discussions of Jewish ritual art, the Royal Albert Hall catalogue of 1887 stated, apropos of Jewish art, that:

> [its] historic survey must be limited to the remark that, whatever the normal artistic capabilities of the Hebrew people, they must have been strongly affected, if not altogether transformed by the stupendous catastrophe of the Dispersion, and the career of ceaseless wandering and misery which subjected them to the perplexing influences of ever changing surroundings . . . [15]

Within 61 years of these words being written they had taken on an even more horrible significance and one of the most devastating changes in the unhappy history of the Jewish people had been effected.

The 'catastrophe of the Dispersion' culminated in the Holocaust, the ultimate obscenity carried out by the German Third Reich when it instituted its methodical and cold-blooded attempt to eliminate the whole of European Jewry between 1933 and 1945. Yet within three years of the end of the Second World War the Jewish nightmare was followed by the accomplishment of 'the dream of a thousand years' when, on 14 May 1948, (5th *Iyar* 5708 in the Jewish calendar) the state of Israel was established. This sudden change in fortune must represent one of the most dramatic reverses of fortune in history. It has had a profound and troubled effect upon the history of the peoples of the Near East, and a profound effect upon Judaism, Jewish consciousness and the whole field of Jewish affairs, including the arts.

Many of the Jewish museums of Europe, together with many private collections of Judaica, were swept away during the Second World War. From the wreckage of that conflict, however, a few collections were salvaged, one of the richest being the State Jewish Museum in Prague. The foundation of this institution is one of the most chilling and macabre tales in the whole history of museums, and has nothing to do with the small museum founded in 1906 by Lieben. This new museum is composed of the contents of the synagogues and Jewish libraries of Bohemia and Moravia which were gathered together by the Gestapo into what was called the Judisches Zentral Museum Prag (Central Jewish Museum of Prague) to serve as the display of the artefacts of what was intended to be an extinct race, deemed by the Nazis, in accordance with their perverted ideology, to be a sub-human species. Millions of Jews perished in the Holocaust, including the Jewish scholars pressed into service to catalogue this collection. But it was the Third Reich which was destined for complete

[15] Royal Albert Hall, *op. cit.*, p. 83.

destruction. In April 1950, the post-war Czech government, in collaboration with the survivors of the Jewish communities of Bohemia and Moravia, set up the museum to serve as a memorial to the victims of Nazi butchery. In 1980 art treasures from this unhappy collection were displayed at the Whitworth Art Gallery in Manchester,[16] a city which now has its own Jewish museum.

The destruction and displacement of the large Jewish populations of eastern Europe left a cultural vacuum which was filled by the United States and by the newly created state of Israel. The Holocaust, together with the influx of European Jews who had survived the war, made Jewish-Americans aware of their special identity in a country where, despite Theodore Roosevelt's dislike of the tendency, 'hyphenated-Americans' still existed. This fact coupled with pride in, and identification with, Israel led to an increased awareness of being a Jew as well as an American and one of the many ways in which this manifested itself was the rapid expansion in the number of Jewish museums.

The history of Jewish museums in the United States, however, can be traced back to the exhibition of the Judaica collection of the art dealer Ephraim Benguiat as part of the Columbia Exposition in Chicago, 1892–3. Following the closure of the exposition, this collection was displayed at the Smithsonian Institute in Washington, DC, before being purchased by Felix M Warburg, who then presented it to the Jewish Museum in the Jewish Theological Seminary of America, in New York. Similarly the private collection of Sally Kirshstein formed the basis of the Jewish Museum of the Hebrew Union College in Cincinnati. But the impact of the Second World War has had a marked effect and since 1945 many Jewish communities and institutions have set up museums: in 1947 the Skirball Museum of Hebrew Union College, Los Angeles, came into existence; and in 1967 the Maurice Spertus Museum of Judaica was opened under the aegis of the Spertus College of Judaica in Chicago. In Israel also many museums, both private and municipal, have been established to supplement the rich Judaica collection held by the Israel Museum in Jerusalem.

It is against this background that the growth of the Victoria & Albert Museum collection must be viewed. It represents an early, if unintentional, conglomeration of Judaica which began accumulating before the general taste for collecting Judaica had started. Two of the first three pieces of Judaica obtained by the museum[17] were purchased on behalf of 'Marl-

[16] Whitworth Art Gallery, *Jewish art treasures from Prague: the State Jewish Museum...and its collections.* Exhibition Catalogue. Manchester, University of Manchester, 1980.

[17] These two objects are the spice box (cat. no. 48) and the wedding ring (cat. no. 58).

borough House'[18] when the Bernal collection was sold in 1855.[19] Ralph Bernal, MP, was an art collector of distinction. Although he himself was brought up as a Christian, both his parents were Jewish, and his grandfather (Jacob Israel Bernal) had been a warden of the Spanish-Portuguese (Bevis Marks) synagogue. Neither his father nor his grandfather formally renounced Judaism but gradually, almost imperceptibly, they withdrew their connections with the Jewish community in London as they allowed themselves to be absorbed into the Christian society around them.

The most interesting of these purchases from the Bernal collection is the small 13th-century copper-gilt spice box (cat. no. 48) which is one of the oldest still in existence.[20] Professor Narkiss has pointed to the stylistic comparison between this object and the famous *Ḥanukkah* lamp, found in the remains of the old Jewish quarter of Lyons, and now in the Musée Cluny.[21] The Cluny lamp formed part of the original collection of Isaac Strauss and was displayed at the first two exhibitions of Jewish art: the Trocadéro, Paris (1878), and the Royal Albert Hall (1887). The spice box was not exhibited in 1887 because it was believed to a reliquary, presumably because Bernal and the museum authorities were unaware of its proper function.[22] In all probability Ralph Bernal acquired his pieces of Jewish ritual art earlier in the century than Strauss, but whereas the Englishman made his purchases either without knowledge of, or regardless of, their religious significance, the Frenchman deliberately set out to collect Hebrew ritual items, fully aware of their function.

For a great part of the 19th century, Jewish ritual art was not considered a legitimate area of aesthetic study in its own right; consequently little academic expertise was available. There were also comparatively few collectors of Judaica, as opposed to religious Jews who purchased ritual objects for sacred use, with the result that the art market prices for items

[18] Somers-Cocks, *op. cit.*, p. 3: '... in 1852 Queen Victoria gave the museum its first permanent home in Marlborough House'.

[19] See Christie & Manson, *Catalogue of ... works of art ... of that distinguished collector, Ralph Bernal* [to be] ... *sold by auction, ... at the Mansion, No. 93, Eaton Sq.* [etc.]., London, Christie & Manson, 1855.

[20] Barnett, *op. cit.*, p. xvii. (Introduction, C Roth): 'A bronze tower-shaped container in the Victoria & Albert Museum, London, long imagined to be a reliquary, may perhaps in fact be a simple spice box for use at the conclusion of the Sabbath.'

[21] Narkiss, B, 'Un objet de culte: la lampe de Hanuka'. In: Blumenkranz, B (ed.), *Nouvelle Gallia judaica. Art et archéologie des juifs en France medièvale* [etc.], Vol. 9. Paris, Centre National de la Recherche Scientifique, 1980, pp. 187–206.

[22] This object was lot no. 1288 in the Bernal sale of March 1854, when it was incorrectly described as a Byzantine reliquary.

specifically identified as Jewish were comparatively low. The author believes that it was lack of knowledge that resulted in the Bernal spice box being described as a reliquary, rather than a desire to enhance its market value, but another object described in this catalogue (cat. no. 107) is possibly a spice box which has been deliberately altered by adding a crudely shaped cross to make it look like a Christian piece. With a few exceptions, ritual objects seem to have been bought as functional pieces rather than for their inherent aesthetic qualities. Even when used to adorn, as in the case of *Torah* mantles and other *Torah* ornaments, the primary function was to enhance the beauty and majesty of worship. The Victoria & Albert Museum, however, along with the few discerning collectors, obtained Jewish objects because they were well designed or interestingly decorated.

Despite the lack of a department of Jewish art or a specific mandate to collect Jewish objects, the museum has a long and distinguished record of staging or participating in exhibitions of Jewish art. This began, as has already been shown, with the contribution to the 1887 Anglo-Jewish historical exhibition and has continued until the present day. By 1887, 25 pieces of Judaica were in the holdings, including the Bernal spice box, 13 wedding rings, a *Ḥanukkah* lamp, an amulet and an excellent pair of *rimmonim*.[23] Jewish textiles were represented by two Ark curtains, two reading desk hangings (*Almemor*), a piece of lace intended as a *tallit* ornament, two embroidered shawls (not specifically Jewish, but said to have been worn by Jewish brides), and a magnificent Dutch *Torah* mantle (purchased with the pair of *rimmonim*).[24] The museum had also acquired an incomplete Moroccan *Torah* scroll, a *megillah* written by Michael (Yehuda) Judah Léon and a miniature prayerbook written and decorated by Aaron Schreiber Herlingen of Gewitsch in 1784.[25]

The *rimmonim* and mantle were purchased in 1876 from Murray Marks, a dealer who sold *objets d'art* to George Salting, an Australian millionaire who bequeathed several thousand art objects to the museum. In the following year a certain Caspar Clarke sold to the museum the two Ark curtains and the two reading desk hangings. This Mr Clarke was to become Sir Caspar Purdon Clarke; he was the architect who designed the Indian Court for the Paris Exhibition, and later, in 1886, became the

[23] These objects are illustrated as follows: wedding rings, cat. nos 58–70; *Ḥanukkah* lamp, cat. no. 19; amulet, cat. no. 75; and *rimmonim*, cat. no. 8.

[24] These objects are illustrated as follows: Ark curtains, cat. nos 5 and 6; reading desk hangings, cat. nos 4 and 7; lace for *tallit*, cat. no. 12; embroidered shawls, cat. nos. 80 and 81; and *Torah* mantle, cat. no. 2.

[25] These objects are illustrated as follows: Moroccan *Torah* scroll, cat. no. 1; *megillah*, cat. no. 34; and miniature prayerbook, cat. no. 79.

first keeper of the Indian Section (now the Indian Department). The *Dictionary of National Biography* records that C Purdon Clarke made a trip through Turkey, Syria and Greece purchasing objects for the museum, and had also visited Italy (in 1869), Alexandria (in 1872) and Teheran (in 1874). He displayed considerable skills as both an organiser and a collector and by 1896 he had become the director of the South Kensington Museum, a post in which he remained for nine years; it was during his time as director that it was renamed the Victoria & Albert Museum (in 1899). In 1905 he resigned from the V&A to take up the directorship of the Metropolitan Museum in New York.

During the course of the next 69 years the museum acquired only another 44 Jewish items. It was not until the acquisition of the Hildburgh Bequest in 1956 – the year when, by coincidence, the tercentenary exhibition of the Anglo-Jewish resettlement was being staged in the museum – that there was a significant increase in the holdings of Judaica. No fewer than 23 of the 109 items listed in this catalogue came from the unique American collector Dr W L Hildburgh, FSA, one as a gift in 1941 (a *wimpel* from Alsace dated 1719–20, cat. no. 74) and the rest as a result of his enormous bequest. Dr Hildburgh was a prodigious and knowledgeable collector who greatly enriched the museum, impoverishing himself in the process.[26] The Jewish items he donated represent a mixed collection, some being of excellent quality and interest[27] while others are less authentic,[28] being copies of earlier models.

The catalogue of the 1887 Anglo-Jewish historical exhibition listed 19 objects which were displayed at the South Kensington Museum (now the Victoria & Albert Museum) and 18 are still in the collection.[29] Two pieces which were originally displayed at the Royal Albert Hall and which were then in private ownership have since been acquired by the museum: an amulet (cat. no. 76) and a *Havdalah* candlestick (cat. no. 55).

William Gross, in his article listing all the catalogues of Jewish art published between 1878 and 1978 noted that 19 exhibitions of Jewish interest have been held in the British Isles, two of them (not including the

[26] Somers-Cocks, *op. cit.*, p. 36: '1956 brought the gigantic bequest from a slightly eccentric American, Dr W L Hildburgh, who for many years had had the endearing habit of giving the museum presents at Christmas and on his own birthday... Although a rich man when young, by the end of his life Hildburgh had probably spent most of his money on the museum, and his life was eccentrically austere.'

[27] See the 16th-century *Hanukkah* lamp from Italy, cat. no. 23.

[28] See cat. no. 24. This *Hanukkah* lamp is a 19th-century copy, probably a recast from a late 16th-century Italian original.

[29] These objects are cat. nos 1, 2, 3, 34, 58–70 and 75.

1887 exhibition) having been held in the Victoria & Albert Museum.[30] These two exhibitions were entitled 'Anglo-Jewish Art commemorating the Tercentenary of the Resettlement of Jews in England', held in 1956, and 'Anglo-Jewish Silver', held in 1978. The latter was devoted to a display of silver plate associated with British Jewry – not all of it ritual silver. Two V&A objects were also included in the London Jewish Museum exhibition of permanent and loan collections in 1974,[31] and a member of the staff, Natalie Rothstein, also contributed the entry on Jewish textiles to the catalogue which was published to coincide with the exhibition.

The Victoria & Albert Museum has made a significant contribution to the history of Anglo-Jewry, and to Jewish art history. Its collection is of use not so much for its contents as for its pedigree. Few other museums started collecting Jewish objects as early as the mid-19th century; therefore an examination of the V&A holdings gives an idea of what items of ritual art were being offered for sale in the last century. Jewish art can now command large prices in the art market and undoubtedly fake articles are being made to cater for the growing demand for Judaica. But ritual art is essentially conservative – people feel safer and happier with established patterns and this applies to religious objects as much as to liturgy. The author is of the opinion that many 19th-century copies of earlier Jewish artefacts were made and sold as copies for bona fide ritual use, and not for passing off as originals.

The V&A collection can be used to demonstrate the changing attitudes towards Judaica which have taken place over the last 130 years as collectors have begun to understand and acknowledge the real nature of the object they have purchased; they no longer represent, whether by accident or design, a spice box as a reliquary.

The collection also reflects the history and the composition of British Jewry. There are, for example, a large number of Sephardic objects of high quality reflecting the early predominance of the Sephardic Jews who entered Britain by way of Spain and the Spanish Netherlands during the 17th century. This early Sephardic dominance in the life of Anglo-Jewry is reflected in several other private and public collections of Judaica in Britain which also show in the number of works available a bias in favour of the Spanish communities. A Sephardic congregation was holding religious services in a small building in Creechurch Lane, Aldgate, as early as 1656 and it was this group which built the Spanish-Portuguese (Bevis Marks) synagogue which was consecrated in 1701. The Bevis Marks synagogue is an attractive building filled with many fine ritual objects,

[30] Gross, *op. cit.*

[31] Barnett, *op. cit.*; cat. nos. 109 and 598. In this catalogue, nos 8 and 75.

10

including textiles and plate.[32] Its painting, *Moses and Aaron with the Ten Commandments*, painted by Aaron de Chavez in 1675 possibly served as a model for the dummy board figures in the V&A (see cat. nos 105 and 106), though these figures were painted about 100 years later.[33]

World Jewry is divided into several groupings, the two major divisions being the Sephardim and the Ashkenazim. The Sephardim have their roots in the communities of the Babylonian diaspora and these groups were spread along the Mediterranean littoral, particularly the Iberian peninsula (where their culture reached its zenith during the 14th and 15th centuries) and north Africa (whence many of the Spanish Jews fled following their expulsion from Spain in 1492 during the reign of Ferdinand and Isabella). They developed a lingua franca called Ladino (Judaeo-Spanish) based upon Spanish but including Hebrew, Arabic, Italian and Turkish borrowings. The Ashkenazim, by contrast, have their origins in the Judaic traditions of Palestine from whence they passed, by way of Italy, to northern and eastern Europe. Their common language is Yiddish, a dialect of German which includes an admixture of Hebrew and Slavonic words and phrases (the word 'Ashkenazim' is derived from an old Jewish name for Germany). Apart from minor liturgical differences, the religious beliefs of the two divisions are largely identical. The differences between them tend to be cultural, based on the nature of the host communities in which they were settled: Islamic in the case of the Sephardim, and Christian in the experience of the Ashkenazim. Adherents of both communities eventually settled in Britain, but the Sephardim from Holland, although originally of Italian or Iberian extraction, were the first to re-establish themselves in these islands. All items from the original pre-expulsion community in Britain (i.e., from before 12 November 1290) are held in other collections.

The Ashkenazi immigrants of the mid-18th century originated from north-east Germany and the Netherlands and represented a lower social class than the settled Sephardic community. The newcomers were, for the main part, itinerant traders who spread their small communities throughout Britain, whereas the Sephardim, many of whom were armigerous, were prosperous merchants based in London and the Home Counties. Thus while the Sephardim were, for the most part, of upper- or middle-class status, the street-trading Ashkenazim were equated with the proletarian elements of British society. They were seen throughout Britain, and were obviously a distinct and exotic group, the first generation speaking

[32] For a more detailed account of the history and the holdings of the Bevis Marks synagogue, see Grimwade, A G (*et al.*), *Treasures of a London Temple: a descriptive catalogue of the ritual plate, mantles and furniture of the Spanish and Portuguese synagogue in Bevis Marks* [etc.]. London, Taylor's Foreign Press, 1951.

[33] See Croft-Murray, E, 'A note on the painting of Moses and Aaron'. In: Grimwade, A C (*et al.*), *op. cit.*, pp. 67–8.

fractured English. Consequently they lent themselves to caricature, being used as models for porcelain figures[34] as well as for dummy board figures.[35]

Throughout the late 18th and the first three-quarters of the 19th century, the Jews, together with Christian nonconformists, waged a peaceful campaign to achieve complete religious and civic freedom. But even while these goals were being pursued, Jews were taking their place in the business life of Britain. The glass bowl (cat. no. 102) and the decanter (cat. no. 103) made by the Jacobs family of Bristol reveal that the skilled crafts were no longer forbidden to Jews and illustrate 19th-century Jewish endeavour in the decorative arts of Britain. This opening up of the skilled trades to Jews allowed the Anglo-Jewish communities of the 18th century the opportunity to create a more secure niche for themselves in British society and business life than had been allowed to their medieval predecessors. It was during this period that the leading members of the community started to commission Christian silversmiths to produce an annual present of a piece of fine silver plate for the lord mayor of London. This communal presentation seems to have encouraged the more affluent of them to purchase pieces of plate for themselves and among these commissions were orders for ritual objects. These moves led to an enrichment of Jewish art in the country because the Christian silversmiths made objects that were both ritually correct and yet also manifested many of the best qualities and characteristics of 18th-century silversmithing. The museum owns an excellent example of a rococo *Ḥanukkah* lamp (cat. no. 27) made by Jacob Marsh, hallmarked 1747–8, which was commissioned by Solomon de Aaron Abecassis and illustrates this growing tendency. There are also two other lamps by the same maker listed in the Bevis Marks catalogue.[36]

During the 17th and 18th centuries, Jews had often been perceived in English literature in negative terms, being portrayed as venal or corrupt. An example is Richard Sheridan's comic opera *The Duenna* (1775), in which Isaac, a Jew, is portrayed as being a most distasteful character. In the late 18th and 19th centuries these negative stereotypes started to disappear and a more balanced view began to emerge. Indeed, George Eliot's noble hero in her novel *Daniel Deronda* (1876) is depicted as a Jew of scruple and high principle; this novel anticipates the Zionist movement by several years, for it ends with Deronda leaving Europe and all its prejudices to return to find salvation in the Holy Land.

[34] See Barnett *op. cit.* p. 141; nos 693a–6, col. pl. 17 and pl. clxxvi.

[35] *ibid.*, p. 141, no. 699, pl. clxxvii. This entry describes and illustrates a dummy board figure identical to that in cat. no. 104, and includes a reference to a third example at Hatfield House.

[36] *op. cit.*, p. 14, cat. nos 72 and 74, pl. 13.

The visual arts also can be seen to manifest the same extremes of perception. This can be demonstrated by reference to the three late 18th- or early 19th-century dummy board figures in the Furniture and Interior Design Department's collection. The figures of Moses and Aaron already referred to (cat. nos 105, 106) show the positive aspect of the Jew in art, exemplified by the dignity bestowed upon these figures of the Patriarchs; the Jewish pedlar (cat. no. 104) has more of the popular stereotyped and caricatured image of the Jewish hawker and door-to-door salesman of the mid-18th and 19th centuries.

The last 26 years have seen a dozen more objects added to the departmental collections, including a silver *yad* (pointer) made in London and hallmarked 1797–8 (see cat. no. 9). There are also eight items of an Iraqi Jewish costume, among which is a finely brocaded *am al-kasa* (grandmother's dress) (cat. no. 93). In 1981 the museum obtained one solitary example of contemporary Jewish ritual art, an ingenious *Havdalah* set designed and made by the Israeli goldsmith Eli Gera, (cat. no. 56).

The growing number of private collectors, coupled with the expanding number of Jewish museums, has led to a marked increase in the cost of Judaica which has in turn reduced the likelihood of the V&A being able to make any appreciable additions to its holdings of pre-20th-century items of Jewish ritual art. On the other hand, the increasing number of contemporary artists, craftsmen and craftswomen producing excellent pieces of ritual objects lead one to hope that the museum will still be able to obtain significant items of contemporary Jewish religious art, whether by purchase or by gift. The V&A was not only set up to be a repository of past art but also to act as an institution prepared to display and acquire the best of contemporary decorative art. It contributed to the first exhibition of Jewish art in 1887 by displaying the few pieces it then held, and it repeated this, on a much larger scale, in 1987.[37] Perhaps the year 2087 will see this museum able to mount a richer and even more varied exhibition of Judaica.

[37] 20 May to 5 July 1987. The Judaica at the V&A exhibition was held at the Bethnal Green Museum of Childhood as the museum's contribution to the East End Jewish Festival.

ORGANISATION OF THE CATALOGUE

The catalogue has been divided into five sections, as is evident in the contents list. All five sections are prefaced by introductory texts. The first section deals with public worship in the synagogue and the second with the major festivals and holy days in the Jewish year. The third part is devoted to artefacts required for private worship and observance in the home. The fourth and fifth sections are of a more general nature, dealing respectively with Jewish costume and with miscellaneous items and doubtful or specious objects. In some instances the placement of an item in one section or another has been, of necessity, somewhat arbitrary.

A glossary, a select bibliography and an index follow the catalogue section.

DESCRIPTION OF THE OBJECTS

Every catalogue entry is arranged in the following sequence:
 Line 1 Catalogue number and title of item.
 Line 2 Museum accession number (see below), with the department to which the item belongs in brackets.
 Line 3 Dimensions of the object.
 Line 4 Place and date of manufacture.

Then follows a detailed description of the object itself. After this there are three sections with the following abbreviated headings: *Prov.*, *Lit.* and *Notes*.

Prov. is the abbreviation for 'provenance'. Under this heading is included the history of former ownership (if known), also the person or institution from whom or which it was obtained and the method of acquisition (purchase, gift or bequest).

Lit. is the abbreviation for 'literature'. Under this heading are listed any books, articles or exhibition catalogues in which the object has been mentioned.

The *Notes* contain any additional information available, such as the historical context, peculiarities in production and theories about the origin of the item under consideration.

MUSEUM NUMBERS

When objects are received into the V&A they are given an accession number. In the early days of the museum these numbers were assigned in a simple numerical sequence beginning with 1, but around the time when these numbers had reached sequences containing five digits a new system was introduced. Thereafter, new objects were accorded a year-of-acquisition number – hence the *Torah* scroll (cat. no. 1), for which the number is 38–1876, was the 38th item acquired in 1876. Even this system proved too unwieldy and eventually every department resorted to using an initial letter to designate its own accessions. Consequently the silver spice box (cat. no. 53) with the number M434–1956 was the 434th object received into the Metalwork Department in 1956. As a general rule the last four digits in every museum number represent the year of acquisition of the object.

CATALOGUE

PART I
Public Worship and
the Synagogue

FESTIVALS AND HOLY DAYS: THE JEWISH RELIGIOUS CALENDAR

The Jewish New Year occurs in the early autumn, at the end of September or the beginning of October. *Tishri*, the first month of the Jewish year, begins with *Rosh ha-Shanah* (ראש השנה = New Year's Day), which is a day of celebration as in other faiths. A modern custom of sending New Year cards has developed, and people exchange the greeting *Shanah Tovah* (שנה טובה = Good New Year). Sometimes a New Year meal will end with slices of apple, dipped in honey, to attract a 'sweet' new 12 months. But New Year's Day ushers in the ten days of penitence which conclude with *Yom Kippur* (יום כפור = Day of Atonement).

Yom Kippur is the most solemn festival in the Jewish year. It is a day of fasting on which every Jew is required to make atonement and ask forgiveness, through the agencies of prayer, repentance and reparation, for any ills done to others during the preceding year. Pardon is deemed to have been obtained if all three of these obligations have been scrupulously observed. No food is taken until the evening and every member of the community is required to walk (not ride) to the synagogue for the *Yom Kippur* service. As a sign of purification white curtains are draped in front of the *Aron ha-Kodesh* and the *Torah* mantles are draped in white. The service concludes with the blowing of the *shofar*, the ancient ram's horn trumpet, as a sign that the fast is over and that repentant sinners have been restored to grace.

The next festival, which falls on 15th *Tishri*, is *Sukkot* or the Feast of Tabernacles. Its observance is required in Deuteronomy 16, 13: 'Thou shalt observe the feast of tabernacles seven days, after that thou hast gathered in thy corn and thy wine'. *Sukkot* is, therefore, a harvest festival. During its celebration all meals should be taken in a *sukkah*, a temporary shelter (סוכה), decorated with seasonal fruit and flowers, as a reminder of the

temporary shelters the people's forefathers constructed while wandering in the wilderness after their escape from captivity in Egypt:

> Ye shall dwell in booths seven days; all that are Israelites born shall dwell in booths: That your generations may know that I made the children of Israel to dwell in booths, when I brought them out of the land of Egypt: I am the Lord your God. (Leviticus 23, 42–3)

During the morning service in the synagogue *hallel* (psalms of thanksgiving) are sung and the worshippers bear a bundle of palm leaves, bound together with two strips of willow and three of myrtle, in one hand and a citrus fruit (*etrog* in Hebrew) in the other as symbols of the ingathering of the harvest, the fruit often being enclosed within containers made in their shape:

> And ye shall take on the first day the fruit of goodly trees, branches of palm trees, and boughs of leafy trees, and willows of the brook; and ye shall rejoice before the Lord your God seven days. (Leviticus 23, 40)

Sukkot is followed by five intermediary days (*hol ha-mo'ed*) which are followed, on 22nd and 23rd *Tishri*, by the two days devoted to the Rejoicing of the Law (*Shemini Atseret* and *Simchat Torah*) when the annual cycle of reading aloud the Pentateuch during the weekly Sabbath services at the synagogue comes to an end. The second day is given over to rejoicing and two men from the congregation, known as the bridegroom of the Law and the bridegroom of the first portion, are chosen to read the last section of the old and the first section of the new *Torah* scroll.

Whereas the first month of the Jewish year has no fewer than four major festivals, the second month, *Heshvan*, contains no major religious celebration at all. It is not until *Kislev*, the third month, that another religious feast falls due. This event is *Hanukkah*, which is held on 25th *Kislev* (mid- to late December) to celebrate the successful rebellion of Judas Maccabeus against the Greek rulers of Syria and the rededication of the Temple in Jerusalem following its profanation by the Hellenes. This winter event is marked by the exchange of gifts and by the lighting of the special eight-branched candlestick or *hanukkiyah*. *Hanukkah* lasts for eight days, 25th *Kislev* to 2nd *Tevet*; it starts with one light on the first night and an additional flame is kindled every night until all eight are burning by 2nd *Tevet* (late December).

There are two minor holidays, the Fast of the 10th of *Tevet* and *Tu bi-Shevat* on 15th *Shevat*, but it is not until 14th *Adar* (March–April) that the next major religious event takes place. This holiday is *Purim*, the Feast of Lots, which is the joyful commemoration of the saving of the Jews of ancient Persia from extermination at the hands of Haman, chief minister

18

of King Ahasuerus (Xerxes), through the divinely inspired actions of Queen Esther and Mordecai. The story is told in the Book of Esther. Among the religious artefacts utilised during *Purim* are the intricately decorated personal scrolls containing the story of Esther and the metal platters made to receive the gifts of alms for the poor.

One month after *Purim*, the week-long celebration of *Pesach* (Passover) occurs. The first day, falling on 14th *Nisan*, is the Fast of the Firstborn and this is followed immediately by the first day of Passover. Like *Sukkot* and *Shevu'ot*, this is one of the three pilgrimage festivals (*shalosh regalim*) of the Jewish calendar, and is a time when, in the days of the old kingdoms, the Jews were expected to gather in Jerusalem. *Pesach* is of importance because it commemorates the release of the ancient Israelites from their bondage in Egypt and their wanderings in Sinai before the return to the Promised Land. A special religious ceremony-cum-meal called the *seder* (order) is held in the home. It serves the dual function of remembering the days of servitude and of teaching the young about the miraculous deliverance from Egyptian bondage. The ritual is recorded and explained in a text called the *Ḥaggadah*, and many of these texts are finely illustrated, in an unbroken tradition that stretches from the medieval period to the present day. Other artefacts connected with this celebration include fine table linen; well-made tableware, including plates to hold the unleavened bread (*mazzot*) and wine cups. Both the tableware and the cups are often inscribed or decorated with an appropriate word or text.

The *'Omer* [עמר = sheaf] is the name of the 50-day period between Passover and Pentecost [Greek, πεντηκοστή = 50th day], which is the final important religious holiday in the Jewish calendar. The *'Omer* recalls the ancient daily offering of a barley sheaf that was made in the Temple during this period between the festivals. Pentecost, known more usually by its Hebrew name of *Shevu'ot* (Feast of Weeks) is held on 6th *Sivan* and is believed to mark the time when the Law was revealed to Moses upon Mount Sinai; consequently it is celebrated as a day of thanksgiving. Some synagogues used to have gaily decorated *'Omer* boards, or rollers, which counted off this seven-week period, the roller being turned to reveal the appropriate number day by day.

The museum has objects pertaining to only three of the major festivals, these are *Ḥanukkah*, *Purim* and *Pesach*.

THE SYNAGOGUE AND ITS APPURTENANCES

When the Romans destroyed the Temple in Jerusalem in AD 70, Judaism lost its central architectural and geographical focus, but the faith was maintained by the widespread system of worship in synagogues and by devoted adherence to domestic rituals.

The concept of every community having its own central meeting place was already well established before the destruction of the Temple, and the Hebrew names for these places bear testimony to their manifold usages: meeting-place (*beth ha-knesset*), house of prayer (*beth tefillah*), place of study (*beth ha-midrash*). 'Synagogue' itself is derived from the Greek word συναγωγή (*synagogé*, to come together).

The dominant feature of the synagogue is the Ark of the Law (*Aron ha-Kodesh*) in which the *Torah* scrolls are kept. It origins lie in the Ark of the Covenant (*Aron ha-brith*) which was kept in the Holy of Holies (*Kodesh ha-K'odeshim*) in the Temple. The Ark has two doors which are concealed behind a curtain (*parochet*), two examples of which can be found in the museum (cat. nos 5 and 6) and are beautifully embroidered late 17th-century Italian examples.

The Ark of the Law (*Aron*) in the Spanish–Portuguese synagogue in Amsterdam

This engraving depicts the Ark of the Law in the Amsterdam synagogue for which the V&A's *Torah* mantle (cat. no. 2) is believed to have been made. It is shown with the Ark opened during the *Simchat Torah* (Rejoicing of the Law) ceremony, and the many Scrolls of the Law can be seen covered with finely embroidered mantles. Comparison should be made between this image and the medallion on the front of the *Torah* mantle.

SOURCE: B Picart *Cérémonies et costumes religeuses de tous les peuples du Monde. Représentées par des Figures dessinées de la main de B.P. Avec une Explication Historique, et quelques Dissertations curieuses. Tome premier qui contient les cérémonies des Juifs et des Chrétiens Catholiques.* Amsterdam, 1723.

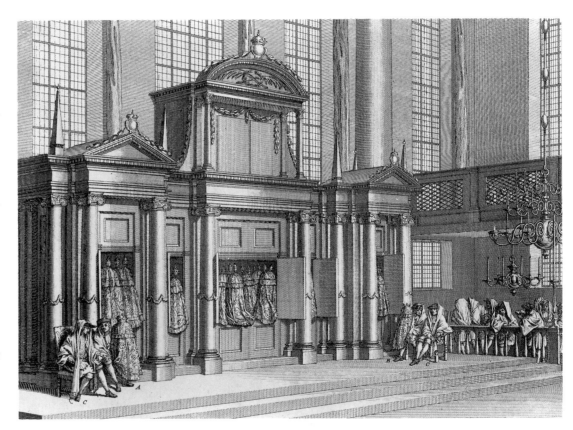

Immediately in front of the *Aron ha-Kodesh* is the reading desk (*Almemor*) on which the Scrolls of the Law are placed prior to being recited aloud. The fronts of these reading desks would be hung with decorated cloths such as the early 18th-century piece (cat. no. 7). An eternal flame is kept alight in a lamp (*ner tamid*) suspended before the Ark, a practice based on the injunction in Exodus 27, 20–1:

And thou shalt command the children of Israel, that they bring thee pure olive oil beaten for the light, to cause the lamp to burn always. In the tabernacle of the congregation without the veil, which is before the testimony, Aaron and his sons shall order it from evening to morning before the Lord: it shall be a statute for ever unto their generations on the behalf of the children of Israel.

Men and women sit separately and in many synagogues the ground floor is reserved solely for men, the women and younger children being housed in a gallery from which they look down upon the proceedings taking place below. In Britain, as in lands to the west of the Holy Land, the Ark is placed at the eastern wall of the building, nearest Jerusalem. This practice is also followed at home where the eastern wall of the room used for family worship houses an emblem (a plaque, painting or piece of cut-paper work) called a *mizrach* (literally, east).

The Scrolls of the Law consist of the Pentateuch, or five books of Moses (Genesis, Exodus, Leviticus, Numbers and Deuteronomy), and these are written by a scribe (*sofer*) in accordance with strictly defined rules. The text must not be decorated, it must be written without vowels (a technique common to all Semitic languages) and it must be free from correction. The parchment should be without blemish. These rules seem to be common to all Jewish communities, which is why doubt must be cast upon the information that the *Torah* scroll (cat. no. 1) was used in a synagogue at Mogador: there are several mistakes which have had to be corrected in the text and it appears to be incomplete.

While the text is free from decoration, the scrolls themselves are covered with rich trappings, for Jews believe that these texts and the Law they contain emanate from God. They are treated like a ruler, a king, and due ceremony and dignity are accorded to them. They are wrapped in richly decorated mantles, a custom common to both the Sephardic and Ashkenazi communities in Britain.[1] The scrolls are wound on rollers called Trees of Life (*Azei Hayyim*), a reference to Proverbs 3, 18: 'She [the Law] is a tree of life to them that lay hold upon her: and happy is everyone that retaineth her.' These rollers are capped with finials of precious metals called *rimmonim* (literally, pomegranates). This tradition possibly derives from a reference to the high priest's robes in Exodus 28, 33: 'and beneath upon the hem of it thou shalt make pomegranates of blue, and of purple, and of scarlet, round about the hem thereof; and bells of gold between them round about'. Many *rimmonim* now affect architectural rather than natural forms, but the fine filigree-silver pair in the museum (cat. no. 8) reflect the traditional pomegranate shape and reveal another decorative tradition in

[1] In Sephardic communities in north Africa and the Middle East the *Torah* is housed within a hinged and decorated box (*tik*, c.f. Greek *théké*, box) which is placed in the *Aron*.

that they are capped with a crown (*keter* or *atarah*) and a fleur-de-lis, both being symbols of majesty.

When a scroll is removed from the Ark it is treated with great ceremony, and before being read it is partially opened and held aloft so that all present can see it. Every effort is made to refrain from touching the text, and the reader uses a pointer (*yad*, literally a hand) made of ivory or a precious metal to follow the reading. There are two pointers in the collection: cat. nos 9 and 108.

Ritual objects used in the synagogue

These include the box for drawing lots to decide which members of the congregation will be called to carry the *Sepher Torah* (Scroll of the Law); a *Torah* opened to reveal the text; a *yad* [pointer] with which to follow the text; a closed scroll; a *rimmon* and the *Sepher Torah* complete with *Torah* mantle and *rimmonim*.

SOURCE: Picart *Cérémonies et costumes religeuses ...*

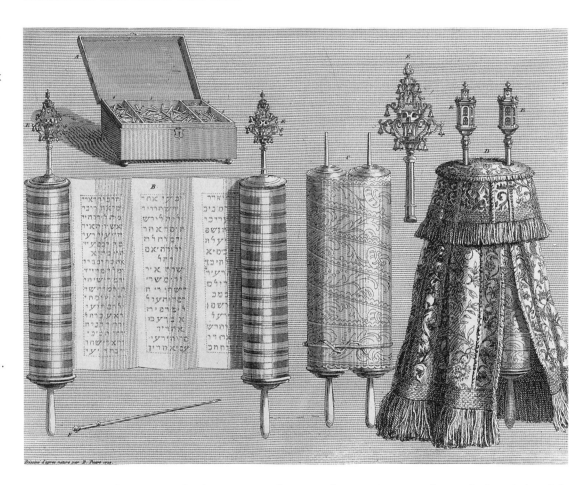

There are other ritual objects, such as a laver (jug and wash basin) with which the *Cohanim*[2] wash their hands before blessing the congregation on festival days, and the *Torah* shield (*tas*). These are not represented in the collections.

[2] The *Cohanim* are priests, descendants of the family of Aaron who was the high priest in the time of Moses. The Levites are Temple servants who assist the *Cohanim*.

1 Hebrew manuscript (*Torah* scroll)

38-1876 (National Art Library)
Height 56 cm × length 238 cm
North African (Morocco): 19th century

Scroll of the Law (*Torah*) or Pentateuch, the first five books of the Bible (Genesis, Exodus, Leviticus, Numbers and Deuteronomy). Written in square Sephardic letters and unadorned save for flourishes added to the words כל ישראל (*kol-Israel*, all Israel) which close the final line of text. The scroll is wound upon wooden rollers (*Azei Ḥayyim*, Trees of Life) contemporary with the scroll.

Prov.: Purchased from Maurice Moseley, 19 January 1876.

Lit.: Royal Albert Hall, *Catalogue of the Anglo-Jewish historical exhibition*. Publications of the Exhibitions Committee IV. London, Royal Albert Hall, de luxe ed., 1888, no. 1, p. 181.

Notes: A note in the 1876 register states that this *Torah* was 'formerly used in a synagogue at Morocco or Mogador', a statement consistent with the style of both the scroll and the script. The scribe has, however, had to correct several errors in the manuscripts, and the entry in the 1887

catalogue (the first edition of the catalogue listed above) noted that the scroll was incomplete. In these circumstances it would seem unlikely that this scroll would have been used in a synagogue. There is a Moroccan *Torah* scroll of the 19th century in the Israel Museum, Jerusalem, which is stylistically close to this manuscript.

1 Hebrew manuscript (*Torah* scroll). 38–1876.

Showing the Scroll of the Law to the congregation, prior to the reading

This engraving shows the Scroll of the Law being raised above the reader's head, for the congregation to see, just before the text for the day is read aloud. The scroll has just been carried, with all due ceremony, from the Ark (*Aron*) and the *Torah* mantle has been removed (it can be seen discarded on the left of the reading desk). Immediately above the reader's head is the eternal flame (*ner tamid*). The men have their heads covered (with the contemporary tricorn hats) and have their prayer shawls draped over their heads and shoulders.

<small>SOURCE:</small> Picart *Cérémonies et costumes religeuses ...*

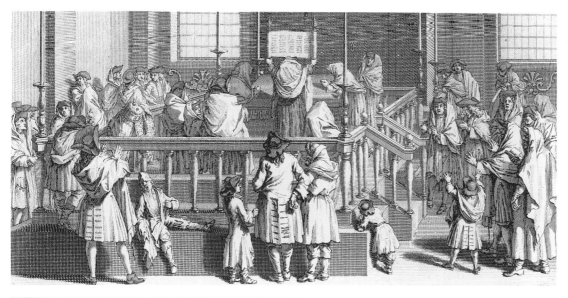

2 *Torah* mantle

349-1870 (Textiles)
Length (including fringe) 114.5 cm × circumference (at bottom) 206 cm
Netherlands (Amsterdam): 1650–1700.

Mantle for a *Torah* scroll. Silk velvet and silk brocaded with silver, embroidered with silver-gilt thread, twist, coil and purl with some silver inlaid and couched work; elaborately padded. Trimmed with silver-gilt fringe and silver tassels. The whole mantle is magnificently decorated: on the front, within a large medallion, is a representation of the *Aron ha-Kodesh* (Ark of the Law) of the Sephardic synagogue at Amsterdam. At the back are two other medallions, one showing the harp, sceptre and crown to symbolise King David. The second depicts the breastplate, laver of brass, altar, Aaron's rod, shovels, flesh-hooks and firepans used in the sacrifices at the Temple in Jerusalem (see Exodus 27, 3). All three medallions are surmounted by the Crown of the Law.

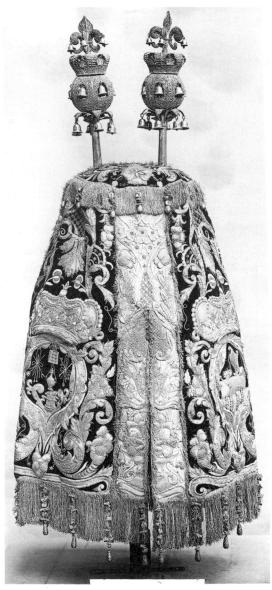

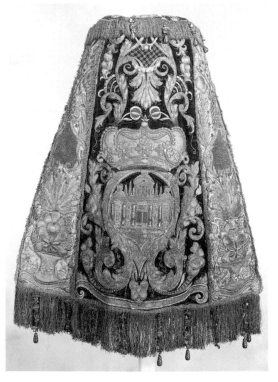

2 *Torah* mantle.
349–1870

Prov.: Believed to have been made for the Spanish–Portuguese (Sephardic) synagogue in Amsterdam. Purchased from Murray Marks on 17 February 1870, together with the *rimmonim* cat. no. 8.

Lit.: Royal Albert Hall, *Catalogue of the Anglo-Jewish historical exhibition.* Publications of the Exhibitions Committee IV. London, Royal Albert Hall, de luxe ed., 1888, no. 2, p. 181.

Symonds, M & Preece, L, *Needlework in religion: an introductory study of its inner*

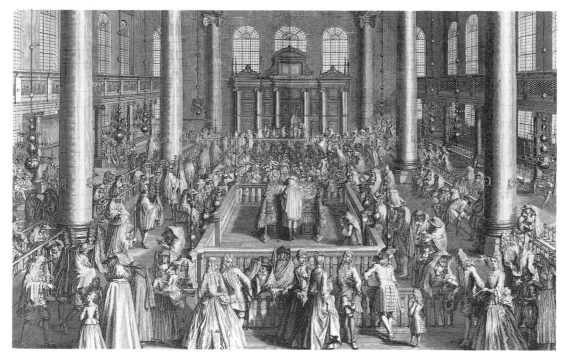

meaning, history and development; also a practical guide to the construction and decoration of altar clothing and of the vestments required in church services. London, Pitman, 1924 [?], pp. 36–9, pl. III.

Salomon, Kathryn, *Jewish ceremonial embroidery*, London, Batsford, 1988, fig. 1, p. 10.

Notes: Comparison can be made between the *Aron* depicted on the front of the mantle and that shown in Emanuel de Witte's (1617–1692) oil painting *Interior of the Portuguese Synagogue in Amsterdam*, which belongs to the Israel Museum; also compare with the engraving of the dedication of the new Sephardic synagogue, 1675, made by Bernard Picart in 1721 (above). Another mantle bearing some similarity to this one is in the possession of the Spanish–Portuguese synagogue (Bevis Marks). It also has a red silk ground brocaded with silver thread, and was also exhibited at the 1887 Royal Albert Hall exhibition; it is believed to be from the Netherlands and to date from the early 18th century.[1]

[1]See Gutmann, J, *Jewish ceremonial art*. New York and London, Yoseloff, 1964, p. 33, fig. 11.

3 *Torah* mantle

T258-1920 (Textiles)
Height 34.5 cm (including fringes) × width 53 cm (maximum)
Netherlands: 18th century

Small mantle for a *Torah* scroll, or possibly the top of a larger mantle; of cream-coloured silk completely covered with silver bobbin lace, fringed round the edges. Flat and oval stiffened top pierced with two round holes for rollers, with short pendant flounce; it opens down the front. Close horizontal rows of fan-like and floral devices united by an irregular mesh. It has a cream-coloured silk lining, and the lace is composed both of thread and strip.

Prov.: Gift of Sir Charles and Lady Walston.

4 *Almemor* cloth

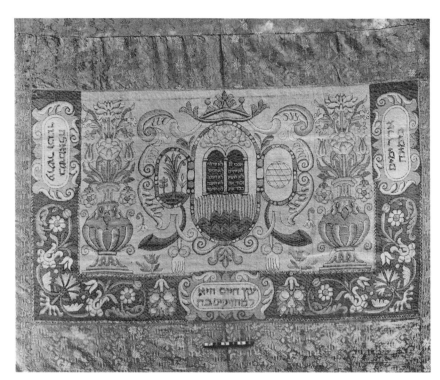

4 *Almemor* cloth.
511a–1877

511a-1877 (Textiles)
148.5 cm × 145 cm
Italian: late 17th century

Cloth made to hang at the front of a reading desk (*Almemor*), of canvas embroidered with coloured silks, and having borders of brocaded satin. In the middle, within an oval compartment, is a representation of the Tablets of the Law, with clouds (of fire?) above and a schematic rendering of Mount Sinai below. To the right of this central motif a *mazzah* (portion of unleavened bread) is depicted and to the left the bitter herbs of the Passover *seder* are shown. Above the central section is the *Keter Torah* (Crown of the Law), and below are two *shofarot* (ram's-horn trumpets). Flanking these central devices are two vases of flowers, with three margins (at the sides and the bottom) filled with floral scrollwork and three cartouches containing embroidered inscriptions from Proverbs 3, 16 and 18: ימים בימינה בשמאולה עשר וכבוד עץ חיים היא למחזיקים בה ותמכיה מאשר ארך (Length of days is in her right hand; and in her left riches and honour-...She [the Law] is a tree of life to them that lay hold upon her.)

Prov.: Purchased from Caspar Clarke, together with the *parochet* (cat. no. 5) for the sum of £30.

Lit.: Salomon, Kathryn, *Jewish ceremonial embroidery.* London, Batsford, 1988; fig. 59, p. 81.

5 *Parochet* (Ark curtain)

511–1877 (Textiles)
Height 190.5 cm × width 165 cm
Italian: (probably Venice): dated *Ellul* 5436; August–September 1676 CE.

Parochet of embroidered canvas, with borders of brocaded satin. The embroidery is of silk and silver-gilt thread in brick stitch and couched work. The Tablets of the Law form the centrepiece of the design and this is surrounded by 12 smaller motifs (one top and bottom, and five on either side) representing the major Jewish festivals. The

whole curtain contains numerous Hebrew inscriptions which include (in the margins to the side of the centrepiece) the date the work was finished באלול שנת ה'תלו ותשלם כל המלאכה (all work was completed by *Ellul* 5436 [August–September 1676]) plus the donor's name בר חיים סגל פולאקו שנת ה'תסג כ'ס'ר יוסף (the honoured Joseph bar Ḥaim Segal Polacko, 5436 [1676]) which is contained in the margin immediately below the centrepiece. The festivals illustrated in the outer border (working anticlockwise from the top left:

שבת זכור (*Shabbat Zachor*, and quotations from Exodus 17, 16.); שבת ח"ה חג הסוכות (*Shabbat Ḥol Hamo'ed Sukkot*, and quotation from Zechariah 14, 4); שבת נחמו (*Shabbat Nachamu*, and quotation from Isaiah 40, 1); שמחת פורים (*Simchat Purim*, and quotation from Esther 9, 26); שבת פרה (*Shabbat Parah*, and quotation from Numbers 19, 6); שמחת תורה (*Simchat Torah*, and quotation from *Midrash Rabbah, Kohelet*); שבת החדש (*Shabbat ha-Kodesh*, and quotation from Exodus 12, 2); שבת וחנוכה (*Shabbat Hanukkah*, quotation the last verse of *Ma'oz Tsur)*; שבת הגדול (*Shabbat ha-Gadol*, and quotation from Psalms 112, 10); שבת ח'ה חג המצות (*Shabbat Ḥol Ḥamo'ed Pesach*, quotations from Ezekiel 37, 12 and Psalms 72, 6); שבת שקלים (*Shabbat Shekalim*, and quotation from Exodus 30, 13) and, finally, in the centre of the top row יום [ה]כפור (*Yom Kippur*, and quotation from *Mishna, Yoma IV*, 41 b).

Prov.: Purchased from Caspar Clarke, together with the *Almemor* cloth (cat. no. 4), for the sum of £30.

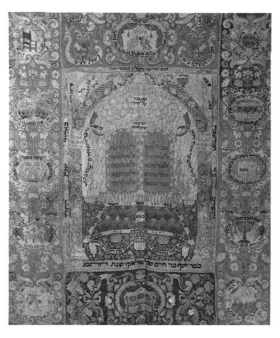

5 *Parochet* (Ark curtain). 511–1877

Lit.: Cohen, S, 'A 17th century parochet. *Jewish Chronicle*, 10 July 1953.

Salomon, Kathryn, *Jewish ceremonial embroidery*. London, Batsford, 1988, fig. 52, p. 73.

6 *Parochet* (Ark curtain)

512–1877 (Textiles)
Height 77.5 cm × width 61 cm
Italian: late 17th century

Parochet of brocaded silk velvet. Faded green and reddish-pink pile (the pink having almost completely worn away), brocaded with silver-gilt thread and fringed with silver thread.

Prov.: Purchased from Caspar Clarke for £2.10s.0d. (£2.50) and received on 12 March 1877.

Notes: Noted as being worn and faded when received into the museum. It is of the same fabric as the *Almemor* cloth (cat. no. 7).

6 *Parochet* (Ark curtain). 512–1877

7 *Almemor* cloth

513–1877 (Textiles)
Height 61 cm × width 110.5 cm
Italian: late 17th century

Almemor cloth, made to hang at the front of the reading desk in a synagogue. Silk velvet: green and reddish-pink cut pile with metal thread. The material is worn and faded. Hanging loops provided at the back are made of the same yellow fabric as the lining. Silk and metal thread fringe.

Prov.: Purchased from Caspar Clarke, 12 March 1877.

Notes: Made of the same material as the *parochet* (Ark curtain) (cat. no. 6).

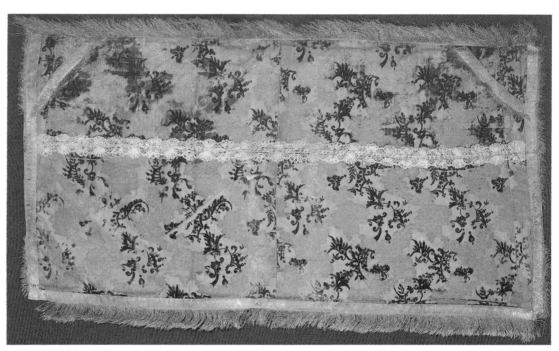

7 *Almemor* cloth.
513–1877

8 *Rimmonim*

350 & a-1870 (Metalwork)
Height 43 cm and 44.5 cm
Italian (?): 17th century

Rimmonim (= literally, pomegranates) are finials for the Scroll of the Law. A pair, made of silver-filigree openwork in the form of large bulbous spheres hung with six silver-gilt bells; six other bells are suspended from openwork leaves at the base of the spheres. Above are ornate crowns (*Keter Torah*, Crown of the Law) surmounted by a fleur-de-lis, to the 'petals' of which are attached four more silver-gilt bells. The shafts are plain, and are possibly later additions. No marks.

Prov.: Purchased from Murray Marks, February 1870. The *Torah* mantle (cat. no. 2) formed part of the same purchase.

Lit.: *Jewish Encyclopaedia*, 1901–6, IV, p. 391, fig. 8.

Barnett, R D, *Catalogue of the permanent and loan collection* [etc.]. London, Jewish Museum, 1974, no. 109, p. 26, pl. lv.

Notes: A bell is missing from one of the fleurs-de-lis.

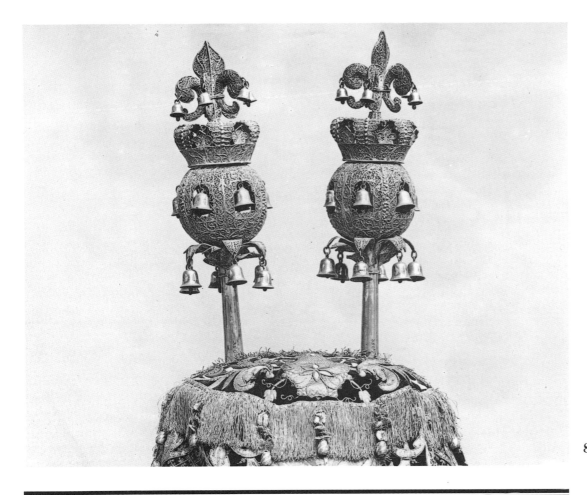

8 *Rimmonim.*
350 & a–1870

9 *Yad* (*Torah* **pointer**)

M275–1960 (Metalwork)
Length 25 cm × diameter 2.5 cm
English: London hallmark for 1797–8

Silver *Torah* pointer or *yad* (hand), having a cylindrical handle with a ribbed band round the middle, and a suspension ring. Maker's mark R D (?).

Prov.: Gift from Mrs Oved.

Notes: This object is similar to a pointer in the New Synagogue, Leadenhall Street, illustrated in the London Jewish Museum catalogue.[1]

[1]Barnett, R D, *Catalogue of the permanent and loan collections* [etc.]. London, Jewish Museum, 1974, no. 175, p. 36, pl. lxvi.

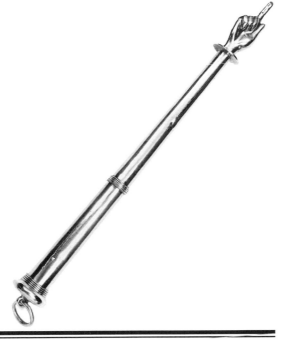

9 *Yad* (*Torah* pointer).
M275–1960

10 *Tallit* (Prayer shawl)

921–1907 (Textiles)
Length 185.5 cm × width 152.5 cm
French: 1700–1725.

Tallit (prayer shawl) of white silk twill, embroidered with white silk. The pattern consists of elaborate borders of broken and interlacing foliate scrolls, with lace-like fillings down the centre and along the longest sides. In the four corners are sprays containing conventionalised pomegranates. The silk is woven in a series of broad and narrow stripes along the ends of each length, two of which are sewn together to make the mantle. Long and short, satin and stem stitch with French knots and laid and couched work.

Prov.: Purchased from Fulgence *Fils*, 71 rue la Boetie, Paris.

Lit.: Salomon, Kathryn, *Jewish ceremonial embroidery.* London, Batsford, 1988, fig. 84, p. 117.

11 *Tallit* ornament

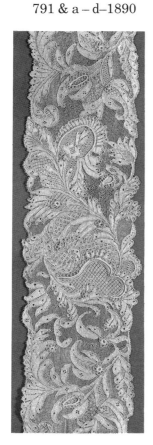

11 *Tallit* ornament.
791 & a – d–1890

791 to d–1890 (Textiles)
Squares (791a,b): 22.5 cm sq.; border (791c): length 120.6 cm × width 13 cm; border (791d): length 1432 cm × width 5 cm
Italian (Venetian): late 17th century

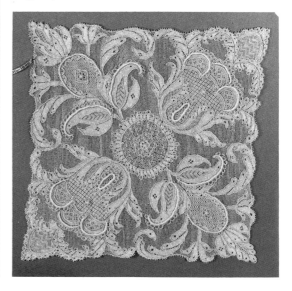

Three squares and two borders used for ornamenting a *tallit* (prayer shawl). Silk needle lace with a design consisting of large blossoms, leaves and fruit, with details in relief.

Prov.: From the bequest of Mrs Harriet Bolckow.

Notes: Exhibited at the International Exhibition, 1874. One of the borders has been slightly stained.

12 *Tallit* ornament

25–1865 (Textiles)
21 cm sq.
Italian (Venetian): late 17th century

Border of needle-point lace for ornamenting
a *tallit* (prayer shawl). Needlepoint silk
lace, *punto tagliato a folami* with hexag-
onal *bridés picotées* ground.

Prov.: Gift from Miss Edith Webb.

Notes: A broad border and three similar
squares were left to the museum by the
same donor (under her married name, Mrs
Edith Cragg) in 1925 (see cat. no. 13). A
square of an identical pattern can be found
in the Musée d'Art et d'Histoire, Geneva.[1]

[1]Cherbuliez, E, *Guide à la collection des dentelles
Salle Amébe Piot*. Geneva: Musée d'Art et d'Histoire,
[1930], fig. 6.

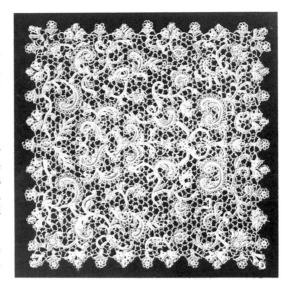

12 *Tallit* ornament.
25–1865

13 *Tallit* ornament

T71a-c-1925 (Textiles)
Border: length 184.3 cm × width 16.5 cm;
squares: 20.7 cm sq., 20.3 cm × 19.7 cm,
19.7 cm sq.
Italian (Venetian): late 17th century

Broad border and three squares of silk
needle lace used for ornamenting a *tallit*
(prayer shawl), consisting of a repeating
vertical arrangement of symmetrical plant
forms, floral stems and leafy scrollwork
united by *bridés picotées*. Some of the de-
tails are in relief and partially detached;
there is an edging of leaves and blossoms.

Prov.: Bequest of the late Mrs Edith
Cragg.

Notes: A fourth square (cat. no. 12), was
given by the same donor (under her maiden
name, Miss Edith Webb) in 1865.

13 *Tallit* ornament.
T71a – c–1925

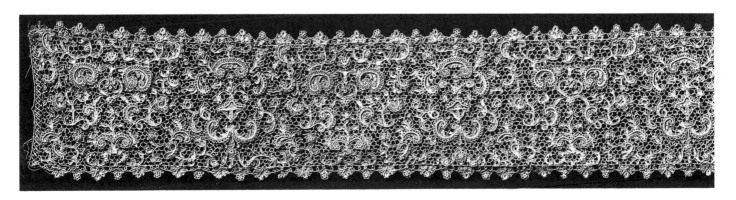

13 *Tallit* ornament.
T71a – c–1925

14 Synagogue wall sconces

M410 & a-1956 (Metalwork)
Diameter of wallplates 9 cm; length of arms
22.5 cm; diameter of grease-pans 8.5 cm
and 8.8 cm; height of candle-holders 7 cm
Eastern European: late 18th or early 19th
century

Pair of brass sconces (one of which is illus-
trated here), of the type used in eastern
European synagogues. Each consists of a
circular backplate, pierced for two screws,
with a large eye into which the end of the
arm hooks. Branch cut and pierced to form
the silhouette of a running stag. Moulded
candle-holders with saucer-shaped grease-
pans; both the holders and the pans can be
unscrewed. The arms and wallplates are
marked with punched dots to indicate
which belongs to which. The candle-holders
and grease-pan do not match, and the
grease-pan of one is cracked.

Prov.: Hildburgh Bequest (ex-Hildburgh
loan 4933 & a).

Notes: A similar pair of sconces, each with
three lights, was offered for sale by
Sotheby's at the Hilton Hotel, Jerusalem,
on Sunday 24 May 1987.[1]

[1]*Judaica: books, manuscripts and works of art.* Jeru-
salem, Sotheby's Israel Ltd, 1987, lot no. 170, p. 65.

14 Synagogue wall
sconces.
M410 & a–1956

15 Synagogue wall sconces

M411 & a-1956 (Metalwork)
Branches 24.5 cm long; grease-pans 9.5 cm
long; wallplates height 20 cm × width 7.5
cm, and height 20.3 cm × width 7.6 cm;
candle-holders 7.6 cm and 8.3 cm
Eastern European: late 18th or early 19th
century

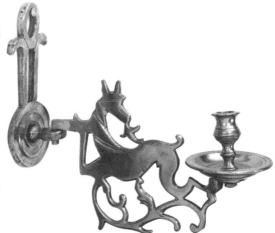

A pair of brass synagogue wall sconces.
Each lamp consists of a circular wallplate
made in one piece, with two vertical bars
which terminate in a loop for attachment to
the wall; on each side, where the bars and
loops join, is a scroll in the silhouette of an
eagle's head. In the centre of each plate is a
pierced bracket into which the end of the
branch hooks. The branches are cut in the
silhouette of a running stag looking back-
wards, with a flower in its mouth. Both the
moulded candle-holders and the circular
grease-pans can be unscrewed; the candle-
holders do not match.

Prov.: Hildburgh Bequest (ex-Hildburgh
loan 4934 & a).

Notes: As for the sconces (cat. no. 14).

15 Synagogue wall
sconces.
M411 & a–1956

PART II
Festivals and Holy Days

ḤANUKKAH

Ḥanukkah is an eight-day festival beginning on 25th *Kislev*[1] every year. The celebration is believed to have been instituted by Judas Maccabeus and his family in 165 BC following the success of their rebellion against Antiochus Epiphanes, the Greek king of Syria. The rebellion was the direct result of the Syrian ruler's campaign to suppress Judaism, during the course of which he defiled the Temple in Jerusalem by turning it over to pagan worship. *Ḥanukkah* [חנוכה = dedication], commemorates the re-dedication of the altar and the repurification of the Temple subsequent to the Jewish victory.[2] The 25th of *Kislev* was chosen as the beginning of the festival because it marked the third anniversary of the issuing of the edicts of Antiochus which had resulted in the profanation of the Temple.

The holiday is marked by the lighting of a special eight-branched lamp called a *ḥanukkiyah*, and the festival is sometimes referred to as the Feast of Lights.[3] One of the lights on the *ḥanukkiyah* is lit on the first night of *Ḥanukkah*, and this number is increased by one every night until all eight lights are lit on the eighth and final evening of the festival. There are several explanations offered for the tradition of a festival of lights extending over eight days. The one that is most repeated recalls that the Maccabeans,[4] on re-entering the Temple, found only one cruse of oil undefiled by the Greek interlopers – sufficient to keep the *menorah* (the eight-branched candlestick which was one of the major ritual objects in the building) alight for one night. A miracle occurred and it remained alight for eight nights, providing sufficient time to replenish the stock of suitable fuel.

Most extant *Ḥanukkah* lamps have an additional lamp, and this ninth lamp is known as the *shammash*, or servitor. There are two reasons

[1] *Kislev* is the month in the Jewish calendar which approximates to December.

[2] Maccabees 4, 36–59.

[3] Narkiss, M, *The Ḥanukkah lamp* (in Hebrew). Jerusalem, The National Bezalel Museum, 1939, p. C: 'Josephus calls it the Feast of Lights [ταφωτα]'.

[4] The name more commonly given to the dynasty otherwise known as the Hashmonaeans, a name derived from an ancestor named Hashmonaeus.

34

advanced for its use. The first argues that as the light from the eight lamps is holy, each should be lit from another, non-sacred, light.[5] The second argument suggests that as the eight 'holy' lamps are sacred the light they shed should not be used for illumination; the light cast by the ninth lamp is not sacred and thus circumvents the religious proscription which would otherwise pertain to the use of the *hanukkiyah*.[6]

[5] Abrahams, I, *Festival studies*, 1906, London, Goldston, pp. 147–8.

[6] Narkiss, M, *op. cit.* p. C: 'the use of its light permits the use of the rest'.

16 Ḥanukkah lamp

M430–1956 (Metalwork)
Height 14.4 cm × width 14 cm
19th-century copy based on a 14th-century
Italian original

Bronze Ḥanukkah lamp, consisting of a
backplate together with eight square-
nozzled lamps cast in one, attached across
the bottom by pins. The backplate is pierced

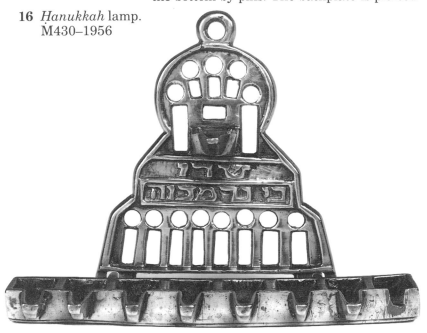

16 Ḥanukkah lamp.
M430–1956

with rows of vertical slits surmounted by
round holes in crude emulation of an
arcade. There is a two-line Hebrew inscrip-
tion across the middle of the backplate
which reads:

> Top line: שדי (*Shaddai*, Almighty)
> Bottom line:[כי נר מצוה [ותורה אור
> ('For the Commandment is a lamp
> (and the *Torah* is a light)'; Proverbs 6,
> 23).

Immediately above this inscription is the
shammash (servitor lamp) and above and
to the sides of the *shammash* is another
crudely rendered arcade, the whole sur-
mounted by a suspension ring.

Prov.: Hildburgh Bequest (ex-Hildburgh
loan 4965).

Notes: The letters in the inscription are
badly formed: the *yodh* [י] in *Shaddai* (top
line) looks like a *vav* [ו], and the *nun* [נ]
and *resh* [ר] in *ner* [נר = light] have been
run together to look like *tet* [ר = and נ =
ט]. Poorly rendered letter shapes of this
type can be seen on a lamp of similar design
in the Ticho Collection, Jerusalem.[1]

[1]Israel Museum, *Architecture in the Hanukkah lamp*
[etc.]. Exhibition Catalogue 186. Jerusalem, Israel
Museum, 1978, p. 17, illus. 44.

17 Ḥanukkah lamp

M431–1956 (Metalwork)
Height 13 cm × width 16.5 cm
19th-century copy based on a 14th-century
southern French or Spanish original

Bronze Ḥanukkah lamp, consisting of a
backplate, together with eight square-
nozzled lamps cast in one, attached across
the bottom by pins. The backplate is gable
shaped with a foliated finial cast in low
relief, in the centre of the inscription is a

pierced sexfoil with a circle of triangular
and round holes framing an oblong slot for
the attachment of a *shammash* (servitor
lamp). Inscribed in Hebrew
כי נר מצוה ותורה אור ('For the Com-
mandment is a lamp (and the Torah is a
light)'; Proverbs 6, 23).

Prov.: Hildburgh Bequest (ex-Hildburgh
loan 4966).

Notes: The servitor lamp is missing from the centre back. A lamp exactly like this one was exhibited at the Royal Albert Hall exhibition in 1887; it was owned by F D Mocatta.[1] There are similar lamps in the Jewish Museum[2] and in the Ticho Collection, Jerusalem,[3] but the finials differ in all three.

[1]Publications of the Exhibition Committee IV. Royal Albert Hall, *Catalogue of the Anglo-Jewish historical exhibition.* London, Royal Albert Hall, de-luxe ed., 1888, no. 1738, p. 110, pl. facing p. 108.
[2]Barnett, R D *Catalogue of the permanent and loan collections* [etc.]. London, Jewish Museum, 1974, no. 218, p. 45, pl. lxxix.
[3]Israel Museum, *Architecture in the Ḥanukkah lamp* [etc.]. Exhibition Catalogue 186. Jerusalem, Israel Museum, 1978, no. 44, p. 17, fig. 44.

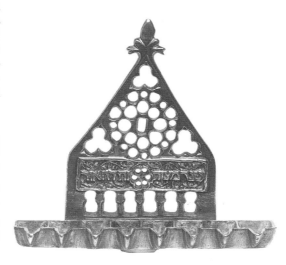

17 *Ḥanukkah* lamp.
M431–1956

18 *Ḥanukkah* lamp

M432–1956 (Metalwork)
Height 15.5 cm × width 19 cm
19th-century copy based on a 13th- or 14th-century southern French or Spanish original

Bronze *Ḥanukkah* lamp consisting of a triangular backplate and a base formed from nine square-nozzled lamps. These two pieces are soldered together, but the original on which this lamp is modelled probably had these parts pinned together. The backplate is pierced with triangular and circular holes in emulation of a rose window which is set above a row of twelve Moorish arches in the form of an arcade; there is a suspension ring at the top in the shape of a pierced trefoil. The eight lamps used during the *Ḥanukkah* festival project from the front of the lamp base, while the *shammash* (servitor lamp) is set sideways on to them, at the right of the base.

Prov.: Hildburgh Bequest (ex-Hildburgh loan 4967).

Lit.: Eis, R, *Ḥanukkah lamps of the Museum.* Berkeley, Judah L Magnes Museum, 1977, MC1, p. 19.

Narkiss, B, 'Un objet de culte: la lampe de Hanuka'. In: Blumenkranz, B (ed.),

Nouvelle Gallia judaica. Art et archéologie des Juifs en France mediévale [etc.]. Paris, 1980, pp. 187–206.

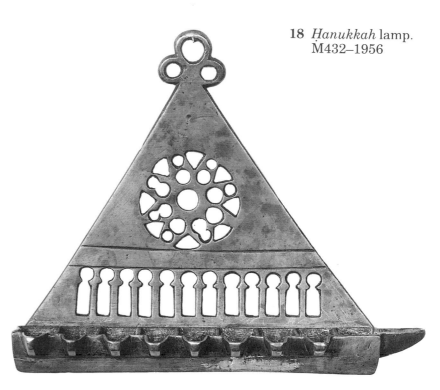

18 *Ḥanukkah* lamp.
M432–1956

Notes: The Musée Cluny owns a lamp (Collection Strauss Rothschild, no. 12 248) which was excavated from the old Jewish quarter of Lyons, indicating manufacture prior to 1394 CE when the Jewish population was expelled from the city. This lamp differs from the V&A example in the decoration of the rose window, the arcades and the positioning of the servitor light, which on the Cluny example is sited on the top left-hand side of the backplate. Lamps almost exactly like the V&A article exist in the Israel Museum (118/351), the Judah L Magnes Memorial Museum (MC 1) and various private collections. The discovery of the Cluny lamp in Lyons has resulted in its being attributed to France, but Siegfried Strauss and Bezalel Narkiss (see article quoted above) have argued that they are of Spanish design and manufacture. An attribution to southern France or to Spain seems reasonable, particularly given the common Trans-Pyranean culture of the medieval period which has been overlaid and obscured by the centralising tendancies, political and cultural, of the modern French and Spanish states.[1] The Cluny original formed part of the Strauss collection which was exhibited at the Galeries du Trocadéro, Paris, in 1878.

[1]'The early Jewish communities of southern France were fundamentally Sephardic and wholly under Spanish influence'; *Encyclopaedia Judaica.* Jerusalem, 1971, col. 1290.

19 *Ḥanukkah* lamp

19 *Ḥanukkah* lamp.
4366–1857

4366–1857 (Metalwork)
Height 18 cm × width 23 cm
Italian: 16th century

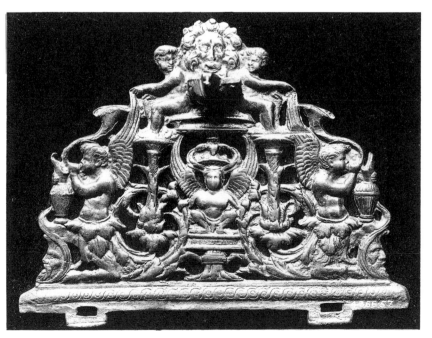

Backplate of *Ḥanukkah* lamp, cast bronze. It has an openwork design of grotesque figures, masks and foliage, symmetrically arranged on either side of a central winged figure. The apex of the triangle formed by the backplate consists of a mask supported by two *putti* which also flank the *shammash* (servitor light). The base, ornamented with a band of guilloche, has two holes for the attachment of the lamp tray, which is missing.

Prov.: Purchased for £1 from an unknown vendor.

Notes: There is another lamp that is similar, but not exactly alike, illustrated in the Feuchtwanger catalogue,[1] also in *Jüdisches Lexicon* (IV, col. 113, pl. cxxv) and in Narkiss, M, *The Ḥanukkah lamp* (in Hebrew). Jerusalem, The National Bezalel Museum, 1939, no. 31. Another version, minus *shammash*, is in the Musée Cluny (Cluny 18304).

[1]Shachar, *Jewish tradition in art: the Feuchtwanger collection of Judaica.* Jerusalem, Israel Museum, 1981, no. 342, p. 134.

20 Ḥanukkah lamp

M415–1956 (Metalwork)
Height 18 cm × width 25 cm
Italian: 16th century

Bronze *Ḥanukkah* lamp, held together with
pins and rivets. The back and sides are in
the form of a battlemented wall, with a
tower-like element riveted in the centre.
All crenellations are in the form of swal-
low's tails. The back and side panels are
pierced with a reticulated pattern. The base
consists of a single piece with eight nozzled
lamps cut into it, and there is a *shammash*
(servitor light) attached to the right-hand
tower. The lamps are probably replace-
ments. The left-hand side panel has been
broken and then poorly repaired with sol-
der.

Prov.: Hildburgh Bequest (ex-Hildburgh
loan 4839).

Notes: There is an identical lamp in the
Israel Museum (no. 118/349).[1] The Judah L

20 *Ḥanukkah* lamp.
M415–1956

Magnes Museum[2] has a similar example
differing from these others only in that the
side pieces have been extended below the
lamp to provide feet thereby allowing it to
stand upon a table in addition to being
hung upon a wall.

[1] Israel Museum, *Architecture in the Ḥanukkah lamp*
[etc.]. Exhibition Catalogue 186. Jerusalem, Israel
Museum, 1978, no. 8, p. 13.
[2] Eis, R, *Ḥanukkah lamps*. Berkeley, Judah L Magnes
Museum, 1977, MC 8, pp. 26–7.

21 Ḥanukkah lamp

M416–1956 (Metalwork)
Height 16.5 cm × width 21.5 cm
Italian: 16th century

Bronze *Ḥanukkah* lamp, with traces of gild-
ing. It consists of a backplate cast in the
form of two tritons blowing horns, enclos-
ing two dolphins and a central element
made up of a nude half-length female figure
supporting a vase upon her head; the whole
backplate is surmounted by a suspension
ring in the form of a wreath. The eight
beak-like lamps, cast in one piece, are sol-
dered to the backplate.

Prov.: Hildburgh Bequest (ex-Hildburgh
loan 4939).

Notes: Ḥanukkah lamps incorporating
Classical motifs made their appearance in
Renaissance Italy.[1] The readiness of some
Jewish communities to accept non-Jewish
decorative elements on traditional ritual
objects is not unusual; Professor Narkiss

21 *Ḥanukkah* lamp.
M416–1956

has noted the same tendency with regard to
Jewish illuminated manuscripts.[2]

[1] See Toeplitz, E, *Beiträge zur jüdischen Kulturges-
chichte.* p. 17; also Narkiss, M, *The Ḥanukkah lamp*
(in Hebrew). Jerusalem, The National Bezalel
Museum, 1939, p. F.
[2] Narkiss, B, *Hebrew illuminated manuscripts*. Jeru-
salem, Keter, p. 15.

22 Ḥanukkah lamp

M417–1956 (Metalwork)
Height 16.5 cm × width 21.5 cm
Italian: 16th century

Bronze *Ḥanukkah* lamp consisting of a backplate, together with eight square-nozzled lamps all cast in one, attached along the bottom by two pins. The back is cast and pierced with two couchant lions arranged on either side of spreading scrolls of foliage, above which is an urn surmounted by a standing figure of Cupid; each lion has one forepaw raised and resting upon an orb.

Prov.: Hildburgh Bequest (ex-Hildburgh loan 4940).

22 *Ḥanukkah* lamp.
M417–1956

23 Ḥanukkah lamp

M419–1956 (Metalwork)
Height 16.5 cm × width 22 cm
Italian: second half of the 16th century

23 *Ḥanukkah* lamp.
M419–1956

Bronze *Ḥanukkah* lamp with traces of gilding. The lamp consists of a backplate and an eight-nozzled lamp tray, all made in one. The backplate is cast and pierced with scrolling foliage; the design includes cornucopias and two dolphins supporting a half-length human figure holding a coat-of-arms above its head. On either side of the coat-of-arm are passant lion supporters while the crest consists of a cardinal's hat flanked by two *amorini*. The arms are those of Inigo d'Avalos, who was created cardinal in 1561 and grand chancellor of the Kingdom of Naples in 1562; he died in 1600.

Prov.: Hildburgh Bequest (ex-Hildburgh loan 4942).

Lit.: Narkiss, M, *The Ḥanukkah lamp* (in Hebrew). Jerusalem, The National Bezalel Museum, 1939, p. F, no. 34, pl. xii.[1]

Notes: One of the pins holding the lamp and backplate together has been lost and replaced with solder. The suspension ring is missing from the top, and the lamp is probably older than the backplate.

[1]*op. cit.*: 'The love of heraldic emblems among the Jews of Spain and Italy was most prominent...To Don Inigo d'Avalos the Jews expressed their thanks for his attitude towards them.'

24 Ḥanukkah lamp

M420–1956 (Metalwork)
Height 24.5 cm × width 27 cm
19th-century copy based on a late 16th- or
early 17th-century Italian original

Bronze *Ḥanukkah* lamp made in four parts
(backplate, two sides and shallow front)
held together by pins. The sides are cast
with volutes, and the back is solid cast with
a scrollwork gable and a relief inscription in
Hebrew (much rubbed) plus an undercor-
nice with foliage which frames a plain
shield. The front is cast with a second relief
inscription, also in Hebrew, and resting on
top of this are eight lamps, all made in one.
There is a *shammash* (servitor light) on the
top left-hand side of the backplate and
there is a screw hole on the opposite side for
an additional servitor light. The Hebrew
inscription on the back plate is the prayer
beginning הנרות הללו (*Hanerot Halalu...*,
We kindle these lights on account of the
miracles, the deliverances and the wonders
which thou didst work for our fathers, by
means of thy holy priests . . .) which is
recited immediately after the blessings dur-
ing the *Ḥanukkah* service, while the lamps
are being lit. The inscription on the front
plate, below the lamps, is an Halakic text
on *Ḥanukkah* lamps.

Prov.: Hildburgh Bequest (ex-Hildburgh
loan 4943).

Lit.: Narkiss, M, *The Ḥanukkah lamp* (in
Hebrew). Jerusalem, The National Bezalel
Museum, 1939, p. M, no. 63, pl. xxiii.

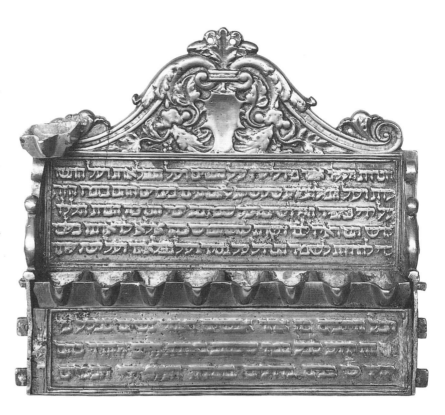

Notes: The inscriptions and the relief de-
coration are very badly rubbed, and in the
case of the former are barely legible. The
cast was either one taken at the end of a
run of castings or was, more likely, a re-
casting from an already badly rubbed ori-
ginal. It is certainly a copy, not a 16th–
17th-century original. There are finely cast
examples of this particular lamp form in
the Musée Cluny (Cluny 18304) and the
Museum für Kunst und Gewerbe, Ham-
burg.

24 *Ḥanukkah* lamp.
M420–1956

25 Ḥanukkah lamp

M28–1965 (Metalwork)
Height 20 cm × width 23 cm
Italian: late 16th century or early 17th cen-
tury

Brass *Ḥanukkah* lamp. The backplate is of
openwork formed by two winged figures
(seraphim?) holding vases and blowing
trumpets, and backed by a vase-shaped

pediment upon which stands the figure of
Judith holding a sword in her right hand. A
shammash (servitor lamp) projects beneath
the horn of the trumpet on the left-hand
side. There is a suspension ring attached to
the back of the lamp, behind the shoulders
of the Judith figure. The base is formed of
an eight-lamp tray, all cast in one piece.

25 *Ḥanukkah* lamp.
M28–1965

Prov.: Bequeathed by Miss Estella Canziani.

Notes: The sword in the right hand of the Judith figure is broken off at the hilt. An intact version, belonging to the Cincinnati Jewish Museum, is illustrated in Gutmann.[1] See also the Feuchtwanger catalogue.[2] Another example is illustrated on pl. cxxv of *Judisches Lexicon*, IV, col. 113.

[1]Gutmann, Joseph, *Jewish ceremonial art*. New York and London, Yoseloff, 1964, no. 11, p. 34, fig. 38.
[2]Shachar, I, *Jewish tradition in art: the Feuchtwanger collection of Judaica*. Jerusalem, Israel Museum, 1981, pp. 134–5.

26 *Ḥanukkah* lamp

26 *Ḥanukkah* lamp.
M418–1956

M418–1956 (Metalwork)
Height 20 cm × width 22.5 cm
Italian: early 17th century

Gilt-bronze *Ḥanukkah* lamp consisting of a backplate and an eight-nozzled lamp all cast in one, attached along the bottom by pins. The backplate has been cast and pierced with two grotesque long-necked female forms issuing from scrolling foliage and flanking a cartouche bearing a coat-of-arms. Below is a faun mask; above, two *amorini* support a cardinal's hat over the arms. There is a suspension ring at the top. The coat-of-arms is that of Jacopo Synessino, created cardinal in 1604, impaling those of Pope Clement VIII (Ippolito Aldobrandini). The coat-of-arms, however, has been reversed in the casting.

Prov.: Hildburgh Bequest (ex-Hildburgh loan 4941).

Lit.: Narkiss, M, *The Ḥanukkah lamp* (in Hebrew), Jerusalem, The National Bezalel Museum, 1939, p. F,[1] no. 35, pl. xii.

Notes: One pin has been replaced with solder.

[1]*op. cit.:* '...the Jews of Ferrara remembered with gratitude the fact that Cardinal Aldobrandini had permitted them to live in Ferrara five years longer instead of driving them out at the conquest of the city by the Papal army in 1598.'

27 Ḥanukkah lamp

M75 and a-1949 (Metalwork)
Height 39 cm × width 25 cm; bowl diameter 7.5 cm; bowl height (with handle extended) 10 cm
English: hallmarked 1747–8, made by Jacob Marsh

Silver *Ḥanukkah* lamp; London hallmark for 1747–8, mark of the initials J L A framed in rich embossed and chased foliage against a background of scaled ornament, cast scrolls and shell border into the top of which is set the *shammash* (servitor lamp). At the bottom is a tray of eight lamps, above a trough fitted to a drain, to which a bowl is hooked. The bowl is round with swelling sides and swivel handle, rather like a miniature cauldron.

Prov.: Gift from Miss Gladys Abecassis.

Notes: This lamp was made for Solomon de Aaron Abecassis, who came to Britain from Gibraltar in the early 18th century. The initials on the backplate are those of the donor's grandparents, Jules and Lavinia Abecassis, who lived during the middle of the 19th century.

27 *Ḥanukkah* lamp.
M75 & a–1949

28 Ḥanukkah lamp

164–1891 (Metalwork)
Height 29.5 cm × width 23.5 cm
Netherlands: 18th century

Brass *Ḥanukkah* lamp, with a row of eight shallow oil reservoirs. The back is pierced in openwork, with a vase of flowers and leaves symmetrically arranged with stamped outlines. Beneath is a tray for catching the oil. The *shammash* (top right) has been broken off.

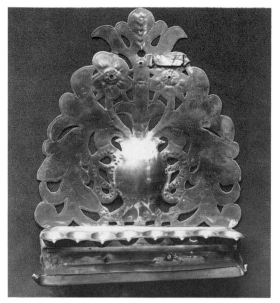

Prov.: Given by Angus, Craibe & Son, Fine Art Dealers, 159 Queen Street, Glasgow.

Notes: There are three Dutch lamps of this same general type, although not exactly like this one, in the Jewish Museum.[1] See also the sabbath/synagogue lamp (cat. no. 110) donated by this same company.

[1]Barnett, R D , *Catalogue of the permanent and loan collections* [etc.]. London, Jewish Museum, 1974, nos 253, 256 and 257, p. 50, pl. lxxxi and lxxxii.

28 *Ḥanukkah* lamp.
164–1891

29 *Ḥanukkah* lamp

M102–1912 (Metalwork)
Outer tray: height 35 cm × width 33 cm × depth 11 cm; inner tray: height 28 cm × width 30 cm × depth 10 cm
Netherlands: 18th century (?)

Brass *Ḥanukkah* lamp with eight lights. Cast and pierced backplate surmounted by a *Magen David* (Star of David), with a *shammash* (servitor lamp) and a Hebrew inscription which reads:כי נר מצוה ותורה אור ('For the commandment is a lamp and the Torah is a light'; Proverbs 6, 23). The outer part is hammered, forming a plain wall bracket, with a row of repoussé bosses along the front wall of the drip pan.

Prov.: Purchased from Mrs C E S Watson.

Notes: There is an identical lamp in the Judah L Magnes Museum (MC 50) which is 'fashioned after a lamp dated 1630 belonging to the Portugees Israelitische Gemeente, Amsterdam'.[1] Other examples can be seen, with an inscription dated 1757, in the Kayser catalogue;[2] the London Jewish Museum;[3] the Narkiss catalogue;[4] and in the Gross family catalogue,[5] which also contains a detailed bibliography.

[1]Eis, R, *Hanukkah lamps*. Berkeley, Judah L Magnes Museum, 1977, MC 50, pp. 68–9.
[2]*Kayser, S, & Schoenberger, G, Jewish ceremonial art*. Philadelphia, Jewish Publication Society of America, 1955, no. 133, pp. 127–30, pl. lxv.
[3]Barnett, R D *Catalogue of the permanent and loan collections* [etc.]. London, Jewish Museum, 1974, no. 247, p. 49, pl. lxxxi.
[4]Narkiss, M, *The Hanukkah lamp* (in Hebrew). Jerusalem, The National Bezalel Museum, 1939, no. 58, pl. xxi.
[5]Narkiss, B & Yaniv, B, *Index of Jewish art: the Gross family collection, I*. Jerusalem, Hebrew University (Centre for Jewish Art), 1985, pp. 211–16.

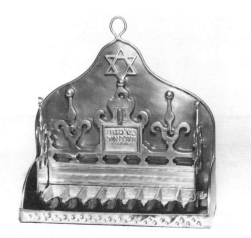

29 *Ḥanukkah* lamp.
M102–1912

30 Ḥanukkah lamp

708–1892 (Metalwork)
Height 26.5 cm × width 27.5 cm
Netherlands: 18th century

Brass Ḥanukkah lamp holder. The back-plate is repoussé, with an ewer in the centre, surrounded by large floral devices; there is a tray for catching the oil. The eight-light lamp is missing, as is the *sham-mash* (servitor lamp).

Prov.: Purchased from Mr Joshua Binns, 186 Brompton Road, London, for the sum of 18s.0d (90p).

Notes: A Ḥanukkah lamp of similar type, with an identical ewer depicted on the backplate, was offered in the Sotheby's sale held in the Hilton Hotel, Jerusalem, on Sunday 27 May 1987.[1]

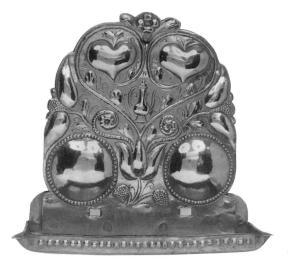

30 Ḥanukkah lamp.
708–1892

[1]*Judaica: books, manuscripts and works of art.* Jerusalem, Sotheby's Israel Ltd, 1987, lot no. 244, p. 104.

31 Ḥanukkah lamp

M412–1956 (Metalwork)
Height 26 cm × width 30 cm
Polish: late 18th or early 19th century

Brass Ḥanukkah lamp. The rack is made of plates held together by bolts and wing-nuts. They are pierced with a pattern of circles, semi-circles and (on the backplate) a vase of flowers with two birds as suppor-ters. There are four terminals in the form of conventionalised serpent heads. Each end-plate has two feet and a branched *sham-mash* (servitor lamp) candle-holder, both of which have a socket and grease-pan. Screwed to the bottom are eight tubular lamps or candle-holders. The backplate curves up in the centre to terminate in a suspension ring, enabling the lamp to be hung on a wall as well as to be free-standing.

Prov.: Hildburgh Bequest (ex-Hildburgh loan 4935).

Notes: Obtained in Salzburg in 1911. Said to be from a synagogue at Bokaima, in Galicia, where it had been one of a pair.

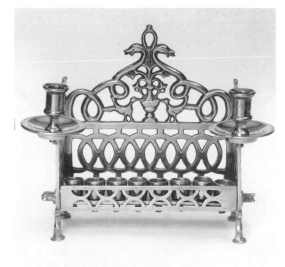

31 Ḥanukkah lamp.
M412–1956

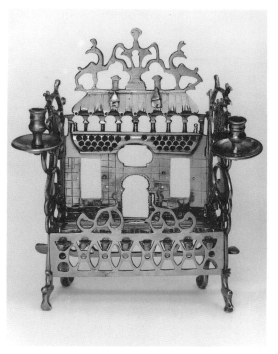

32 Ḥanukkah lamp

M413–1956 (Metalwork)
Height 35 cm × width 30.5 cm
Polish: late 18th or early 19th century

Brass *Ḥanukkah* lamp, cast and with cut-out work. The backplate is shaped like a synagogue (or house?), with a gallery or balcony backed' by a 'Moorish' arcade. Above the balcony is a roof with gable windows and two stylised birds (peacocks?) acting as supporters to a vase which could also act as a suspension ring. Each side panel has two feet, and is formed in the shape of a lion rampant with a candle socket and grease-pan screwed to the end of its tail, to act as a *shammash* (servitor light) or Sabbath candle-holder. The small frontplate is pierced with a fretted pattern through which protrude the nozzles of the eight lamps. The lamp tray is cast all in one piece. The plates are held together with pins or with wing-nuts and bolts.

Prov.: Hildburgh Bequest (ex-Hildburgh loan 4936).

Notes: Similar to three lamps in the New York Jewish Museum (nos F2486, F2664 and F2799) and to a lamp illustrated in Narkiss.[1]

[1]Narkiss, M, *The Hanukkah lamp* (In Hebrew). Jerusalem, The Bezalel Museum, 1939, no. 88.

33 Ḥanukkah lamp

M414–1956 (Metalwork)
Height 33.5 cm × width (excluding screws) 30.5 cm
Polish: late 18th or early 19th century

Brass *Ḥanukkah* lamp, held together with pins and thumb-nuts. The back is pierced with foliage and two kneeling reindeer, looking back over their shoulders and holding leaves in their mouths (see the wall sconces, cat. no. 14); above are two stylised birds (peacocks?). The sides are formed as lions rampant, with a candle socket and grease-pan screwed to the end of each tail to act as a *shammash* (servitor light) or Sabbath candle-holder. The front is pierced with a cable pattern and the nozzles of the eight lamps, all cut from one plate, project from below.

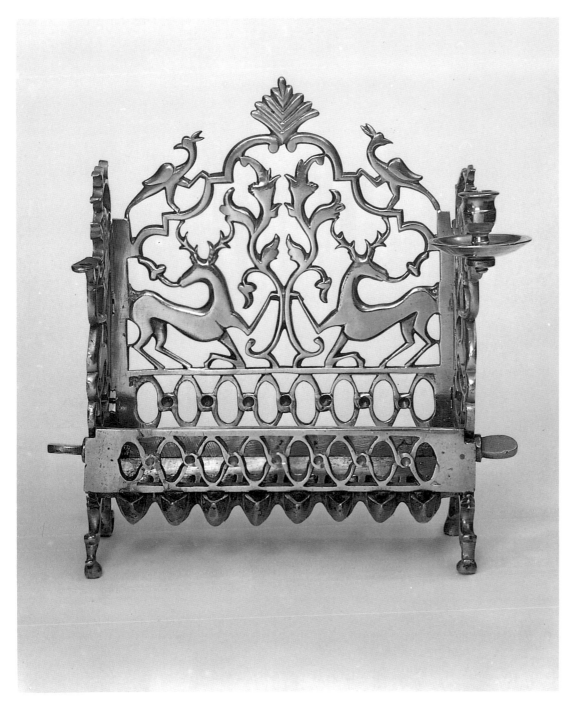

33 *Hanukkah* lamp.
M414–1956

Prov.: Hildburgh Bequest (ex-Hildburgh loan 4937).

Notes: One candle socket and grease-pan is missing. There is an identical lamp in the Berger collection.[1]

[1]Hausler, W, & Berger, M, *Judaica. Die Sammlung Berger* [etc.]. Wien and Müchen, Jugend und Volk, 1979, no. 455, p. 256.

PURIM (FEAST OF LOTS)

The Feast of Lots is a time of general rejoicing in the Jewish calendar. This springtime festival begins on the 14th day of the month of *Adar* (March–April) and commemorates the delivery of the Jews of the ancient Persian Empire from extermination at the hands of Haman the Agagite, the chief minister of King Ahasuerus (Xerxes, 485–65 BC), through the action and intervention of Mordecai and Esther. It is not difficult to see the attraction of this story for the Jewish people, with its promise of deliverance from destruction through the agency of a brave and resourceful man and woman. Implicit in the tale is the premise that these two leaders acted as they did because they were under divine guidance and protection.

The story is expounded in the Book of Esther (*Megillah Ester*), and the name *Purim* is derived from the word *pur* meaning lot hence the Festival of Lots. *Pur* is mentioned twice in the book:

> In the first month, that is, the month Nisan, in the twelfth year of King Ahasuerus, they cast Pur, that is, the lot, before Haman from day to day, and from month to month, to the twelfth month, that is, the month Adar. (Esther 3, 7)

> Wherefore they called these days Purim after the name Pur. Therefore for all the words of this letter, and of that which they had seen concerning this matter, and which had come unto them. (Esther 9, 26)

Another verse, Esther 9, 28, specifically enjoins the Jewish people: 'that these days should be remembered and kept throughout every generation, every family, every province, and every city; and that these days of Purim should not fail from among the Jews, nor the memorial of them perish from their seed.' As a consequence of this injunction the central part of the festival consists of the reading aloud in the synagogue of the whole of the Book of Esther. During this recitation the congregation drowns any mention of the name of Haman, often by the use of special rattles known in Hebrew as *ra'ashan* and in Yiddish as *grager*, this custom being particularly popular with the children.

The synagogue scroll from which the story is read is always an unadorned parchment wound upon a plain wooden or metal roller. The personal *megillot* from which the congregation follow the story, however, are often richly and ornately decorated. This tradition appears to have developed in 16th-century Italy. The argument advanced for its adoption, seemingly in breach of the second commandment, which forbids the use of graven

48

images, seems to be founded on the belief that because God's name is not mentioned in the Book of Esther this proscription does not apply. Whatever the original reason for its acceptance, this custom has become firmly established and has given rise to the production of work of artistic excellence both in the nature of the decoration and in the calligraphic skills of the scribes. The most expert of the scribes were able to produce the so-called 'royal' scrolls by arranging that every column of text, except the last, began with the word המלך (*hamelech*, the king).

Jewish art has always been multifaceted, reflecting the fashions and traditions prevailing in the areas in which it has been created, as was noted in the 1888 edition of the Anglo-Jewish historical exhibition catalogue – the authors wrote of a 'a geography [rather] than a history of Jewish Ecclesiastical art'. This characteristic often helps art historians to place an otherwise unattributable work in its time and location by making a stylistic comparison with works of sound provenance. It has been possible to attribute one of the four *megillot* held by the National Art Library to Italy in the late 17th or early 18th century by comparing it with the decoration and script used on dated Italian *ketubbot* (marriage contracts) of that period. *Megillot* with engraved borders framing the handwritten texts appeared during the 17th century, first in Italy and a short while later in Holland. One of the finest exponents of this form of engraved ornament was Shalom Italia,[1] an Italian Jew who moved to Holland in the early 1600s. Both he and Michael Judah Léon worked for Manassah ben Israel, the printer-entrepreneur of Amsterdam who prevailed upon Oliver Cromwell to allow Jews openly to resettle in Britain.[2] The earliest of the *megillot* in the library is cat. no. 34. It is a fine work written by Michael Judah Léon, illustrated with pen and wash drawings by another hand (possibly by his brother Jacob Judah Léon, known as *Templo*, or, less likely, by Shalom Italia), and dated 1643 CE. In addition to the scrolls mentioned above, there is also an unadorned 18th-century *megillah* from Morocco, written in an excellent square Sephardic script (cat. no. 36). There is also an example of a modern printed scroll from Israel (cat. no. 38). This was designed by Gabriela Rosenthal and produced by Hertzfelder of Tel-Aviv in 1951.

Another fashion directly linked with the acquisition of personal *megillot* was the production of silver cylinders, usually with a central spindle and winding handle on which the scrolls could be wound and in which they could be safely stored. There is an excellent Dutch example of the 17th century in the Metalwork Department (cat. no. 39). This example is in the

[1] *Encyclopaedia Judaica*. Jerusalem, 1971, IX, col. 1100; Shalom Italia (brief biography, and bibliography).

[2] *op. cit.* XI, cols 855–6; Manasseh ben Israel.

form of a cylinder, but some craftsmen displayed both their skill and their sense of humour by producing containers in the shape of fish, alluding to Pisces (the fish), the zodiacal sign which coincides with the month of Adar.

Purim was, and still is, marked by communal merrymaking including singing, dancing, drinking and play acting. The needy are not forgotten during these celebrations, and the custom of giving alms to the poor (*shalaḥ manot*) has become part of the *purim* festival. This practice led to yet another artistic manifestation, that of *Purim* plates made expressly for the collection of gifts for the poor. These plates, often made of pewter, bear representations of Mordecai overcoming Haman and of the execution of Haman and his ten sons. Both these motifs are engraved upon the large German *Purim* plate (cat. no. 40) belonging to the Metalwork Department, which is dated 1771.

34 Hebrew manuscript (*Megillah Ester*)

MSL36–1879 (National Art Library)
Height 28.1 cm × length 406.6 cm
Netherlands (Amsterdam): dated [5]403,
1643 CE; the scribe was Michael Judah
Léon

Esther scroll, or *megillah*, made from six
pieces of vellum sewn together. Written in
square letters enclosed within 18 columns
of text separated by decorated bands con-
taining alternating figures of Esther and
Mordecai. There are nine identical draw-
ings of each, commencing with Mordecai
and ending (at the roller) with Esther.
Esther is depicted looking to her right,
three-quarters face, wearing a contempor-
ary gown and holding a closed fan in her
right hand. Mordecai is shown in left pro-
file, wearing a fur-lined surcoat and a tur-
ban with a plume; in his left hand he holds
a small sceptre or staff. Immediately above
and below every one of these figures are
small cartouches (36 in all, 18 in each
margin) containing small drawings. Those
at the top depict contemporary townscapes,
landscapes and seascapes; those at the bot-
tom depict the story of Esther. The decora-
tion has been drawn in sepia ink, the top
and bottom borders consisting of running
foliated designs in the antique taste inter-
spersed with scrollwork cartouches. There
is an opening heart-shaped cartouche sur-
mounted by a plumed helmet and flanked
by two seated angels, each holding a trum-
pet. Within the cartouche are written the
following words:

מיכאל יהודה מחקקי בשנת ה'ת'ג ליצירה
(Michael Yehuda [Judah], letter-cutter [?],
in the year [5]403 to the creation [of the
world]). The scroll is wound upon a silver-
gilt roller. The lower part is repoussé with
foliage; the upper portion is decorated with
the figures of Esther and Mordecai (copied
from the scroll) amidst scrolls, capped with
a crown which also serves as a candle-
holder. The roller is Dutch, second quarter
of the 19th-century.

Prov.: Purchased from Elkington & Com-
pany for £40, on 8 November 1879.

Lit.: Royal Albert Hall, *Catalogue of the
Anglo-Jewish historical exhibition*. Pub-
lications of the Exhibition Committee IV.
London, Royal Albert Hall, de-luxe ed.,
1888, no. 5, p. 181.

Notes: This drawn *megillah* is close in
style to the engraved *megillot* of Shalom
Italia (*c.*1619–*c.*1655), who spent the latter
part of his life in Amsterdam; many of the
vignettes are similar. There is an undated
engraved scroll in the Jewish Museum,
London (*c.*1637?), another in the Israel
Museum (*c.*1640?), while a third (also ten-
tatively dated as 1640) was auctioned at
the David Solomon Sassoon sale, Hotel
Baur au Lac, Zurich, on 5 November, 1975.
There is also a *ketubbah* (marriage con-
tract) in the Israel Museum bearing several
motifs in common with this drawn *megil-
lah*; it was from Amsterdam and was dated
1648. This scroll was first received by the
Metalwork Department, presumably first
acquired for the silver-gilt roller, but it is
now in the collection of the National Art
Library.

34 Hebrew
manuscript
(*Megillah Ester*).
36–1879

35 Hebrew manuscript (*Megillah Ester*)

MSL36–1985 (National Art Library)
Height 17.1 cm × length 142.2 cm
Italian: late 17th or early 18th century

Esther scroll, or *megillah*, on vellum, made from two pieces sewn together. Written in square letters surrounded by an ornamented border. The letters are well formed and the text is in good condition, being divided into ten blocks of text, incorporating 19 columns of script. The drawing and painting is, by contrast, naïve and badly executed, lacking proper detail and poorly coloured in green, red and yellow. The upper and lower margins contain borders of strapwork design and filigree ornament, with the story of Esther illustrated in 20 coloured miniatures, arranged in two rows of ten in the upper and lower margins. The opening margin is decorated with two lions and an unidentifiable bird. There is no colophon or signature.

Notes: An attribution has to be made on stylistic grounds and this is done by comparison with similar, dated, *kettubot* (marriage contracts) from northern and central Italy. Comparable *megillot* are illustrated in Frauberger[1] and the Feuchtwanger catalogue.[2] A similar scroll was auctioned at the Parke-Bernet Galleries in 1970,[3] the date being given as the late 16th century.

[1]Frauberger, H, 'Verzierte Hebräische schrift und Judischer Buchschmuck'. In: *Mitteilungen der Gesellschaft zur Erforschung Judischer Kunstdenkmäler zu Frankfort-am-Main*, October 1909, V, vi.
[2]Shachar, I, *Jewish tradition in art: the Feuchtwanger collection of Judaica*. Jerusalem, Israel Museum, 1981, no. 413, pp. 156–7.
[3]Parke-Bernet Galleries, *Collection of Michael Zagaski*, 28 January 1970. New York, Parke-Bernet Galleries, 1970, lot 208 (illustrated).

36 Hebrew Manuscript (*Megillah Ester*)

MSL391–1925 (National Art Library)
Height 27 cm × length 540.3 cm
North African (Moroccan): 18th century

Esther scroll, or *megillah*, on nine pieces of deerskin sewn together. Written in square Sephardic letters arranged in 32 columns and completely undecorated. The wooden roller has one turned ivory handle, the top handle is missing.

Prov.: Presented by the Royal Asiatic Society, 13 March 1925.

Notes: Originally received for the Indian Department but now in the National Art Library collection. There are errors in the text which would make it unlikely that this scroll was used in a synagogue service.

37 Hebrew Manuscript (*Megillah Ester*)

M616–1911 (National Art Library)
Height 15 cm × length 312 cm
Ottoman Empire (Salonika): 19th century

Esther scroll or *megillah*, consisting of six pieces of vellum sewn together. The text, written in square Sephardic letters, is contained within 20 columns; there are small palmette motifs in the margins and interspersed throughout the text. The scroll is wrapped around a silver-gilt roller which has a tapering filigree handle at the bottom and is capped by a conical crest formed of four filigree crowns of diminishing size which fit inside one another. There is a small element missing from the top, perhaps a coral bead. The parchment is covered by a square of blue velvet embroidered in coloured silks with the letters D P and flowers which have a border of gold thread.

Prov.: Purchased for £5 from Mirza Yusuf Khan, 1 Coptic Street, Bloomsbury, London on 1 November 1911.

Notes: The original register entry notes that this object was from Salonika, and there is a similar silver-gilt filigree roller from Turkey (*c.*1873) in the Gross collection.[1]

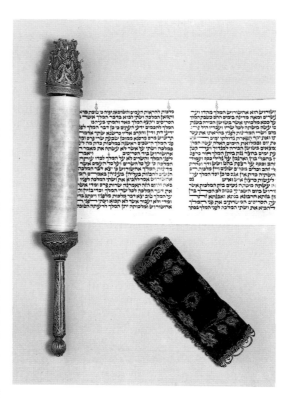

37 Hebrew manuscript (*Megillah Ester*). M616–1911

[1]Narkiss, B, & Yaniv, B, *Index of Jewish Art: I. The Gross family collection.* Jerusalem, Hebrew University (Centre for Jewish Art), 1985, p. 221.

38 Hebrew Manuscript (*Megillah Ester*)

95.Z.61 (press mark) (National Art Library)
Height 35 cm × length 269 cm
Israeli: 1951

Printed Esther scroll or *megillah* on paper, with its own cardboard container. Both the scrolls and tube are decorated with coloured illustrations by Gabriela Rosenthal, Jerusalem. Printed in Tel-Aviv by Hertzfelder, 1951.

Prov.: Purchased for the National Art Library in 1951.

39 *Megillah* case

M28 and a–1896 (Metalwork)
Height 18.5 cm
Netherlands 17th century

A silver *megillah* case consisting of a cylinder of pierced and engraved ornament with a panel inscribed in Hebrew. A spindle runs down the centre of the cylinder and terminates in a knob which is in the form of an open flower; this allows the scroll to be rolled and unrolled. The scroll is missing. A separate but matching piece of openwork, with ring attached, is provided for fixing to the end of the scroll. The inscription reads: מגילה זו של התלמיד קיעי'[?] כק'[?] יוסף חיים אלקנסטנטין יצ"ז (This is the megillah of the scholar [?] Yosef Ḥaim al-Constantin, may God protect and preserve him).

Prov.: Purchased from The Revd E Spers.

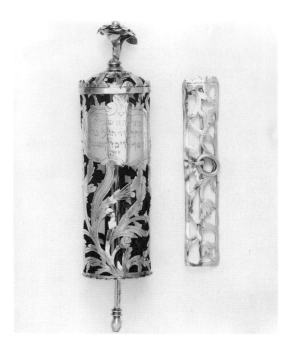

39 *Megillah* case.
M28/M28a–1896

40 *Purim* plate

M127–1913 (Metalwork)
Diameter 25 cm
German: 1771 CE, 5531 AC

Purim plate of silvered pewter, with engraved decoration. The bottom of the plate contains two scenes from the Esther story: at the top Haman is shown leading a horse upon which Mordecai sits, the phrases ברוך מרדכי (blessed be Mordecai) and ארור המן (cursed be Haman) are engraved alongside the appropriate figure. In the bottom half, Haman, his wife and his ten sons are shown hanging from the gallows intended for Mordecai, Esther and the Persian Jews. There are two lines of inscriptions, one inside the other, around the rim of the plate. The outer one is in Hebrew and refers to the giving of *Purim* gifts: ומשלוח מנות איש לרעהו ומתנות לאביונים ('and of sending portions one to another, and gifts to the poor'; Esther 9, 22) The second inscription is in Yiddish and records the names of the owners, Leib of Gelbach and his wife Pessele Auerbach who were residing in Rome, and the names of Ahasuerus (Xerxes) and Esther: דער ש'מ טעלר גהערט כ' ליב מגאלבך ואשתו מ' פעסלה אורברך וואנט אין ראם. אהשורש. אסתר At the top of the rim is a heart-shaped shield bearing the letters לפר LPR and supported by two lions. Above this motif is the date 1771, while below in Hebrew characters is the date [5]531 by the Jewish calendar. The back is inscribed SHVD. Marks: lamb and flag, and a coat-of-arms.

Prov.: Given by Abraham Cohen, MD

Notes: Compare this with two similar plates in the Harry G Friedmann collection, illustrated in Keyser.[1]

[1]Keyser, S, & Schoenberger, G, *Jewish ceremonial art.* Philadelphia, Jewish Publication Society, 1955, pp. 142–3, nos 151 and 152, pl. lxxvi.

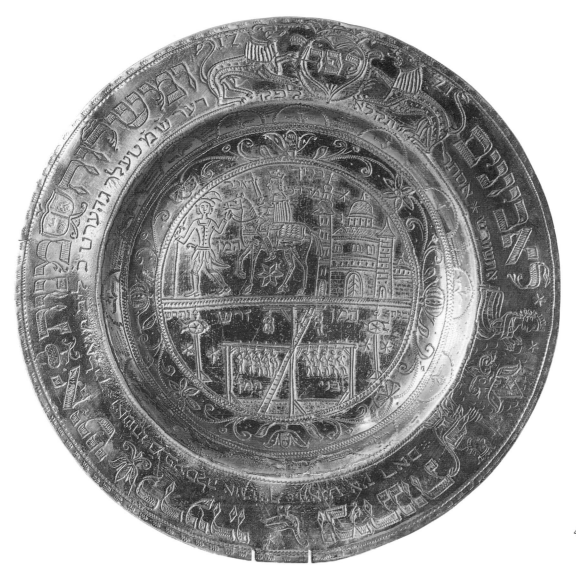

40 *Purim* plate.
M127–1913

41 Bottle with Hebrew texts

C674–1936 (Ceramics)
Height 27 cm
Near Eastern (Damascus?): mid-19th century(?)

Reddish-brown bottle, acid etched. It has a flattened globular body, narrow neck and small looped handle on one shoulder. The body is engraved all over with Hebrew texts interspersed with floral decoration of the type usually seen on Arab bottles of similar type. There is a turned ivory stopper with a silver chain attached. The Hebrew inscription reads thus (with the handle on the left): 'Behold his bed, which is Solomon's; threescore valiant men are about it, of the valiant of Israel' (Song of Solomon 3, 7) and 'Mordecai the physician . . . This is my handicraft.' On the reverse (with the handle on the right): 'Now king David was old and stricken in years; and they covered him with clothes, but he gat no heat' (Kings 1,1) and 'This is the handiwork of Mord[ecai of] Egypt, may God guard him and preserve him, [and] may He prosper his hand.'

55

41 Bottle with
Hebrew texts.
C674–1936

Prov.: Gift of William Buckley (ex-Buckley loan 618).

Lit.: Mayer, L A , 'Jewish art in the Moslem world'. In: Roth, C, *Jewish art: an illustrated history.* London, Valentine Mitchell, 1971, pp. 132–6, fig. 155.

Wigoder, G, *Jewish art and civilization.* Fribourg, Office du Livre, 1972, I, p. 115.

Notes: These bottles are believed to have been used for oil or wine during *Purim*, but the nature of the text leads one to speculate that it held medicine. Whatever its function, the Hebrew inscription contains several errors which suggest that Mordecai of Egypt, the craftsman who produced this bottle, was unused to rendering Hebrew in this fashion. Mayer has suggested that badly rendered Hebrew inscriptions on Damascus glass lamps were the work of 'Jewish craftsmen, who were literate, but in a different script.'[1] There were Jewish glassblowers working in Syrian workshops during the 17th and 18th centuries, and it is possible that Mordecai was one of these Jewish craftsmen, living in Damascus, who produced Hebrew objects (bottles and synagogue lamps) based upon Arab designs and techniques. There are several bottles of this type, and one which was formerly owned by Charles Feinburg of Detroit is now in the Israel Museum.[2]

[1]*Encyclopaedia Judaica.* VII, Jerusalem, 1971, col. 612.
[2]*ibid.*, col. 613.

Pesach (*Passover*)

Passover [פסח = *Pesach*] commemorates the exodus from Egypt and is one of the major festivals of the Jewish year. It begins on 15th *Nisan*, which approximates to April, and lasts for eight days (seven days in Israel). Passover is a religious holiday of great antiquity, and tradition relates that its rites were divinely ordained to remind the Jewish people of their release from slavery in Egypt. Its observance is commanded in Exodus 12, 1–28 and in Leviticus 23, 4–8.

The first and last two days of Passover are holidays during which work is set aside, but on the other four intermediate days, *Ḥol ha-mo'ed* in Hebrew, work is allowed. In Israel the duration of the festival differs from that in the Diaspora; in the Holy Land only the first and last (seventh) day are considered *yom tov* [יום טוב = good or festival days].

The special symbolic ceremony called the *seder* [סדר = order] is held at home on the first night of Passover and is based on the injunction that parents should instruct their children of the miraculous deliverance from Egyptian bondage; Exodus 13, 8–9:

The Passover meal (*Seder*) celebrated by 'Portuguese' (i.e., Sephardic) Jews during the early 18th century

The scene almost certainly depicts a Netherlandish Jewish family, and shows how little the *seder* has changed over the years. Picart draws attention to all the symbolic dishes on the table: the shank of lamb, the hard-boiled egg and the bitter herbs to remind them of the years of bondage in Egypt. The head of the family, with his back to the fire, is breaking the bread and passing it to the other members of the household, including the domestic servants, all of whom have their *Haggadot* (Passover service prayer books) open in front of them. The wine is being kept cool in a wooden bowl in the foreground and the best dinner service, cutlery and wine cups can be seen arranged on the fine linen tablecloth. The seven-light lamp, or Judenstern, illuminates the table.

SOURCE: Picart *Cérémonies et costumes religeuses …*

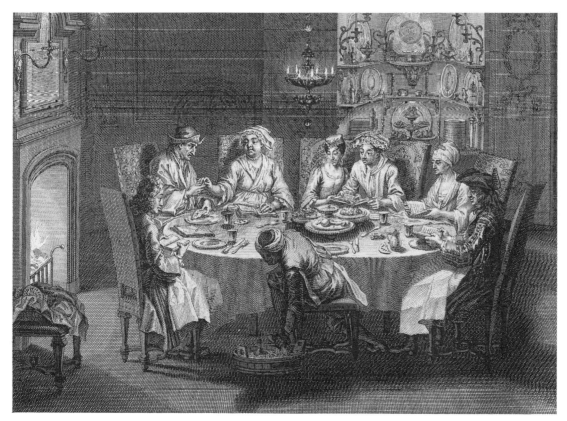

And thou shalt shew thy son in that day, saying, This is done because of that which the Lord did unto me when I came forth out of Egypt. And it shall be a sign unto thee upon thine hand, and for a memorial between thine eyes, that the Lord's law may be in thy mouth: for with a strong hand hath the Lord brought thee out of Egypt.

The celebration takes the form of a joint religious service and meal during which the *Ḥaggadah* (= narration) is recited and sung, with special dishes being presented which symbolise the nature of the Passover. The service itself is followed in elaborately decorated prayer books called *Ḥaggadot* (plural of *Ḥaggadah*). There are many fine medieval examples, such as the Barcelona *Ḥaggadah* in the British Museum (Add.Ms. 14762), and because their use is a living tradition contemporary Jewish artists such as Ben Shahn are still prepared to produce illustrated *haggadot*.

The *seder* table is set with two or three – according to the rite – loaves of unleavened bread or *mazzot*, plus a roasted egg and the shank bone of a lamb which symbolise the Temple offering and the paschal lamb. Also included are a bowl of salt water as the symbol of the ancient Israelites' tears; the *maror* or bitter herbs'; and *haroset* (clay), a paste made from wine, apples and almonds, to serve as a reminder of the mortar the Israelites used during their days of slavery and also to sweeten the bitter herbs. A cup of wine, Elijah's cup, is also placed on the table to serve as a reminder that Israel awaits final redemption when the Messiah comes, for Elijah is to be the herald of the Messiah. During the whole week of Passover no leavened bread is eaten, and the festival is preceded by a ritual in which the house is searched in order to remove all traces of leavened bread. In some households it is thought necessary to leave some crumbs until the last minute so they can be ritualistically removed and destroyed.

Apart from the illustrated *haggadah*, the *seder* requires several other ritual artefacts. The principal item on the Passover table is the *seder* plate or *ge'arah* and this can be made from any material. Many of these plates, however, were made from pewter, which lent itself easily to engraving. It is not unusual to find plates of this sort depicting the *seder* itself and the story of the *had gadya* (a kid for two *zuzim* or the four sons who were traditionally supposed to ask the four questions of the father during the *seder*, and to whom he answered according to each son's intelligence. Many of these pewter plates were made in Germany and included the maker's name among their inscriptions (see cat. no. 42).

Other wine cups, in addition to the elaborate Elijah cup, are needed for the *seder*; the *Ḥaggadah* requires the drinking of four ritual cups of wine, and cups are needed for the *Kiddush*. Many Elijah cups, and also *Ḥaggadot*, feature an illustration showing the prophet blowing a *shofar* (ram's horn trumpet) and leading the Messiah, who is seated upon a donkey, into

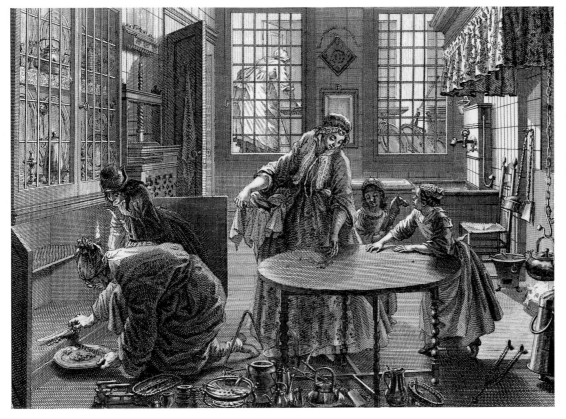

Jerusalem together with King David, who is playing upon his harp. Other ceremonial objects include a cloth (*ḥallah*) to cover the *mazzot*, a towel for the ritual washing and drying of the hands, a white robe for the father to wear and, because the meal is traditionally eaten in a reclining position, a pillow for him to lean on.

It was the custom in ancient Israel to offer a daily sacrifice called the '*Omer* (sheaf) for the 50 days following *Pesach* until the feast of *Shevu'ot* (Feast of Weeks), which corresponds with the Christian festival of Pentecost. Some homes have a small display case containing a scroll which can be turned to reveal the number of days that have elapsed since the Passover.

42 *Seder* plate (*qe'arah*)

M151–1935 (Metalwork)
Diameter 35.5 cm
German (Berlin): dated [5]542, CE; 1764
made by Leib bar Yitzak (Gottlieb Isaac?)

Pewter *seder* plate, or *qe'arah*, with engraved decoration. On the bottom is an eight-pointed star with the Passover lamb and the words קרבן פסח (Passover sacrifice) at its centre. Between the rays of the star are two stags (at the top facing one another), and the four sons whose charac-

ters have to be considered when explaining the symbolism of *Pesach* (Passover): חכם , the wise son with hand extended to emphasise his learned disputation; רשע the wicked son in military uniform and carrying a halberd in his right hand; תם the simple son; [לשאל] שאינו יודע the youngest son clapping his hands and unable to ask questions. In the bottom spaces are a cockerel and a stork catching eels.[1] Around the rim the old Aramaic song *ḥad gadya* (a kid for two *ẓuẓim*) is depicted in words and images

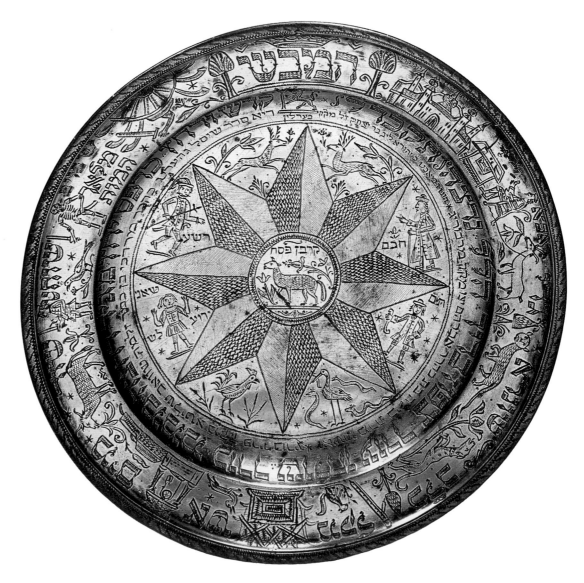

42 *Seder* plate (*qe'arah*).
M151–1935

60

which are (working anticlockwise from the top left): the sun with rays formed of *shofarot* (ram's horn trumpets) and an arm wielding a sword; a skeleton with a sword; a ritual slaughterer with a sword; a well, altar, stick, dog and cat and a goat tethered to the leg of a chair upon which sits a man facing a writing table. All these images are interspersed with representations of small animals and plants. In the curve of the plate are two more inscriptions: the outer (in large square letters) consists of mnemonic *seder* instructions, as are contained in *Ḥaggadot*; which the inner ring (in small letters) is a Judaeo-German inscription recording that the plate was made for Mordecai ben Salman of Friedberg (in Hessen) and his wife Bella of Marburg, daughter of Abraham (?), and that it was made by Leib

bar Yitzak of Berlin. Marks: St Michael and the letters LI; St Michael on a coroneted shield with the name GOTTLIEB IO...

Prov.: Bequest from Captain Frederick Young, late of the 20th Life Guards.

Notes: There is an almost identical plate in the Israel Museum (no. 134/4) by the same engraver, also dated 1764, and a similar plate dated 1767, attributed to Leib bar Yitzak, in the Feuchtwanger collection.

[1]The tale of the stork eating serpents is related in Ginzberg, L, *Legends of the Jews*. Jewish Publication Society, II, p. 286–7. I am indebted to Rabbi Lawrence Rigal for this information.

43 Ḥagaddah

AL1058–1911 (National Art Library)
3rd ed.?[1] 78 pp.; illustrated including woodcuts and titlepage
4to, 21 cm × 15 cm
Italian: Livorno (Leghorn), 1853

A printed *Ḥaggadah* (The service of the *Ḥaggadah* of *Pesach* [Passover] in the language of the Sephardi [Ladino] which opens with the words: סדר הגדה של פסח עם הפתרון בלשון ספרדי. (In order to convey the meaning, in the midst are also made pictures which point to the wonders and the miracles, which happened on the shores of the [Red] Sea and in the Wilderness [of Sinai]. Also . . . every plague . . . in Egypt depicted. All in proper order and prepared for the eye of the reader, also prayers. Printed in Livorno [Leghorn]. The year of the going forth from the land of Egypt by the abbreviated era.[2] By the hand of Moshe Yeshua [Moses Joshua], may the Lord preserve and keep him alive. By the consent of *HaHam* [Rabbi] Yaacov Toviana, to a blessing in the future world.)

Prov.: Purchased from Mrs J H Pollen.

Notes: The original paper cover has been damaged, and the volume is now half-bound. The illustrations in this book are

43 *Ḥagaddah*.
AL1058–1911

copies of the woodcuts first used in *Seder Ḥaggadah shel Pesach* printed on the press of Israel Ben-Daniel ha-Zifroni in Venice, 1609.

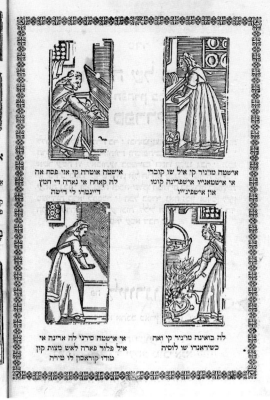

[1] The first and second editions were published in 1822 and 1837. One must, therefore, assume that this is the third edition. See Zedner, J, *Catalogue of Hebrew printed books*. London, British Museum, 1867, p. 444.
[2] This formula, known as Gematria (from Greek γεωμετρια), is a device which allows groups of letters to indicate a numerical value; e.g. the first three letters of the Hebrew alphabet are א (aleph), ב (beth) and ג (gimel) and represent the numbers 1, 2 and 3 respectively. The words המוציא אתכם equal numbers totalling 613; therefore the book was printed in the year 5613 of the Jewish calendar, or 1853 CE. I am indebted to A S Oppenheimer for this calculation.

44 Hebrew printed books (ḥaggadot)

RC.K.35 (press mark) (National Art Library)
40 cm × 30 cm
Paris, 1966

סדר של פסח (*Seder shel Pesach*, Passover service) for use at the Passover meal. Copied and illustrated by Ben Shahn (Benyamin Zvi Shahn). With an introduction and historical notes by Cecil Roth (in English and Hebrew); xx, 134 pp., illustrated with some hand-coloured pages and some colour lithographs. Based on the 11 illuminated pages of 1933 in the collection of the Jewish Museum, New York. No. 50 of the series, signed by the artist.

L317–1965 (National Art Library)
30 cm × 22 cm
American, 1933; printed in Paris, 1966.

The printed edition of the above, xxiv, 136 pp. Illustrations (some coloured). London, McGibbon & Kee; Paris, Trianon Press, 1965.

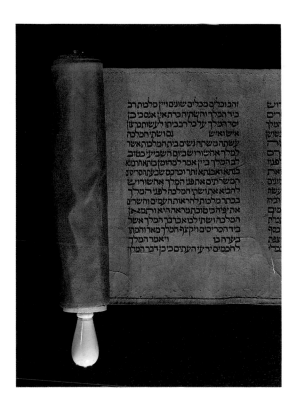

Hebrew manuscript
(*Megillah Ester*).
Moroccan, 18th
century.
MSL391–1925
(cat. no. 36)

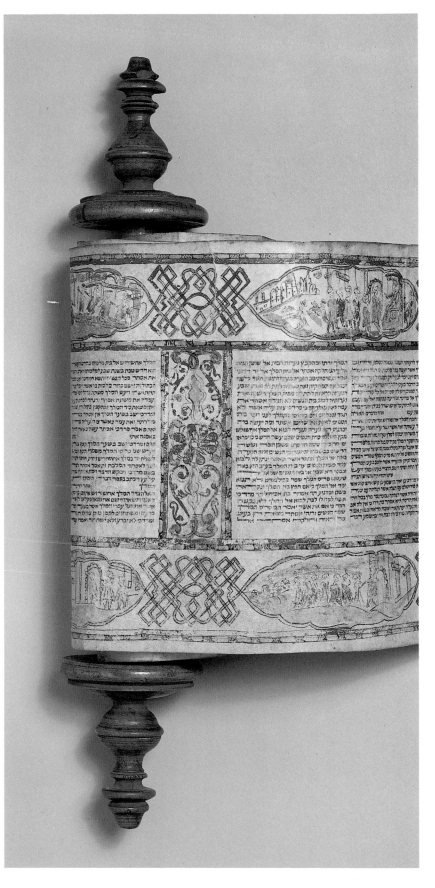

Hebrew manuscript
(*Megillah Ester*).
Italian, late 17th or
early 18th century.
MSL36–1985
(cat. no. 35)

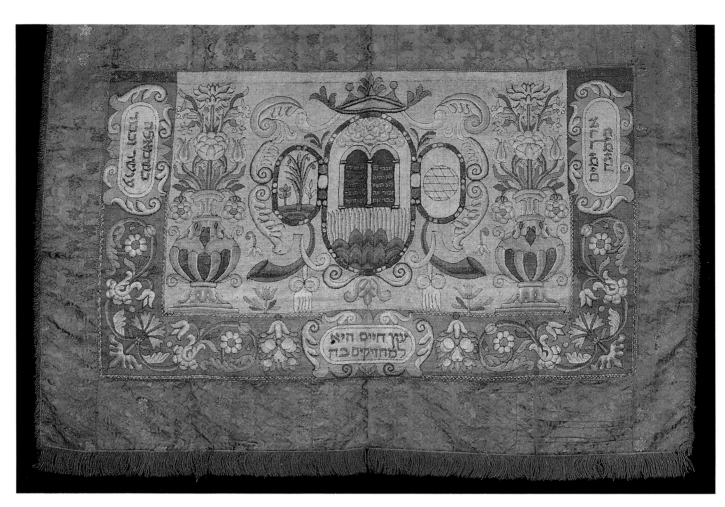

Almemor cloth.
Italian, late 17th
century.
511a–1877
(cat. no. 4)

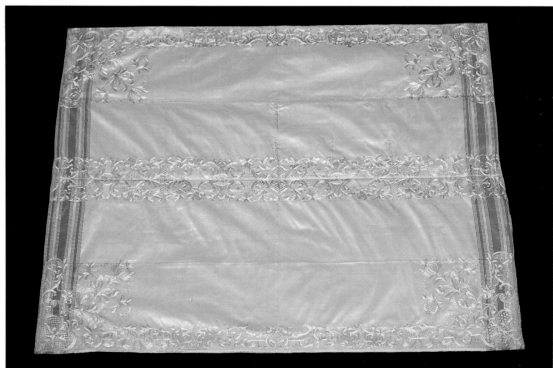

Tallit (prayer shawl).
French, 1700–1725.
921–1907
(cat. no. 10)

Torah mantle. Netherlands, 18th century. T258–1920 (cat. no. 3)

Sabbath tablecloth. Jerusalem, first half of the 19th century. 775–1900 (cat. no. 45)

Ḥanukkah lamp. Polish, late 18th or early 19th century. M413–1956 (cat. no. 32)

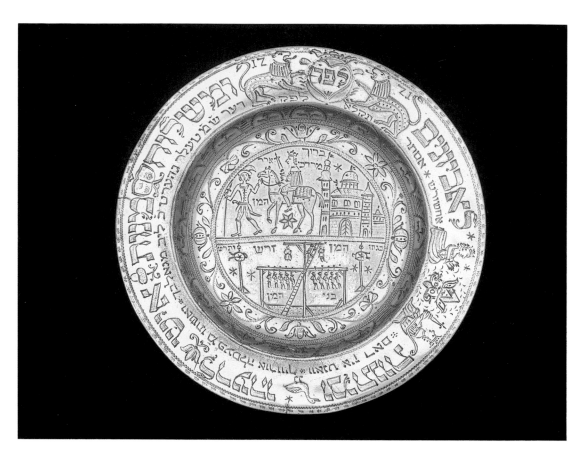

Purim plate.
German, 1771 CE,
5531 AC.
M127–1913
(cat. no. 40)

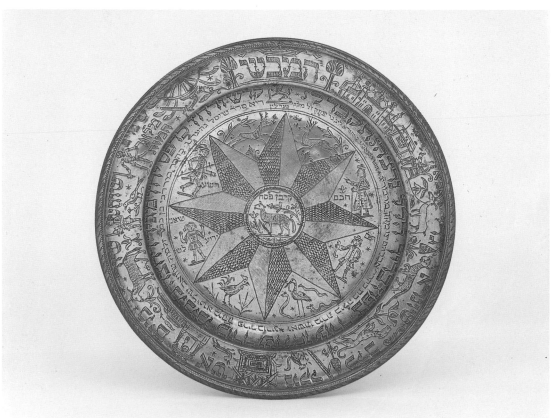

Seder plate (*qe'arah*).
German (Berlin),
1764 CE, 5542 AC.
M151–1935
(cat. no. 42)

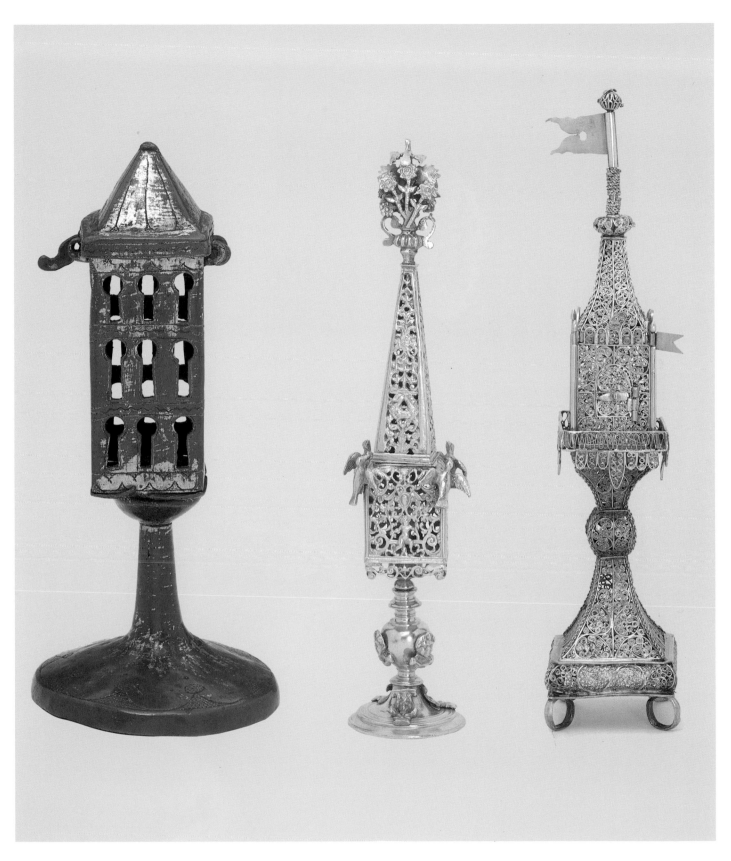

Spice boxes. *Left to right*: Spanish, 13th century, 2090–1855 (cat. no. 48); Italian, mid-17th century, M427–1956 (cat. no. 50); Austrian, 17th century, M409–1956 (cat. no. 52)

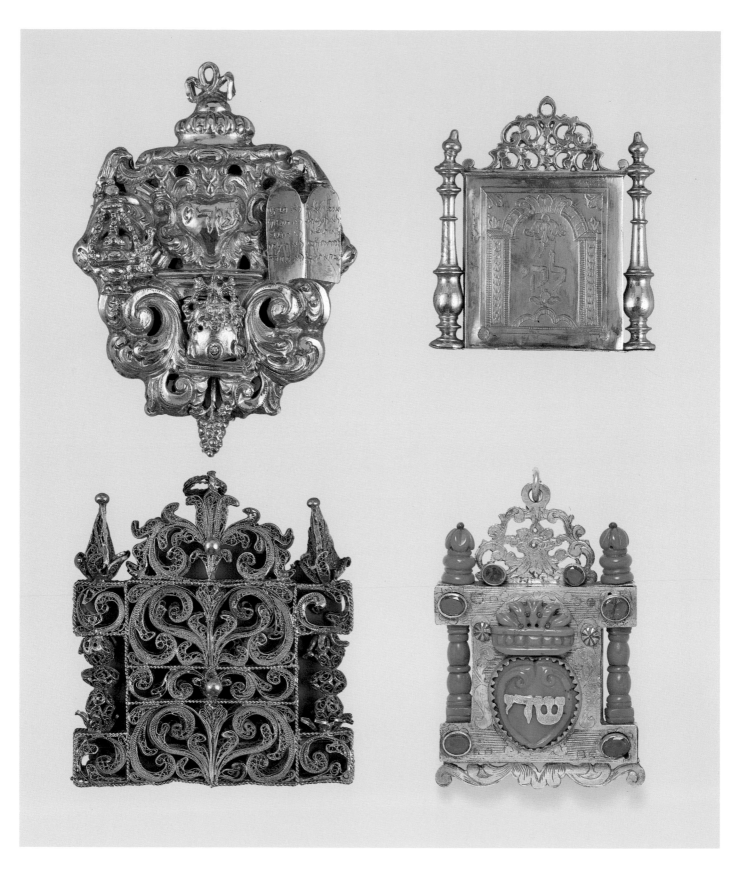

Amulets. Italian, 17th century. *Clockwise from top right*: M493–1956 (cat. no. 78); 18–1884 (cat. no. 75); M492–1956 (cat. no. 77); 1925–1898 (cat. no. 76)

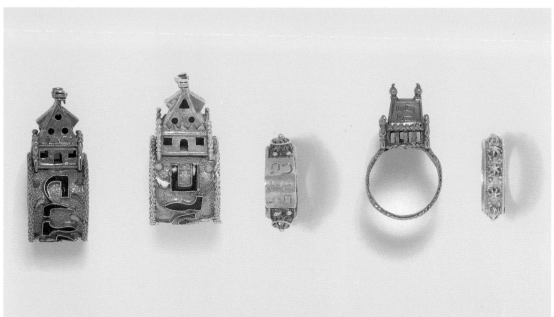

Wedding rings.
Southern German or
northern Italian
(Venice), 16th–18th
century. *Left to right*:
4100–1855 (cat. no.
59); 866–1871 (cat.
no. 63); 869–1871
(cat. no. 66); 453–
1873 (cat. no. 70);
M25–1852
(cat. no. 72)

Woman's robe (*am al-
kasa*).
Iraq, *c.*1870.
T439–1967
(cat. no. 93)

Woman's robe and
jacket. Tunisian, mid-
19th century.
519, a & b–1908
(cat. no. 82)

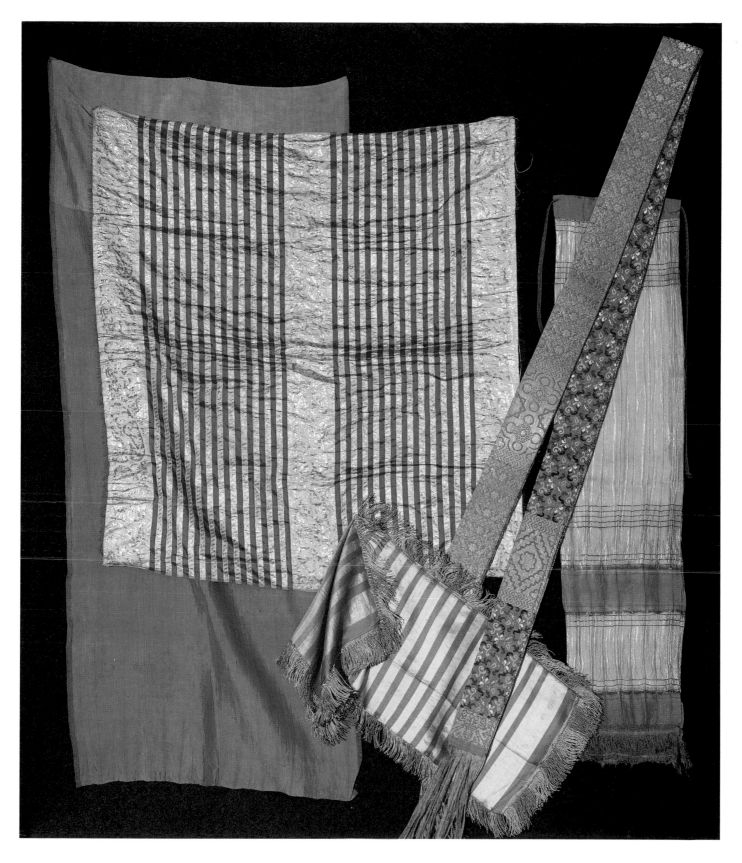

Sashes, girdles and veils for a bridal costume. Moroccan, 19th century. *Anticlockwise from top left*: sash, T180–1912 (cat. no. 89); sash, T178–1912 (cat. no. 87); (*bottom*) oblong silk panel, T179–1912 (cat. no. 88); (*diagonal position*) girdle, T177–1912 (cat. no. 86); veil, T176–1912 (cat. no. 85)

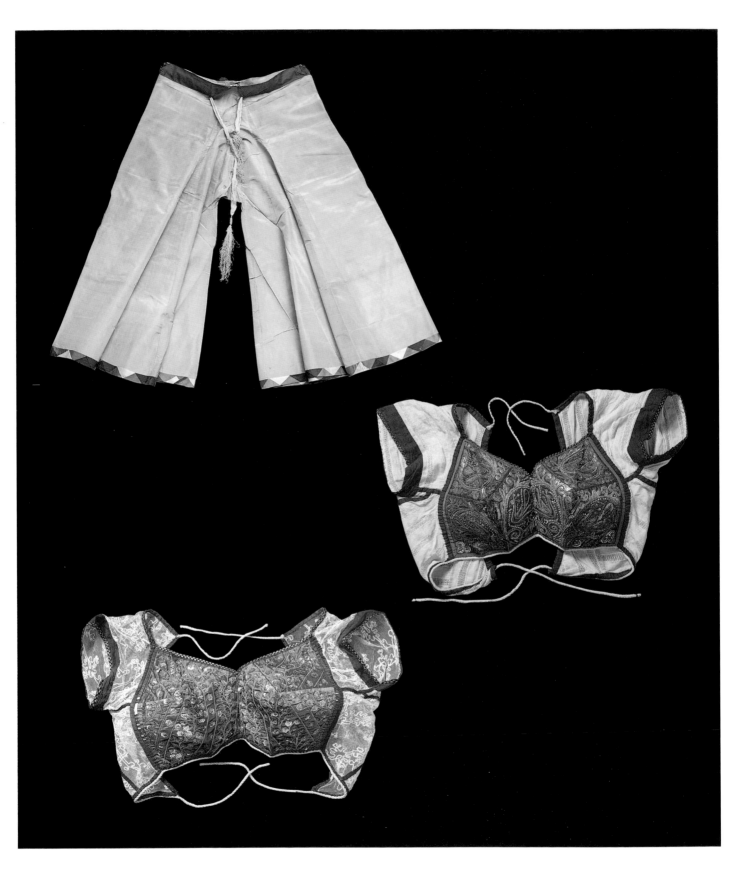

Women's clothing from Iraq, *c.*1870. *Clockwise from top left*: trousers, T441–1967 (cat. no. 95); bodice, T442–1967 (cat. no. 96); bodice, T443–1967 (cat. no. 97)

PART III
Domestic Worship and Observance

THE SABBATH

The opening chapter of Genesis describes how God created the world in six days. On the seventh day he rested from his labours, blessing this day of rest and declaring it to be holy (Genesis 2, 1–3). This seventh day was named *Shabbat* [שבת], anglicised as Sabbath, a word derived from the verb *shavat*, meaning to cease or to rest. It is the day on which mankind is encouraged to refrain from physical toil and to spend its leisure in praising God and achieving spiritual renewal. Thus the concept of a seven-day week, with one day set aside for worship, is a Jewish religious and social model which both Christianity and Islam have adopted, even though they have chosen different holy days. These three great monotheistic religions have between them spread this social and chronological pattern throughout the whole world, so that modern industrialised societies are planned around the ancient Jewish religious system.

The Sabbath is marked by communal services in the synagogue, but it is as a domestic celebration that it has held a special significance for Judaism. From this domestic observance many ritual objects have developed. The Sabbath begins at sunset on Friday and lasts until sunset on Saturday, and both its coming and its departure are marked by festive meals which emphasise the particular and holy nature of the day. The special intimacy of these family celebrations has done as much to reinforce the faith as the communal observance of the high days and holidays. Asher Ginzberg, a Jewish and Zionist writer and sometime resident of Manchester, expressed it far more succinctly: 'Far more than Israel has kept the Sabbath, it is the Sabbath that has kept Israel.'

The two Sabbath meals are mirror images of one another. The one which ushers in the Sabbath requires that the table be set with two candles, a goblet of wine and two Sabbath loaves called *ḥallot* (also known as *berches*) which are covered with an ornately decorated *ḥallah* cloth. The candles are lit by the woman of the house, the first candle serving as an injunction to 'remember the Sabbath day, to keep it holy' (Exodus 20, 8), while the second flame is a reminder to 'keep the Sabbath day to sanctify it, as the Lord thy God hath commanded thee' (Deuteronomy 5, 12). When this is

done the *Kiddush* [קדוש = sanctification] is recited, proclaiming the sanctity of the Sabbath and blessing the cup of wine: the *Kiddush* cup. A final benediction is required before the Sabbath meal can begin, the blessing of the *Ḥallah*.

The Sabbath concludes at sunset on Saturday with the *Havdalah* ceremony [הבדלה = separation], which literally denotes the separation of the day of rest from the working week. The *Havdalah* ritual reverses the procedure which began the Sabbath. It begins with the evening meal and ends with the drinking of a cup of wine and the lighting of a candle, which is of the plaited or twisted-stem type. Another *Havdalah* custom is the inhaling of the scent of aromatic spices which are contained in a spice box (also called *b'samim* or *hadas*). The acrostic *yaknehaz*, formed from the words *yayin* (wine), *kiddush, ner* (candle), *havdalah* and *zeman* (season), encapsulates the sequence of the *Havdalah* ceremony.

Kiddush cups are required to be perfect, without blemish, and are usually made of silver. Other metals are sometimes employed and there is also a tradition of using glass cups. These fine vessels are often engraved with biblical inscriptions or phrases from the *Kiddush* or the name of the owner and donor, as can be seen in the covered cup from Augsburg (cat. no. 47). The Nuremberg example (cat. no. 46) is a good example of the six- and eight-sided silver cups, with flower and shell decorations, produced in Germany in large numbers during the middle decades of the 18th-century, notably in the towns of Augsburg and Nuremberg.

The Textiles Department lacks examples of *hallah* covers, but it does own a typical example of the mid 19th-century embroidered tablecloths produced in Jerusalem (cat. no. 45), which seem to have been inspired by the work of Simche Janiwer.[1]

Whereas artefacts representing the advent of the Sabbath are poorly represented, those used in the *Havdalah* ceremony are well in evidence. One of the eight spice boxes owned by the Metalwork Department is a 13th-century example which is one of the oldest, if not the oldest, still in existence (cat. no. 48). It probably originated in Spain or in that part of southern France with which it shared a common trans-Pyrenean culture during the Middle Ages. There is also a fine *Havdalah* candlestick made by Roettger Herfurth of Frankfurt-am-Main some time around 1750 (cat. no. 55), and a solitary example of modern Jewish silversmithing in the shape of an ingeneous *Havdalah* set (cat. no. 56) designed by the late Eli Gera, an Israeli who was accepted as a foreign member by the Worshipful Company of Goldsmiths.

[1] See Barnett, R, 'A group of embroidered cloths from Jerusalem'. In: *Journal of Jewish Art*, 1975, II, pp. 28–41.

45 Sabbath tablecloth

775–1900 (Textiles)
123.5 cm sq.
Jerusalem: first half of the 19th century
(before 1865)

Linen tablecloth embroidered with coloured wools in chain stitch, used for the Sabbath meal. The centre of the cloth is taken up by a circular motif purporting to show the Temple Mount, but the buildings embroidered in outline are the mosques of the *Haram-esh-Sherif*, the Dome of the Rock being inscribed בית ה׳ (House of the Sanctuary) and el-Aqsa Mosque [מדרש שלמה] מ׳ש׳ (School of Solomon). Below these buildings a grass-covered wall is correctly inscribed כותל מערבי (Western Wall, also called the Wailing Wall). This central panel is surrounded by two circular borders, the outer one consisting of a flower and leaf repeat pattern while the inner one contains a Hebrew inscription which reads as follows:

מי שברך אברהם יצחק ויעקב משה ואהרון
דויד ושלמה הנבון והכהר משה ציבי
(May He who blessed our Fathers Abraham, Isaac, Jacob, Moses and Aaron, David and Solomon, [bless] the wise and honoured Moses Tzebi). The words 'Moses Tzebi' are embroidered in a different hand and the family name has been misspelled as 'Tzibi' (see article by R D Barnett listed below). Beyond the double border and filling all but the four triangular spaces at the corners of the cloth is another decorative element made up of 11 buildings or pavilions which represent holy sites and bear the names of patriarchs and prophets. There is also an embroidered square which represents the Well of Merom, and an amusing lion chained to a tree to symbolise Rabbi Isaac Luria (1534–1572 CE), the cabbalist who is buried at Safed. Embroidered above the lion are the Hebrew words רב ה(א)רי (Rab the lion), and the other names (working anticlockwise from the lion) are בעל הנס (Master of the Miracle – R Meir); זכריה הנביא (Zechariah the Prophet); יד אבשלום (Monument of Absolom – son of David); יואב ב׳ צרוייה (Joab, son of Seruiah); חגי הנביא (Haggai the Prophet); כלבא שבוע (Kalba Sabua); צדיק שמעין (Simon the Righteous); שבעים סנהדר׳ (Seventy [of the] Sanhedrin); אבות עולם (Fathers of the Universe – Abraham, Isaac and Jacob); אבנר בן נר (Abner, son of Ner); בעל ר׳ חכמה (Author of the Beginning of Wisdom – or Jesse, father of King David); and, finally, באר מרום (Well of Merom). In the four corners are embroidered mosques complete with minarets. They are inscribed as follows: top left חלדה נביאה (Hulda the Prophetess); top right מלכי ב׳ דויד (Kings of the House of David); bottom left שמואל הנביא (Samuel the Prophet); bottom right רחל אמנו (Rachel our mother). All these areas are bordered by a long Hebrew inscription, running around the four sides of the cloth, which consists of a Sabbath prayer beseeching the angels of the Sabbath to bring peace.

Prov.: Gift of Elkan N Adler.

Lit.: Barnett, R D, 'A group of embroidered cloths from Jerusalem'. In: *Journal of Jewish Art*, 1975, II, pp. 18–41.

Wilbusch, Z, 'An ornamental Sabbath cloth in the Museum's collection'. In: *Israel Museum News*, April 1975, X, pp. 101–2.

Notes: R D Barnett identified six cloths in this genre: the other five are in the Israel Museum (no. 161/58); the Jewish Museum, London (no. 366); a private collection in London, and two in the Hechal Shlomo Museum in Jerusalem (nos 52/10 2185 and 51/1 257). He ascribes the V&A cloth, the Jewish Museum cloth and the Israel Museum cloth to an unknown designer who he names Master of the Sabbath Cloths. Zohar Wilbusch has suggested that this person may have been the teacher of Simcha Janiwer (1846–1910). The cloth in the V&A is very worn; some of the letters and designs are missing and it has been scorched at some time in the past.

46 *Kiddush* cup

M274–1960 (Metalwork)
Height 12.5 cm × diameter 5.5 cm
German: Augsburg mark for 1763, mark of
Franz Christoph Maderl

Silver-gilt *Kiddush* cup. Octagonal bell-shaped bowl, the sides engraved alternately with a shell and with flowers; octagonal baluster stem and domed foot. Hebrew inscription around lip: וידבר משה אֶת־מֹעֲדֵי [יהוה] עַל־בְּנֵי יִשְׂרָאֵל ('And Moses declared unto the children of Israel the feasts of the Lord'; Leviticus 23, 44).

Prov.: Gift of Mrs Oved.

Notes: There is another Augsburg-made cup with similar shape, letter-type, ornament and date (1761–3), attributed to Hieronymous Mittnacht, in the Feuchtwanger collection;[1] in the Israel Museum there is another of the same type (no. 133/33).

[1]Shachar, I, *Jewish tradition in art: the Feuchtwanger collection*. Jerusalem, Israel Museum, 1981, no. 453, pp. 174–5.

46 *Kiddush* cup.
M274–1960

47 *Kiddush* cup

M40–1959 (Metalwork)
Height 13 cm × diameter 7.5 cm
German (Nuremberg): mid-17th century; Nuremberg town mark, and maker's fleur-de-lis mark

A covered *Kiddush* cup. Silver, parcel-gilt. The bowl spirally gadrooned, every other gadroon embossed with a tulip motif arranged in two rows. The alternating gadroons were left plain, but were subsequently decorated with Hebrew inscriptions. The bowl is supported on ball-and-claw feet. The domed cover is similarly decorated, with a ball finial. The lid is inscribed with the initials of the 14 Hebrew words of the *Kiddush* blessing. The bowl is inscribed: 'A memorial present from the fraternal society *Ohave Hesed* [Lovers of Charity] which was established in the year 5492 [1732] here in Copenhagen in commemoration of the centenary of the Society in 5592 [1832].'

Prov.: Given by Dr Edith Novak in memory of her mother Mrs Ira Rischowski and her aunts Mrs Rosa Friedlander and Mrs Hedwig Malachowski, and in gratitude for the safety found by younger members of her family in the British Commonwealth.

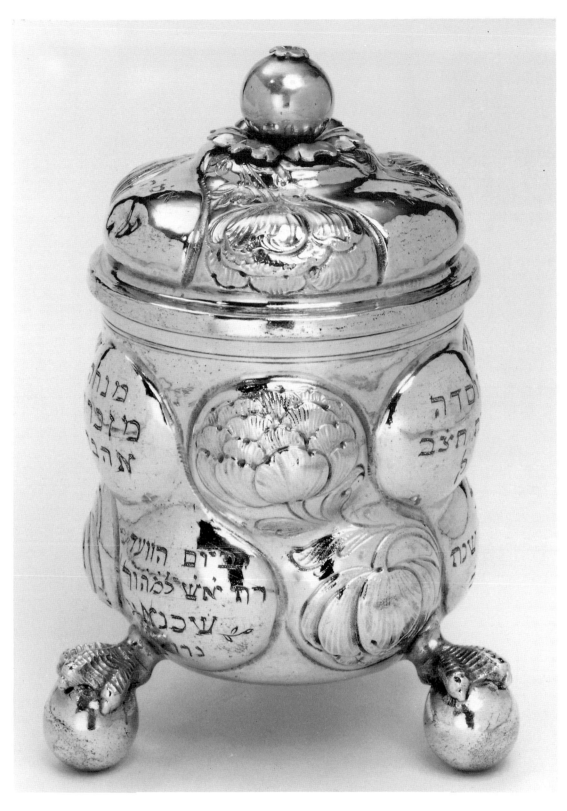

47 *Kiddush* cup.
M40–1959

48 Spice box

2090–1855 (Metalwork)
Height 15 cm × diameter (of base) 5.6 cm
Spanish: 13th century

Spice box of copper gilt in the form of a
tower with a pyramidal roof, the sides
pierced with three rows of arcades; the
whole supported on a cylindrical stem and
round base. The pyramidal roof is hinged to
allow the introduction of spices.

Prov.: Purchased from the sale of the Ber-
nal collection for the sum of £2.6s.0d.
(£2.30).

Lit.: Christie & Manson, *Catalogue of . . .*
works . . . of that distinguished collector,
Ralph Bernal [to be] . . . sold by auction, . . .
[etc.]. London, Christie & Manson, 1855,
no. 1288.

Narkiss, B, 'Un objet de culte: la lampe de
Hanuka'. In: Blumenkranz, B, (ed.),
Nouvelle Gallia judaica. Art et archéologie
des juifs en France mediévale [etc.], Vol. 9.
Paris, Centre National de la Recherche
Scientifique, 1980, pp. 187–206.

Notes: This is possibly the oldest extant
spice box. Bezalel Narkiss (in the article
quoted above) has drawn a comparison be-
tween the decorative arcade on this object
and that on the Lyons *hanukkiyah*[1] and the
15th-century *rimmon* at Camarata in Sicily
illustrated in Joseph Gutmann's book on
Jewish ceremonial art.[2] At some stage in
its history the stem of this object has been
shortened and reattached to the 'tower', the
swelling of the stem where both parts now
connect being the original knop.

[1] The *Hanukkah* lamp found during the excavation of
the old Jewish quarter of Lyons during the 19th
century which is now in the Musée Cluny (Collection
Strauss-Rothchild, no. 12 248). Compare this spice box
with the *Hanukkah* lamp (cat. no. 18), which is a
19th-century copy of the Cluny original.
[2] Gutmann, J, *Jewish ceremonial art.* New York and
London, Yoseloff 1964, p. 12, fig. 1.

48 Spice box.
2090–1855

49 Spice box

1932–1898 (Metalwork)
Height 26.5 cm × width 7.3 cm
German (Augsburg): early 17th century;
mark of Mateus Wolff (?), d. 1716

Spice box of chased silver in the form of a
tower. This edifice is in two parts, the lower
section square and surmounted by a balus-
trade while the upper part is circular. Two
curved legs rise from the circular upper
section to support a conical base below
which hangs a bell and above which is a
flag-pole (or perhaps a weather-vane). The
whole stands upon an octagonal foot,
ornamented with foliage, which appears to
be a later addition.

Prov.: Given by Colonel F R Waldo-
Sibthorpe.

Lit.: Shachar, I, *Jewish tradition in art:
the Feuchtwanger Collection of Judaica.*
Jerusalem, Israel Museum, 1981, no. 237,
p. 94.

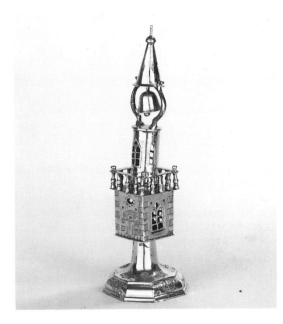

49 Spice box.
1932–1898

Notes: There is a spice box by Matteus
Wolff in the Feuchtwanger collection. See
the catalogue listed above, entry 237.

50 Spice box

M427–1956 (Metalwork)
Height of container and stem 11.5 cm ×
width 5 cm; height of cover 14 cm × width
2.5 cm
Italian: mid-17th century

Silver spice box consisting of a square con-
tainer cast and pierced with scrolling
foliage and putti; at each corner is an
applied figure of a dove. The cover is of
elongated pyramidal shape, cast and
pierced with strapwork foliage and sur-
mounted by a cast urn of flowers and a
dove. The spices were introduced through a
circular hole at the top of the box into
which a flange on the bottom of the cover
fits.

Prov.: Hildburgh Bequest (ex-Hildburgh
loan 4957). Purchased in Venice.

Lit.: Wigoder, G, *Jewish art and civiliza-
tion.* I, Fribourg, Office du Livre, 1972,
p. 186.

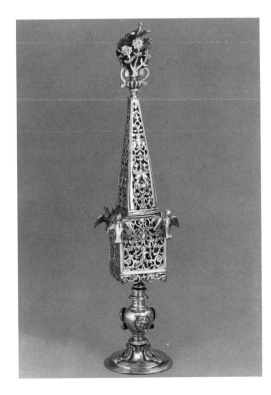

50 Spice box.
M427–1956

51 Spice box

M408–1956 (Metalwork)
Height 19.5 cm × width 7 cm
Netherlands: first half of the 17th century

A silver spice box in the form of a square tower mounted upon a square base supported by four ball feet. The tower itself is pierced with Gothic tracery and surmounted by a spire which is engraved in imitation of tiling. At the point where the tower and spire join there is an applied border, cast and pierced with foliage and cherub heads. There are small turrets at each corner, and all four turrets, together with the central spire, terminate in a silver ball. On one side of the tower is a small door for the introduction of the spice.

Prov.: Hildburgh Bequest (ex-Hildburgh loan 4931). Obtained in London in 1918.

Notes: There is a tower spice box of similar shape in the Musée Cluny collection (no. 12319) which is catalogued as being possibly of German origin, 19th century.[1]

[1]Illustrated in Israel Museum, *Jewish treasures from Paris: from the collections of the Cluny Museum and Consistoire.* Exhibition Catalogue 226, Jerusalem, Israel Museum, 1982, no. 46, p. 45.

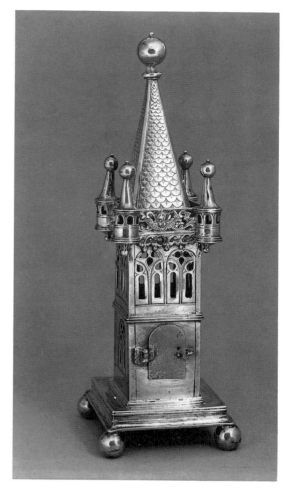

51 Spice box.
M408–1956

52 Spice box

M409–1956 (Metalwork)
Height 25 cm × width 5.5 cm
Austrian (from Linz): 17th century

Spice box of silver-filigree in the form of a tower with a spire, on a stem with a small knop flaring out to a square base standing on four ring-shaped feet. The tower is surmounted by a silver flagstaff and a pivoted flag, with similar but smaller flagstaffs at each corner. There is a small hinged door in one side of the tower for the introduction of spices. Three of the smaller flags and some filigree are missing.

Prov.: Hildburgh Bequest (ex-Hildburgh loan 4932).

Notes: Compare with the spice boxes illustrated in Israel Museum, *Towers of spice: the tower-shape tradition in Havdalah spiceboxes.* Exhibition Catalogue 224. Jerusalem, Israel Museum, 1982, pp. 46–51.

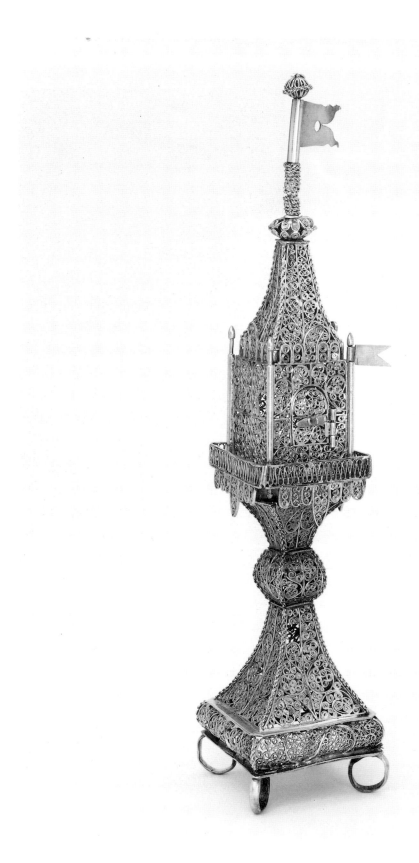

52 Spice box.
M409–1956

53 Spice box

M434–1956 (Metalwork)
Height 27.7 cm × width 7.9 cm
Central Europe: late 17th or early 18th century

A silver-filigree spice box with a moulded stem widening to a small five-sided knop and standing upon an hexagonal base mounted upon five (originally six) cast ball-and-claw feet. The container is in the form of a three-tiered tower with a railed parapet around the bottom. The middle and top tiers of the tower represent the belfry and lantern respectively, and the whole is surmounted by an onion dome and a flagpole flying a small silver 'burgee' emblazoned with an engraved scorpion motif on both sides. At two opposite corners of the lowest tier are small flags, without engraving, mounted on two small silver-filigree balls. On one face of this tier is the small hinged door through which spice was introduced. In the belfry tier immediately above hangs a small gilt bell. Mounted on the angles of the parapet are six cast gilt figures, three of them playing pipes (or *shofarot?*) and the other three clad in long robes, buttoned up the front, and wearing circular hats (probably emulating Jewish costume of the day). Each figure appears to have had a pendant, possibly a bell, hanging from the crook of the left arm but all are now missing.

Prov.: Hildburgh Bequest (ex-Hildburgh loan 4482).

Notes: Silver-filigree spice boxes of this general pattern, with small figures displayed upon them, are known from the 16th and 17th centuries and examples can be seen in Israel Museum, *Towers of spice: the tower-shaped tradition in Havdalah spiceboxes*. Exhibition Catalogue 224, Jerusalem, Israel Museum, 1982, pp. 46–51. Another example, from the Joods Historisch Museum, is illustrated in Wigoder, G, *Jewish art and civilization*. I, 1972, Fribourg, Office du Livre, p. 272.

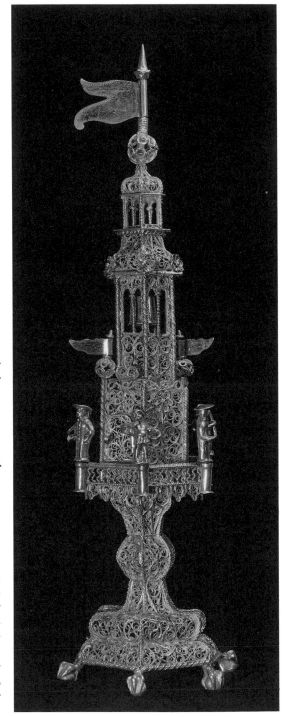

53 Spice box.
M434–1956

54 Spice box

302–1897 (Metalwork)
Height 26 cm × width 6.5 cm
Central or Eastern Europe: 19th century

Spice box of silver-filigree, in the form of a tower standing on an ogee-shaped base with ball-and-claw feet. The upper, or belfry, storey contains a bell, and the lower storey has a small door for introducing the spice. The roof is surmounted by a flagpole flying a small hinged 'burgee'. Pendants hang from the corners of the 'gallery' between the upper and lower storeys.

Prov.: Purchased from F Huth & Co.

Notes: One foot was broken and has been repaired; some of the pendants are missing. When purchased, this spice box was said to have been from Aleppo, but the tradition of architectural spice boxes is European rather than Near Eastern and there are many examples of this general pattern.[1]

[1] See Israel Museum, *Towers of spice: the tower-shape tradition in Havdalah spiceboxes.* Exhibition catalogue 224. Jerusalem, Israel Museum, 1982, pp. 46–51. See also Kolnisches Stadtmuseum, *Judaica . . . Bearbeitet von L. Franzheim.* Cologne, Kölnisches Stadtmuseum, 1980, no. 135, pp. 338–9.

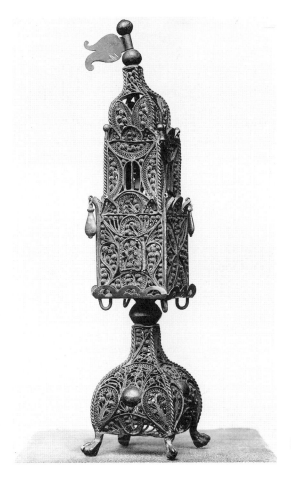

54 Spice box.
302–1897

55 Havdalah candlestick

Unnumbered (Metalwork)
Height (overall) 30 cm × width (of base) 10 cm
German: Frankfurt-am-Main, *c.*1750

Havdalah candlestick of silver, hammered with cast decorations, and made in two parts. The bottom section consists of a rounded base and stem cast in the form of a bearded male figure in 18th-century costume. The figure wears a caped cloak over an unbuttoned surcoat and has a ruff around his neck. The brim of his hat forms part of the base upon which the upper section rests. In his left hand he holds a *Kiddush* cup while his right hand grasps a square tower-shaped spice box, symbolising the *Havdalah* ceremony which closes the Sabbath. The upper portion is a candlestick with four long tapering holders, one at each corner of the square base – which is in the form of a cast and pierced gallery with leaf-like crenellations. There is a moveable candleholder of the same design as the gallery fitted over the four uprights, which are in turn topped with mask-like faces. The upper and lower sections are connected by a screw fitting which rises from the head of the bearded figure, and both parts bear the mark R D, in a rectangle, and the town mark of Frankfurt-am-Main: an eagle within an oval.[1] R D is the mark of Roettger Herfurth.

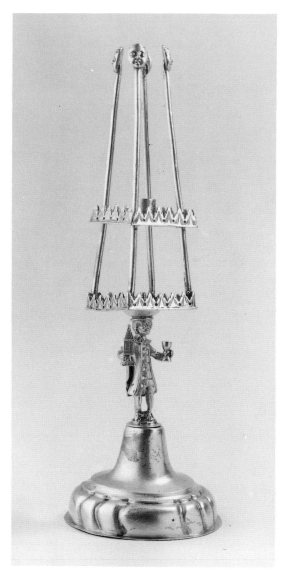

Notes: This would appear to be the candlestick illustrated in the de luxe (1888) edition of the Anglo-Jewish historical exhibition catalogue;[2] at that time it belonged to Solomon Schloss. This candlestick bears a marked resemblance to another *Havdalah* candlestick by Roettger Herfurth, illustrated in S Kayser's book,[3] which provides a bibliography of the artist. For more details of Herfurth's *oeuvre* and its relation to the work of other Frankfurt silversmiths, see the article by Dr V Mann.[4]

[1] For illustration, see Doery, Baron Ludwig, 'Silbernes Altargerat von 1749 aus Frankfurt' [etc.]. In: *Chronik Pfarrer Sankt Crutzen zu Weisskirchen aus Taunus*, 1963.
[2] Royal Albert Hall, *Catalogue of the Anglo-Jewish historical exhibition*. Publications of the Exhibition Committee IV. London, Royal Albert Hall, 1st ed., 1887; de-luxe ed., 1888, no. 1677, p. 105, pl. facing p. 101. Solomon Schloss's address was given as 30 Leinster Square, London, W2.
[3] Kayser, S, & Schoenberger, G, *Jewish ceremonial art*. Philadelphia, Jewish Publication Society of America, 1955, no. 98, p. 98, pl. xlviii.
[4] Mann, V, 'The golden age of Jewish ceremonial art in Frankfurt: metalwork of the eighteenth century'. In: *Leo Baeck Institute Year Book*, 1986, XXXI, pp. 389–403.

55 *Havdalah* candlestick. Unnumbered

56 Havdalah set

M60 & a–1981 (Metalwork)
Candlestick: height 13.5 cm × width 4.3 cm (weight 176.95 g); spice box, wine cup and cover (combined) height 13.5 cm × width 9 cm (weight 379.01 g)
Israel: *c.*1977

Silver *Havadalah* set comprising four items: a candlestick, a spice box and a wine cup and cover. The last three items form a single interlocking piece when not in use. They were designed and made by an Israeli artist-craftsman, Eli Gera, who was a for-eign member of the Worshipful Company of Goldsmiths.

Prov.: Gift from the Jewish Museum, Woburn House, London.

Lit.: Eli Gera Gallery, *Eli Gera*. Illustrated catalogue, Jaffa, Eli Gera Gallery, n.d. (1978?), no. 421.

Notes: These items were displayed in an exhibition of Jewish ritual objects held at the Jewish Museum, London, 8 June to 6 July 1979.

56 *Havdalah* set.
M60 & a–1981

57 Sabbath lamp (*Judenstern*)

1512–1903 (Metalwork)
Height 44.5 cm × width 20 cm
Netherlands: 18th century

A Sabbath lamp of cast brass, of the type known as *Judenstern* (Jewish star). It consists of a baluster suspension rod, from which hangs a semicircular bowl with seven spouts for wicks; hanging below is a semicircular drip pan.

Prov.: Purchased from A Johnson & Sons, 85 Wigmore Street, London, for the sum of £1.2s.6d. (£1.12½).

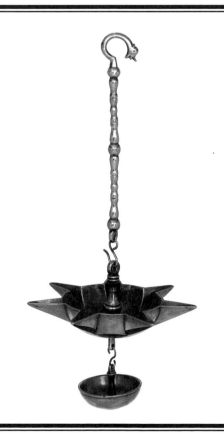

57 Sabbath lamp (*Judenstern*). 1512–1903

75

WEDDING RINGS

Under Jewish law, marriage can be solemnised by an act known as *kiddushin*. This rite requires a man and woman to acknowledge the change in their status, from the single to the married state, in the presence of at least two witnesses and then to effect *kiddushin* by the transfer of *kesef* (כסף = silver or money) or its equivalent, usually in the form of an unadorned ring, from the bridegroom to the bride. By accepting the money or the ring the women demonstrates her willingness to become the bride of the man who has proferred it. The ring itself should not be embellished with precious stones. Although it is almost always made of gold, it can be made from any metal as long as it does not cost more than a *perutah*, which was the smallest denomination of coin in Talmudic times. It is usual for the ring to be placed on the forefinger of the right hand, but this custom varies from one community to another; some oriental groups still exchange money rather than a ring.[1]

Sephardic wedding ceremony

Here we see the bridegroom breaking a glass under foot, presumably to cries of *mazal tov* (good luck), in order to ward off ill fortune. The rabbi who is conducting the service stands beside him, while his bride, flanked by two attendants, sits under the *ḥuppah* (wedding canopy).

SOURCE: Picart *Cérémonies et costumes religeuses ...*

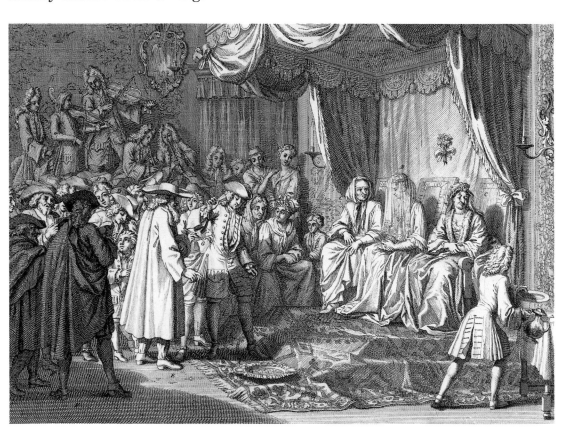

[1] *Encyclopaedia Judaica*. Jerusalem, 1971, XI, cols 1045–9; Marriage: legal aspects.

In southern Germany and northern Italy during the late Middle Ages, Jewish betrothal rings patterned on contemporary secular and non-Jewish examples began to appear, and this practice reached its zenith in the 16th and 17th centuries. These ornate objects were in marked contrast to the simple circles of gold required by Jewish law; nevertheless they became very popular and were widely used in the German and Italian communities. In their 1887 catalogue, Jacobs and Wolff suggested that: 'in early times [these richly embellished rings] were used to surround a sprig of myrtle, hence their large size'.[2] The evidence to support this proposition is largely circumstantial and seems to be based on the fact that the aromatic evergreen myrtle, *myrthus communis* [הדס = *hadas*], was compared with Esther (Hebrew *Hadassah*) and was thus symbolically used in betrothal ceremonies. As a general rule these circlets appear to have belonged to congregations rather than to individuals and were used only for the betrothal ceremony, although in some instances they seem to have been worn by brides for the week following marriage[3] after which they were returned to the synagogue.[4] Whatever the reason for their size and the nature of their usage, these German and Italian rings were ostentatious, and occasionally magnificent, examples of the goldsmith's art. The circulet consisted of a very broad band of gold decorated with filigree ornament or with raised bosses or rosettes, sometimes enlivened with the finest enamel. Many bore the Hebrew inscription *mazal tov* [מזל טוב = good luck or fortune] either rendered in full or represented by the initials מ *mem* (m for *mazal*) and ט *tav* (t for *tov*). Another typical decorative element was the representation of a miniature building said, variously, to portray the Temple, the synagogue or the new home the married couple were about to set up. Cecil Roth[5] favoured the image of the Temple 'so as to comply with the Psalmist's injunction' (Psalm 137, 6) to 'set Jerusalem above my chiefest joy'.

The Victoria & Albert Museum has 15 of these wedding rings in its holdings and collectively they manifest all the decorative motifs mentioned above. Some have no inscription but their form is so characteristic that they are recognisable as belonging to the southern German or Italian Jewish communities rather than to any other group. It is difficult, without possessing a detailed provenance, to give an exact date or ascribe a specific place of origin to these rings. Therefore a general description must serve for all, namely, southern German or northern Italian (Venetian?), 16th to

[2] Royal Albert Hall, *Catalogue of the Anglo-Jewish historical exhibition*. Publications of the Exhibition Committee IV. London, Royal Albert Hall, de luxe ed., 1888, p. 83.

[3] Kayser, S, & Schoenberger, G, *Jewish ceremonial art*. Philadelphia, Jewish Publication Society of America, 1955, p. 152.

[4] Roth, C *Jewish art: an illustrated history*. Rev. ed. London, Valentine Mitchell, 1971, p. 129.

[5] *ibid.*, p. 129.

18th centuries.[6] Wherever possible, in the catalogue entries in the following section, the reader's attention has been drawn to examples in other collections and the dates and places of manufacture attributed to them.

Ashkenazi wedding ceremony

This ceremony is taking place immediately outside the synagogue. The act of *kiddushin*, the presentation of the ring before witnesses under the supervision of the rabbi is here depicted. A *tallith* (prayer shawl) over the heads of the bride and bridegroom serves as a *chuppah* (wedding canopy). The parents flank the young couple, and friends stand close by holding wine bottles from which to drink the health of the married couple. Two young men can be seen holding staffs decorated with bows which they will carry in front of the pair as they walk away from the ceremony.

SOURCE: Picart *Cérémonies et costumes religeuses ...*

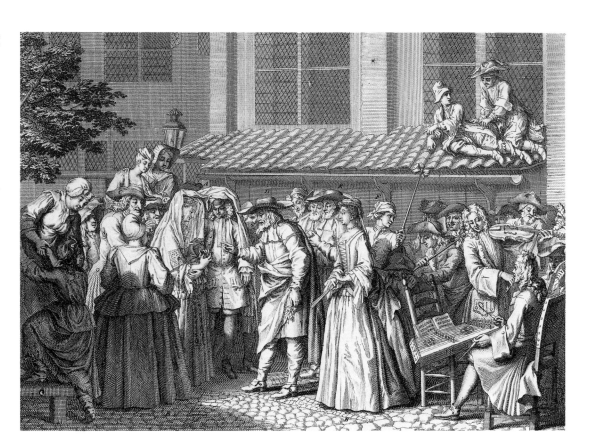

6 Professor Gutmann ascribes these rings to Italy (?), 17th–18th century. See Gutmann, J, *Jewish life cycle*. Fascicle, Leiden, Brill, 1987, pp. 15–16.

58 Wedding ring

2746–1855 (Metalwork)
Diameter 3.3 cm; width of hoop 2.3 cm

Gold wedding ring ornamented with 20 filigree bosses arranged in two matching hoops of ten and inscribed ‏מ"ט‎ (abbreviation for *mazal tov*, good luck) inside the shank.

Prov.: Purchased from the Bernal Collection.[1]

Lit.: Royal Albert Hall, *Catalogue of the Anglo-Jewish historical exhibition.* Publications of the Exhibition Committee IV. London, Royal Albert Hall, 1st ed., 1887; de-luxe ed., 1888, no. 14, p. 182.

Bury, S, *Jewellery Gallery summary catalogue*, London, Victoria & Albert Museum, 1982, no. 3, p. 238.

Notes: Compare with the ring (no. 102/64) in the Israel Museum, attributed to Italy 16th–17th century, which contains the inscription within the hoop, has the bosses

58 Wedding ring.
2746–1855

embellished with light-blue enamel, and to which the mark E T has been added at a later date.[2] Compare also with cat. no. 66.

[1]Christie & Manson, *Catalogue of . . . works of art . . . of that distinguished collector, Ralph Bernal [to be] . . . sold by auction, . . . at the Mansion, No. 93, Eaton Sq.* [etc.]. *Twenty-sixth Day's sale, on Monday, April 23, 1855.* London, Christie & Manson, 1855, no. 3466, p. 280.
[2]Shachar, I, *Jewish tradition in art: the Feuchtwanger collection.* Jerusalem, Israel Museum, 1981, no. 75, pp. 43–4, fig. 75.

59 Wedding ring

4100–1855 (Metalwork)
Diameter 4.5 cm; width of hoop 2.5 cm

Enamelled gold wedding ring with a raised inscription, the letters picked out in black enamel, around the outside which reads ‏מזל טוב‎ (*mazal tov*, good luck). The bezel consists of a conventional representation of the Temple, with two irregular gables and two hinged flags on the roof. The hoop is enlivened with light-blue, green and white enamel.

Prov.: Purchased for £6.10s.0d. (£6.50) in 1855.

Lit.: Royal Albert Hall, *Catalogue of the Anglo-Jewish historical exhibition.* Publications of the Exhibition Committee IV. London, Royal Albert Hall, 1st ed., 1887; de-luxe ed., 1888, no. 18, p. 182.

Bury, S, *Jewellery Gallery summary catalogue.* London, Victoria & Albert Museum, 1982, no. 4, p. 238.

Notes: This ring is almost exactly like cat. no. 63 but the standard of enamelling is far inferior. A ring of this general description was sold to Mr Myers of Old Bond Street, London, at the Bernal sale, 1855[1] for the sum of 6 guineas (£6.30).

[1]Christie & Manson, *Catalogue of . . . works of art . . . of that distinguished collector, Ralph Bernal [to be] . . . sold by auction, . . . at the Mansion, No. 93, Eaton Sq.* [etc.]. *Twenty-sixth Day's sale, on Monday, April 23, 1855,* London, Christie & Manson, 1855, no. 3466, p. 280.

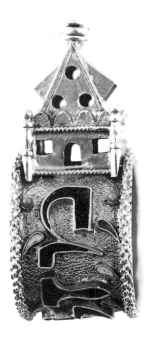

59 Wedding ring.
4100–1855

60 Wedding ring

863–1871 (Metalwork)
Diameter 2.5 cm

60 Wedding ring.
863–1871

Gold wedding ring. This ring has a high, square bezel to represent the Temple, with openings on all four sides of the base. The shoulders are angular and boldly chased; the hoop is ribbed.

Prov.: Purchased from T M Whitehead. Formerly in the Waterton collection.

Lit.: Royal Albert Hall, *Catalogue of the Anglo-Jewish historical exhibition.* Publications of the Exhibition Committee IV. London, Royal Albert Hall, 1st ed., 1887; de-luxe ed., 1888, no. 12[?], p. 182.

Bury, S, *Jewellery Gallery summary catalogue.* London, Victoria & Albert Museum, 1982, no. 9, p. 238.

Notes: Catalogued as Italian, 16th century, in the 1887 exhibition catalogue. Compare with a ring in the Jewish Museum catalogue,[1] which is said to be German, 16th or 18th century. See also cat. no. 61.

[1]Barnett, R D, *Catalogue of the permanent and loan collections* [etc.]. London, Jewish Museum, 1974, no. 459, p. 84, pl. cxxx.

61 Wedding ring

864–1871 (Metalwork)
Diameter 3 cm

61 Wedding ring.
864–1871

Gold wedding ring with square projecting bezel in the form of a tower with entrances on all four sides of the base. The hoop is divided at the shoulders and finished with scroll ornament.

Prov.: Purchased from T M Whitehead in 1870. Formerly part of the Waterton collection.

Lit.: Royal Albert Hall, *Catalogue of the Anglo-Jewish historical exhibition.* Publications of the Exhibition Committee IV. London, Royal Albert Hall, 1st ed., 1887; de-luxe ed., 1888, no. 13, p. 182.

Bury, S, *Jewellery Gallery summary catalogue,* London, Victoria & Albert Museum, 1982, no. 1, p. 238 .

Notes: Catalogued as Italian, but undated, in the 1887 exhibition catalogue. Compare with a ring in the Jewish Museum catalogue,[1] which is said to be German, 16th or 18th century. See also cat. no. 60.

[1]Barnett, R D, *Catalogue of the permanent and loan collections* [etc.]. London, Jewish Museum, 1974, 459, p. 84, pl. cxxx.

62 Wedding ring

865–1871 (Metalwork)
Diameter 4.5 cm

Gold wedding ring with projecting bezel in the conventional representation of the Temple with the words מזל (*mazal*, fortune, destiny) and טוב (*tov*, good) inscribed at the opposite gable ends of the roof. The hoop is formed from a double band of finely twisted gold wire.

Prov.: Purchased from T M Whitehead in 1870. Formerly part of the Waterton collection.

Lit.: Royal Albert Hall, *Catalogue of the Anglo-Jewish historical exhibition*. Publications of the Exhibition Committee IV. London, Royal Albert Hall, 1st ed., 1887; de-luxe ed., 1888, no. 6, p. 181.

Bury, S, *Jewellery Gallery summary catalogue*, London, Victoria & Albert Museum, 1982, no. 5, p. 238.

Notes: Catalogued as Italian, 16th century, in the 1887 exhibition catalogue.

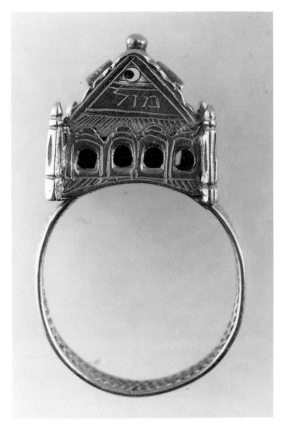

62 Wedding ring.
865–1871

63 Wedding ring

866–1871 (Metalwork)
Diameter 4.5 cm

Enamelled gold wedding ring with a raised inscription – the letters picked out in black enamel – around the outside which reads מזל טוב (*mazal tov*, good luck). The bezel consists of a conventional representation of the Temple, with two irregular gables and two hinged flags on the roof. The roof is engraved in imitation of tiling. The ring is enlivened with light blue, green and white enamel.

Prov.: Purchased from T M Whitehead in 1870. Formerly part of the Waterton collection.

Lit.: Royal Albert Hall, *Catalogue of the Anglo-Jewish historical exhibition*. Publications of the Exhibition Committee IV. London, Royal Albert Hall, 1st ed., 1887; de-luxe ed., 1888, no. 7, p. 181.

Bury, S, *Jewellery Gallery summary catalogue*, London, Victoria & Albert Museum, 1982, no. 2, p. 238.

Notes: This ring is almost exactly like cat. no. 59 but the standard of enamelling is far superior. A ring of this general description was sold to a Mr Myers of Old Bond Street, London for £6.6s.0d. (£6.30) at the Bernal sale, 1855 (object no. 3466).

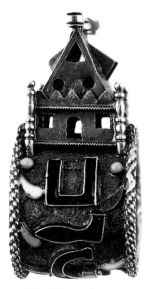

63 Wedding ring.
866–1871

64 Wedding ring

867–1871 (Metalwork)
Diameter 2.8 cm

64 Wedding ring.
867–1871

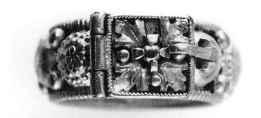

Wedding ring of gilt bronze; the bezel opens with a hinge to reveal the words מזל טוב (*mazal tov* good luck) on the inside. Eight solid bosses around the hoop.

Prov.: Purchased from T M Whitehead in 1870. Formerly part of the Waterton collection.

Lit.: Royal Albert Hall, *Catalogue of the Anglo-Jewish historical exhibition.* Publications of the Exhibition Committee IV. London, Royal Albert Hall, 1st ed., 1887; de-luxe ed., 1888, no. 8, p. 181.

Bury, S, *Jewellery Gallery summary catalogue*, London, Victoria & Albert Museum, 1982, no. 13, p. 238.

Notes: The 1887 catalogue stated that this ring was German, 16th century.

65 Wedding ring

868–1871 (Metalwork)
Diameter 3.9 cm

Enamelled gold wedding ring. A broad hoop with six filigree projections surrounded by white and blue enamel, with six loose pendant rings between each. The inscription מזל טוב (*mazal tov*, good luck) appears within the hoop.

Prov.: Purchased from T M Whitehead in 1870. Formerly part of the Waterton collection.

Lit.: Royal Albert Hall, *Catalogue of the Anglo-Jewish historical exhibition.* Publications of the Exhibition Committee IV. London, Royal Albert Hall, 1st ed., 1887; de-luxe ed., 1888, no. 9, p. 182.

65 Wedding ring.
868–1871

Bury, S, *Jewellery Gallery summary catalogue*, London, Victoria & Albert Museum, 1982, no. 7, p. 238.

Notes: Compare with a similar ring in the Jewish Museum, London,[1] which has the abbreviation מ״ט engraved within the hoop, and which was catalogued as Italian 17th or 18th century. Compare also with cat. nos 68 and 71.

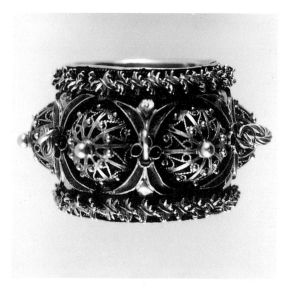

[1]Barnett, R D, *Catalogue of permanent and loan collections* [etc.]. London, Jewish Museum, 1974, no. 462, p. 85.

66 Wedding ring

869–1871 (Metalwork)
Diameter 2.8 cm

Silver-gilt wedding ring. A hoop joined with a small plate on which is engraved מזל טוב (*mazal tov*, good luck), the rest enriched with six openwork bosses and rope ornament.

Prov.: Purchased from T M Whitehead in 1870. Formerly part of the Waterton collection.

Lit.: Royal Albert Hall, *Catalogue of the Anglo-Jewish historical exhibition.* Publications of the Exhibition Committee IV. London, Royal Albert Hall, 1st ed., 1887; de-luxe ed., 1888, no. 17, p. 182.

Bury, S, *Jewellery Gallery summary catalogue*, London, Victoria & Albert Museum, 1982, no. 14, p. 238.

Notes: The engraved plate has been added to the ring, seemingly after two bosses were removed, because the shank beneath the plate had been sawn through and then reconnected. Compare with an example in the Israel Museum (no. 102/66), described as Italian, 17th century.[1] Compare also with cat. no. 58.

[1]Shachar, I, *Jewish tradition in art: the Feuchtwanger collection.* Jerusalem, Israel Museum, 1981, no. 1093, pp. 319–20, fig. 1093. 'Shank ornamented with filigree domes having granules at the top; between are pairs of granules. Shank bordered on one side by twist. Traces of inscription on inside of shank (upper parts of letters: מזל). This ring has been cut and separated from a wedding ring about two or three times as wide!'

67 Wedding ring

870–1871 (Metalwork)
Diameter 2.2 cm

Gilt-bronze wedding ring. A broad hoop edged with rope ornament, having three openwork projections and a plate inscribed מזל טוב (*mazal tov*, good luck) on the outside of the shank.

Prov.: Purchased from T M Whitehead in 1870. Formerly part of the Waterton collection.

Lit.: Royal Albert Hall, *Catalogue of the Anglo-Jewish historical exhibition.* Publications of the Exhibition Committee IV. London, Royal Albert Hall, 1st ed., 1887; de-luxe ed., 1888, no. 11, p. 182.

Bury, S, *Jewellery Gallery summary catalogue*, London, Victoria & Albert Museum, 1982, no. 11, p. 238.

Notes: The standard of workmanship is poor and the Hebrew inscription is inexpertly rendered and misspelled: the word *tov* (good) is formed from the letters *teth,*

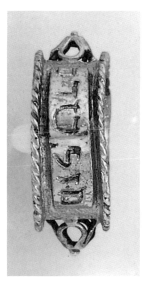

daleth and *beth* [ט ד ב] and not *teth, waw* and *beth* [טוב]. Two other rings in the collection (cat. nos 69 and 72) are of similar design but both are much finer quality. The 1887 catalogue (quoted above) stated that this ring was German, 17th century.

67 Wedding ring. 870–1871

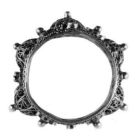

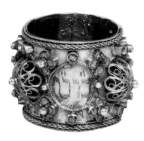

68 Wedding ring.
80–1872

68 Wedding ring

80–1872 (Metalwork)
Diameter 3.3 cm

Enamelled gold wedding ring. A broad hoop ornamented with five bosses of filigree work, light-blue enamel and edgings of cable pattern. Inscribed מ׳ט (M T, abbreviation for *mazal tov*, good luck) on the outside of the hoop.

Prov.: Purchased from H K Kugelsman Kissinger on 13 November 1871.

Lit.: Royal Albert Hall, *Catalogue of the Anglo-Jewish historical exhibition.* Publications of the Exhibition Committee IV. London, Royal Albert Hall, 1st ed., 1887; de-luxe ed., 1888, no. 10[?], p. 182.

Bury, S, *Jewellery Gallery summary catalogue*, London, Victoria & Albert Museum, 1982, no. 8, p. 238.

Notes: Catalogued as Venetian, 16th century, in the 1887 catalogue. This ring resembles one illustrated in Kayser[1] catalogued as Italian, 18th century. Compare also with cat. nos 65 and 71.

[1]Kayser, S, & Schoenberger, G, *Jewish ceremonial art,* Philadelphia, Jewish Publication Society of America, 1955, no. 166, pp. 152–3, pl. lxxxiii.

69 Wedding ring

81–1872 (Metalwork)
Diameter 3.2 cm

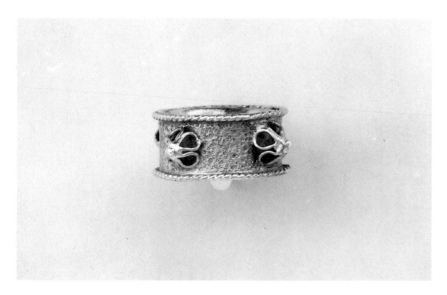

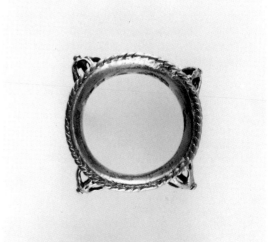

69 Wedding ring.
81–1872

Gilt-bronze wedding ring. A broad hoop, dotted, with spiral edgings and four open-work projections, inscribed with the Hebrew letters מ׳ט (M T, abbreviation for *mazal tov*, good luck) inside hoop.

Prov.: Purchased from H K Kugelsman Kissinger on 13 November 1871.

Lit.: Royal Albert Hall, *Catalogue of the Anglo-Jewish historical exhibition*. Publications of the Exhibition Committee IV. London, Royal Albert Hall, 1st ed., 1887; de-luxe ed., 1888, no. 15[?], p. 182.

Bury, S, *Jewellery Gallery summary catalogue*, London, Victoria & Albert Museum, 1982, no. 15, p. 238.

Notes: Catalogued as German, 17th century, in the 1887 catalogue.

70 Wedding ring

453–1873 (Metalwork)
Diameter 3.8 cm; height of hoop 2.3 cm

Gold wedding ring. A broad hoop with a row of raised dots along the middle and raised edges. The bezel is a representation of the Temple and has the letters מ׳ט (M T, abbreviation for *mazal tov*, good luck) on the sides.

Prov.: Purchased from J & S Goldschmidt on 2 May 1873.

Lit.: Royal Albert Hall, *Catalogue of the Anglo-Jewish historical exhibition*. Publications of the Exhibition Committee IV. London, Royal Albert Hall, 1st ed., 1887; de-luxe ed., 1888, no. 16, p. 182.

Bury, S, *Jewellery Gallery summary catalogue*, London, Victoria & Albert Museum, 1982, no. 10, p. 238.

Notes: Catalogued as German, 17th century, in the 1887 exhibition catalogue. Compare with a ring in the Jewish Museum[1] said to be Italian, late 16th century.

[1]Barnett, R D, *Catalogue of permanent and loan collections* [etc.]. London, Jewish Museum, 1974, no. 460, p. 84, pl. cxxx.

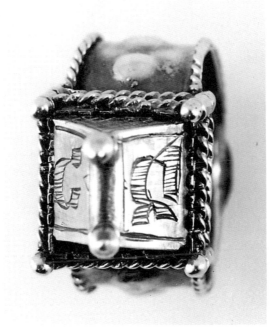

70 Wedding ring.
453–1873

71 Wedding ring

32–1894 (Metalwork)
Diameter 3.8 cm

71 Wedding ring.
32–1894

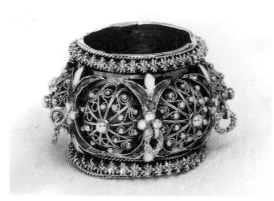

Gold wedding ring decorated with six bosses of filigree work separated from one another by raised ornaments enamelled in white and green. The Hebrew letters ט"מ (M T, abbreviation for *mazal tov*, good luck) are engraved inside the hoop.

Prov.: Purchased for £40 from Baron J von Hoevel.

Lit.: Bury, S, *Jewellery Gallery summary catalogue*, London, Victoria & Albert Museum, 1982, no. 6, p. 238.

Notes: See also cat. nos 65 and 68.

72 Wedding ring

M25–1952 (Metalwork)
Diameter 2.3 cm; height of hoop 0.6 cm

Gold wedding ring. A flat hoop set with eight small filigree bosses and a curved plate engraved with the words מזל טוב (*mazal tov*, good luck) on the outside of the hoop.

Prov.: Gift from Mrs Eugenie Klugsman.

Lit.: Bury, S, *Jewellery Gallery summary catalogue*, London, Victoria & Albert Museum, 1982, no. 12, p. 238.

Notes: Compare with no. 1093 in the Feuchtwanger collection.[1]

[1]Shachar, I, *Jewish tradition in art: the Feuchtwanger collection*. Jerusalem, Israel Museum, 1981, no. 1093, pp. 319–20, fig. 1093.

TORAH BINDERS

A charming custom developed in 16th-century Germany of making *Torah* binders from the swaddling cloth (*wimpel* or *mappa*) used during the circumcision ceremony. After its initial use as a swaddling sheet, the linen cloth would be cut into four strips which were then stitched into one long band. On to these bands were embroidered or painted the boy's name and date of birth, and the words recited during the circumcision ceremony promising that the child would be introduced to the Law (*Torah*) and hoping that he would come to the *huppah* (wedding canopy) and undertake good deeds (*ma'asim tovim*). Some of these binders noted the zodiacal sign under which the boy had been born, and added other data such as a nickname or place of birth.

Wimpels or *mappot* represent a branch of folk art that seemed to have died out but now appears to be reviving in the United States. The decoration, when embroidered, is usually worked in stem or chain stitch and frequently depicts pictorial images such as the *huppah* or the *Torah* scroll, and occasionally human figures in contemporary costume. The Hebrew letters are embellished with frills and flourishes and sometimes have zoomorphic details added in the shape of human or animal heads.

There are several explanations concerning the precise use of the *mappot*. Kayser advances the argument that the binder was presented to the synagogue when the child visited it for the first time, usually at the age of 2 or 3.[1] The same *mappa* would then have been used to bind the Scroll of the Law when the boy celebrated his *Bar Mitzvah* at the age of 13.

[1] Kayser, S, & Schoenberger, G, *Jewish ceremonial art*. Philadelphia, Jewish Publication Society of America, 1955, p. 33.

73 *Torah* binder (*wimpel*)

352–1891 (Textiles)
Length 40.5 cm × width 14.5 cm
Italian: second half of the 16th century

Part of a binder (*wimpel*) made of silk and linen *burato*, or darned netting. The thin border is of light yellow canvas. The pattern of the embroidery consists of a straight central stem from which spring fanciful leafy scrolls (possibly representing a grapevine). The upper border is made up of a narrow motif of repeated leaf shapes, while the lower border consists of the following incriptions (translated from Hebrew): '[Moses] implores Him who dwells on high to gather the unnumbered congregation'.

Prov.: Purchased from Howell & James, Regent Street, London.

Notes: Another fragment of what appears to be the same *wimpel* was lent to the Jewish Museum (see reference quoted above), but neither piece gives any indication as to the name of the owner. There is a complete *wimpel* in the Musée Cluny that is almost identical in terms of letter shapes, materials and decoration to the two London fragments; its inscription shows it to have come from Cremona and to have been dated [5]342, i.e., 1581–2 CE. The major difference between the Cluny *wimpel* and the London pieces is that the former has an inscription in both the top and the bottom margins.

Lit.: Barnett, R D, *Catalogue of the permanent and loan collections* [etc.]. London, Jewish Museum, 1974, no. 512, pp. 96–7, pl. cxlix.

73 *Torah* binder (*Wimpel*). 352–1891

74 *Torah* binder (*wimpel*)

T4–1941 (Textiles)
Length (approx) 361 cm × width 13.5 cm
Alsace: dated 5480; 1719–20 CE

Torah binder (*wimpel*) made from swaddling cloth used at a circumcision ceremony. Silk embroidery on linen, made up of four pieces joined by ornamental seams. Stitches: buttonhole, stem, satin and feather. Colours: dark-green, blue, purple, beige and yellow. The Hebrew inscription translates:

> Alexander son of Napthali known as Hertz, may his light be bright: born under the constellation of the zodiac on 23rd *Teveth* [December–January, the 10th month of the Jewish calendar] in the year 5480. May God, blessed be He, grant that he may come to the nuptial canopy, and to the performance of good deeds; Amen, *Saleh*. And may he be as strong as a lion in doing the will of our Heavenly Father.

There are representations of the child's zodiacal birth sign, Capricorn the goat (Hebrew *Gedi*); an antelope which is the emblem of the tribe of Napthali (Genesis 49, 21: 'A hind let loose'); the *ḥuppah* or nuptual canopy; and a figure in contemporary costume wearing a mortar-board hat, carrying a *Torah* scroll and pointing to the Tablets of the Law.

Prov.: Gift from Dr W L Hildburgh, FSA.

Notes: A label attached to this object states that a former vendor believed the tradition of producing *wimpels* of this type was unique to Alsace, and was obselete by the time the sale took place (late 19th century). The Musée Cluny, the London Jewish Museum and the Maurice Spertus Museum of Judaica have similar binders, but the last example is of a later date.

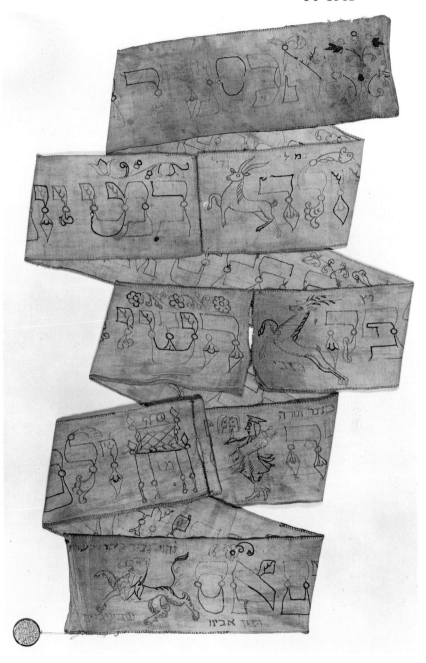

74 *Torah* binder
(*Wimpel*).
T4–1941

AMULETS

The wearing of amulets is an ancient practice common to all cultures and religions, including the Jews, and they were worn by men, women and children. Their uses, likewise, were many and varied: some were made to obtain good fortune or to attract love, while others were intended to protect against sickness or evil, and others to achieve any combination of these desires.

The Hebrew word for amulet is קמיע (*kemi'ah*, pl *kemi'ot*) from a root meaning to bind. They were usually made of paper or metal; often of both materials. The simplest form had one of the renderings of God's name engraved or inscribed upon it, with ה' (*He*, abbreviation of *Elohim*, Lord), יה (*Yah*, abbreviation of Jehovah) and שדי (*Shaddai*, Almighty) being the most favoured.[1] Their efficacy was believed to have been enhanced by the piety of the maker; the more holy the scribe or craftsman the more effective was the charm.

Amulets have been used into this century by Jews in north Africa and the Orient, and their use in European communities extended into modern times, notably among Hassidic groups in Russia and Poland. Their use has been condemned by those who have seen them as manifestations of superstition rather than as sacred and religious artefacts. Notwithstanding these criticisms, they were used by Jews living in western Europe until well into the 17th century. The V&A has four amulets from Italy (cat. nos 75–78), all of which seem to be 17th century. There is an obvious link between the wearing of amulets for magical protection and the wearing of jewellery for adornment, and the amulet at cat. no. 77 seems to be decorative rather than magical. The others bear the inscription שדי (Almighty), which was especially favoured in Italy where amulets were often referred to as *Shaddai*,[2] but a fashion grew up in later centuries for copying the 17th-century originals. The amulet at cat. no. 76 appears to be one of these later copies.

[1] For a more detailed description of the incantations found on amulets, see Shachar, I, *Jewish tradition in art: the Feuchtwanger collection of Judaica*. Jerusalem, Israel Museum, 1981, pp. 237–40.

[2] Spertus Museum of Judaica, *Magic and Superstition in the Jewish tradition*. Text by Marcia Reines Josephy. Chicago, Spertus Museum of Judaica, 1975, p. [68]: 'The amulet case with a prominent central inscription of "Shaddai" is frequently found among followers of the Sephardic rite. The case is often called a *shaddai*. Such cases were very popular in 18th-century Italy as protective amulets for children. Often a lock from the child's first haircut would be placed in the drawer usually found in the case. In North Africa the same type of case was used as a mezuzah.'

75 Amulet (*kemi'ah*)

18–1884 (Metalwork)
Height 8.5 cm × width 6 cm
Italian: 17th century

Square copper-gilt amulet, with a suspension ring. The top is pierced and the back and front are engraved with floral ornaments. There is a heart made of coral in the centre, upon which is affixed silver-gilt Hebrew letters forming the word שדי (*Shaddai*, Almighty), a crown made of coral immediately above it and two turned columns of coral on either side. There are small garnets set in collets on the face and a bowl of flowers engraved on the back.

Prov.: Acquired from Giuseppe Bassani of Padua.

Lit.: Royal Albert Hall, *Catalogue of the Anglo-Jewish historical exhibition.* Publications of the Exhibition Committee IV. London, Royal Albert Hall, 1st ed., 1887; de-luxe ed., 1888, no. 19, p. 182.

Barnett, R D *Catalogue of the permanent and loan collections* [etc.], London, Jewish Museum, 1974, no. 598, p. 113, pl. clxii.

Notes: This item was listed as German, 17th century, in the Jewish Museum catalogue (listed above). A silver amulet of the same general shape in the Feuchtwanger collection,[1] is attributed to northern Italy, 18th century. These amulets bear a striking resemblance to the motif of the Temple entrance used on late 16th- and early 17th-century Italian title pages, e.g. Abraham de Boton's *Lechem Mishneh*, printed in Venice by D Zaneti, 1604. One authority states that amulets with the inscription *Shaddai* were intended as protection for children.[2]

[1]Shachar, I, *Jewish tradition in art: the Feuchtwanger collection of Judaica.* Jerusalem, Israel Museum, 1981, no. 800, pp. 251–2.
[2]Spertus Museum of Judaica, *Magic and Superstition in the Jewish tradition.* Text by Marcia Reines Josephy. Chicago, Spertus Museum of Judaica, 1975, p. [68].

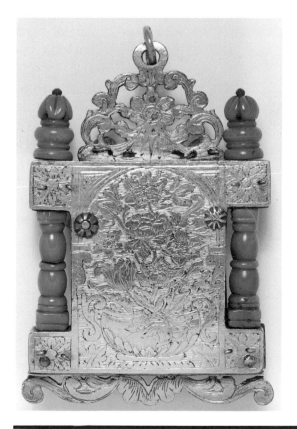 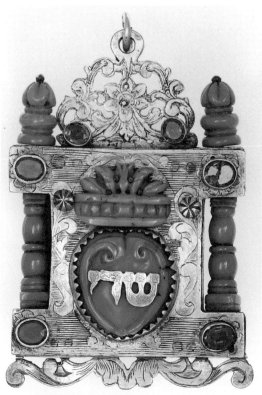

75 Amulet (*kemi'ah*). 18–1884

76 Amulet (*kemi'ah*)

1925–1898 (Metalwork)
Height 12.4 cm × width 9 cm
Italian: 17th century?

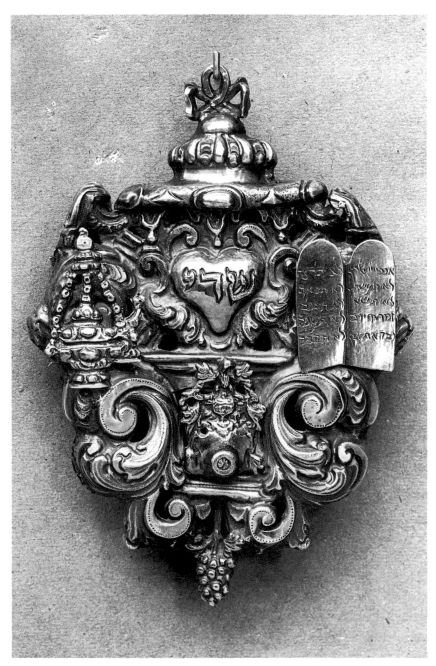

Amulet of repoussé silver in the form of a pendant, with a parcel-gilt suspension ring in the shape of a ribbonwork bow. The front and back are formed of scrollwork and foliage with a parcel-gilt heart, inscribed שדי (*Shaddai*, Almighty) at the centre. On either side of this heart are parcel-gilt representations of a censer and the Tablets of the Law (on the verso these are replaced by a priest's mitre and an eight-branched candlestick, or *menorah*). Below the heart is a heraldic device with an eagle crest, while at the very bottom of the amulet hangs a parcel-gilt bunch of grapes.

Prov.: Given by Colonel F R Waldo-Sibthorpe. Formed part of the Sassoon collection in 1887.

Lit.: Royal Albert Hall, *Catalogue of the Anglo-Jewish historical exhibition.* Publications of the Exhibition Committee IV. London, Royal Albert Hall, 1st ed., 1887; de-luxe ed., 1888, no. 2063, p. 131.

Notes: A note in the Metalwork Department register indicates that this amulet was exhibited in the 1887 exhibition when it formed part of the Sassoon collection of Hebrew ecclesiastical art; this collection was largely assembled by Philip Salomons, and was exhibited by Reuben D Sassoon. In the same catalogue a similar amulet belonging to the Strauss collection (see reference above, no. 1948, p. 124, pl. facing p. 115) was described as a 16th-century scent case. Another amulet of this same general type was illustrated in Kayser[1] and attributed to Italy, *c.*1800. One authority states that amulets with the inscription *Shaddai* were intended as protection for children, and describes an amulet of exactly this pattern as 'Amulet case (for child)'.[2]

[1]Kayser, S, & Schoenberger, G, *Jewish ceremonial art* [etc.]. Philadelphia, Jewish Publication Society of America, 1955, p. 148, no. 160, pl. lxxxi.
[2]Spertus Museum of Judaica. *Magic and Superstition in the Jewish tradition.* Text by Marcia Reines Josephy. Chicago, Spertus Museum of Judaica, 1975, no. 179, p. [69].

77 Amulet (*kemi'ah*)

M492–1956 (Metalwork)
Height 9.5 cm × width 9 cm
Italian (from Bologna): 17th century

Amulet of silver-filigree, square-shaped with filigree column and pyramidal pinnacle at each end. Formed of filigree scroll-work and surmounted by a filigree fleur-de-lis. Suspension ring on top.

Prov.: Hildburgh Bequest (ex-Hildburgh loan 5134).

77 Amulet (*kemi'ah*). M492–1956

78 Amulet (*kemi'ah*)

M493–1956 (Metalwork)
Height 8.5 cm × width 7 cm
Italian (from Bologna): 17th century

Square silver amulet with turned moulded columns at each end and a pediment of cast and pierced scrollwork, pierced at the top for suspension. Engraved on each face is a round-headed arch over two abbreviated inscriptions; שדי (*Shaddai*, Almighty) on one face, and לקי [יהוה קויתי לישועתך] (the initial letters from Genesis 49, 18: 'I have waited for thy salvation, O Lord') on the other face (shown here).

Prov.: Hildburgh Bequest (ex-Hildburgh loan 5135).

Notes: Compare with examples in the Feuchtwanger collection[1] and the Jewish Museum.[2]

[1]Shachar, I, *Jewish tradition in art: the Feuchtwanger collection of Judaica.* Jerusalem, Israel Museum, 1981, no. 800, pp. 251–2.
[2]Barnett, R D, *Catalogue of the permanent and loan collections* [etc.]. London, Jewish Museum, 1974, p. 116, no. 621 and pl. clxiv.

78 Amulet (*kemi'ah*). M493–1956

79 Miniature prayer book

MSL513–1868 (National Art Library)
Height 6.7 cm × width 4.8 cm
Austrian (written in Vienna): [5]507,
1746–7 CE

Miniature prayer book of the Amsterdam type, written in cursive, rabbinic and square script by the scribe Aaron Schrieber (Herlingen) of Gewitsch, also known as Aharon ben Benyamin Ze'ev (with additions in other hands). Hebrew manuscript of 27 folios (originally 30), with two leaves of plain paper and end-papers (covered in green watered silk) at the front and back: The title is: סדר ברכת המזון עם ברכת הנתנין: קליאת שמע בלילה על סמיטה: ושלש מצות לנשים

> (Grace after a meal, prayers before retiring to bed at night, three directives for women [etc.]....Made here in Vienna by the hand of Aaron Schreiber Herlingen. In the year [5]507 of the abbreviated era)

An addition in another hand appears in the cartouche at the foot of the page recording a wedding day in the month of *Ellul* (August–September) in the year '[5]545 of the abbreviated era [1784 CE]'. A note in a third hand, in the bottom margin, reads: ה"זלמן בן "במא"ר זל" מבערלין' (Zalman ben Meir, of blessed memory, of Berlin).

The binding is in the form of tortoiseshell boards with two clasps and corner ornaments of silver-gilt filigree made in a leaf pattern. Silver-gilt inlay on the front cover incorporates floral scrolls, two birds with beaks joined and heart and flame motifs. There is a small floral scroll inlaid on the back cover.

The book contains 13 coloured miniature illustrations, including the title page, and eight decorated words or panels (five coloured). The pictorial illustrations, all half-page with the exception of the title page, are arranged as follows.

> *Title page* (full-page illustration). Text contained within central space flanked by the figures of Moses and Aaron. Above is a scrolled cartouche containing the abbreviation ז"ה"ל"צ"י"ב"

('This is the gate of the Lord into which the righteous shall enter'; Psalm 118, 20), with a lighted lamp on either side. At the bottom of the page in a cartouche, supported by two *amorini*, is a poorly worded inscription in a hand different from that of the scribe. It would appear that an original dedication has been removed and a new one added to the damaged surface of the parchment.

Fo. 5. Judith and Holofernes: a servant girl holds open a sack into which Judith is dropping the severed head of Holofernes.

Fo. 6. Two clown-like figures caper beneath the gibbets on which Haman and his sons are being hanged.

Fo. 13 (back). A walled medieval city, under a cloud-filled sky rent by lightning flashes, accompanying the prayer to be said on hearing thunder.

Fo. 14. A king seated upon his throne flanked by two guards holding halberds, and approached by a bowing courtier; to illustrate the prayer to be said on seeing a king and his court.

Fo. 14 (back). Two dwarfs and an African and Asian giant stand upon a beach; to accompany the prayer to said upon seeing strangely formed persons, such as giants and dwarfs.

Fo. 15. A young woman stands before a seated older woman and a man in dark clothes [a doctor?]; on the same page as the prayer for the sick.

Fo. 15 (back). Two women making *ḥallot*, plus the appropriate benediction.

Fo. 17. A young woman in a bath (to symbolise a *mikveh*, or ritual bath?) which is being filled with water from a wooden jug by a maid; accompanied by the prayer said on the ending of menstruation.

Fo. 17 (back). A woman lights the Sabbath candles with a taper; plus the appropriate prayer.

Fo. 18. A mother sits on the edge of a bed reading to a child in a nearby cradle; on the same page is the night prayer for young children.

Fo. 24. Solomon reclining upon a four-poster bed faced by a soldier in half-armour, while other armed knights, representing the 60 heroes of Israel, are depicted in the background.

Fo. 27 (back). Four young women walk along a river bank or the sea-shore, with a walled town in the background; this image is drawn to accompany the prayer for the casting out of sin (into the water).

Prov.: Formerly in the possession of Zalman ben Meir, Berlin. Purchased for 12 guineas (£12.60) from Mr Caspari, 10 March 1868.

Notes: There are many prayer books of this type in both public and private collections. For a detailed summary, and a brief note on Aaron Schreiber, see the article by E Namenyi.[1] The two leaves of parchment forming the first and last pages of the final gathering (i.e. between ff. 24 and 25, and following f. 27) are missing, having been removed with a razor-edged blade. Sufficient of the final folio remains to show that it contained manuscript notes in Roman script, possibly a more detailed provenance. The tortoiseshell cover, with its twin motifs of love-birds and blazing hearts, was probably added in 1784 at the same time that the alteration, recording a wedding day, was added to the foot of the title page, and this prayer book was almost certainly given as a wedding present by a bridegroom to his bride.

[1]Namenyi, E, 'La miniature juive au XVIIe et au XVIIIe siècle'. In: *Revue des études juives*, 1957, XVI (new series), pp. 27–69.

PART IV
Costumes Worn by Jewish People

The costumes held in the V&A seem to provide support for the belief stated in the de-luxe edition of the Anglo-Jewish historical exhibition catalogue that 'it is more correct to speak of a geography rather than a history'[1] when it comes to Jewish art and artefacts.

As a general rule Jewish communities adopted the patterns of dress current in the areas in which they resided. The exceptions to this rule apply only to garments like the *tallit* (prayer shawl), used for religious services, and to special groups within Judaism, such as the *Ḥassidim*, who have retained older or more traditional styles of dress for religious or doctrinal reasons.

Most of the ornate and colourful pieces of costume in the Textiles Department collection are from oriental or north African Sephardic communities, and of the 21 catalogue entries in this section no fewer than 12 seem to be items of bridal wear.

The first 18 items are of womens' attire. The final three entries are male costumes.

[1] Royal Albert Hall. *Catalogue of the Anglo-Jewish historical exhibition.* Publications of the Exhibition Committee IV. London, Royal Albert Hall, 1st ed., 1887; de-luxe ed., 1888, p. 83.

80 Bridal shawl

213–1872 (Textiles)
85 cm × 83 cm
German or Austrian: 18th or 19th century

Shawl for a Jewish bride. White silk gauze, embroidered with sprigs, and a border of flowers in coloured silks and gold thread.

Prov.: Purchased from A Pickert of Nuremberg, 28 November 1871.

Notes: Purchased on the report of Sir M D Wyatt. A revised description by A S Cole in 1888 suggested that the flowers worked into the borders were Turkish in style, and this item was compared with the shawl at cat. no. 81.

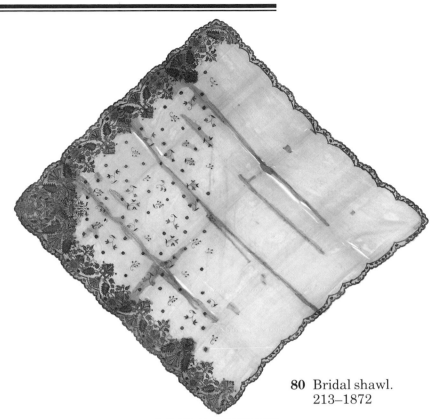

80 Bridal shawl.
213–1872

81 Bridal shawl

612–1872 (Textiles)
79 cm sq.
German or Austrian: 18th or 19th century

Shawl of green silk gauze, for a Jewish bride, embroidered along two edges of the fabric with a gold fringe on silver-tinsel, together with a border of flowers in coloured silks enriched in the centres with gold and tinsel.

Prov.: Purchased from A Pickert of Nuremberg, 28 November 1871.

Notes: As for cat. no. 80.

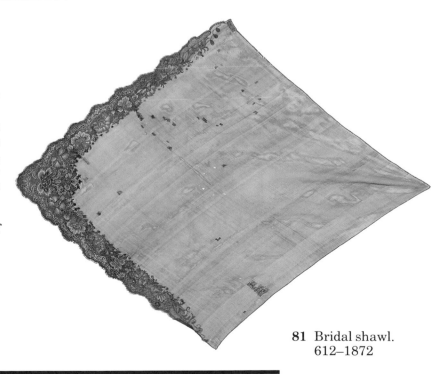

81 Bridal shawl.
612–1872

82 Robe and jacket

519, a & b-1908 (Textiles)
Gown: length 152.5 cm × width 147.5 cm;
jacket: length 63.5 cm × width (at base)
12.5 cm; head-dress: height 89 cm × width
(at base) 12.5 cm
Tunisian: mid-19th century

Robe and jacket from Tunisia, consisting of
a dark blue velvet robe and crimson velvet
jacket, both embroidered with silver-gilt
and silver thread. A frame for a head-dress
of silver formed part of the same gift.

Prov.: Gift of Madame Blumenthal, 12
October 1908.

Notes: Notes accompanying the first regis-
ter entry state: 'The head-dress is older
than the dress, which was mid *c.*1860–1870

and represents the costume of a rich Tuni-
sian Jewess. The jacket has eight conical
buttons on the front and twelve on each
sleeve.' A detailed description of the cos-
tume was also appended: 'The gown of blue
velvet is cut straight, with openings at the
sides for the arms: it is embroidered round
the neck and the openings with conven-
tionalised floral patterns, forming a point
in front and two sprays behind. The jacket
of crimson velvet is embroidered down the
sleeves with geometrical and leaf patterns,
and is further decorated with broad stripes.
The frame for the head-dress is conical,
with a cap-shaped base: it is made up of
thin carving and interlacing stems, some
waved, and some used to enclose a veil.'

83 Ceremonial costume (*keswa el-k'bira*)

T174–1912 (Textiles)
Length 56 cm × width (greatest) 150 cm
Moroccan (acquired in Tetuan): 19th cen-
tury

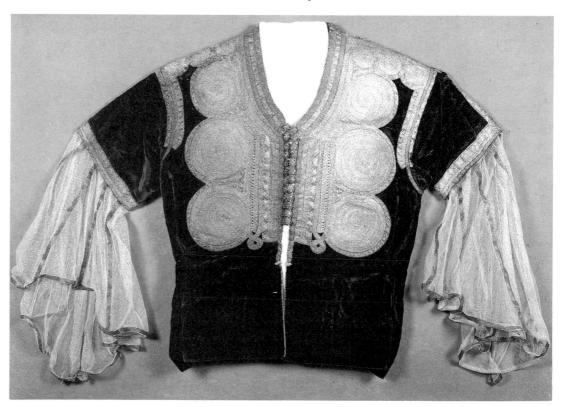

83 Ceremonial
costume (*keswa
el-k'bira*).
T174–1912

Ceremonial jacket (*gombaiz*) worn by a woman from the Moroccan Jewish community. Dark blue velvet decorated with applied silver-gilt braid upon the front, shoulders and sleeve ends, and provided with long ruffles of machine-made net and buttons of silver-filigree. Cut square, with short sleeves; low at the neck, and open down the front. Long and wide ruffles decorated with stripes and border in gold. The pattern, formed by the braid, consists of geometrical figures, chiefly medallions filled with spiral ornament. It is lined with coarse linen, with an inner border, partly striped, of coloured silks. There are 12 filigree buttons down each side of the front.

Prov.: Gift of Miss F L Gilbard.

Notes: Cat. nos 83–92 were all given by the same donor and some, if not all, of them form part of the same ensemble; this was almost certainly a bridal costume (*keswa el-k'bira* or a costume for another ceremonial occasion.[1] The item described here is a *gombaiz*, an open corselet with short sleeves, and cat. no. 84 is the *k'taf* or *punta* worn inside the corselet. The *jeltita*, or fold-around velvet skirt, embellished with bands of gold embroidery which would complete this outfit is missing.

[1]See Israel Museum, *Ḥayei ha-Yehudim be-Morokko.* Jerusalem, Israel Museum, 1983, pp. 202–6. See also Israel Museum, *Treasures of the Israel Museum.* Jerusalem, Israel Museum, 1985, col. pl. 51.

84 Bodice

T175–1912 (Textiles)
Length 47 cm × width 33 cm
Moroccan (acquired in Tetuan): 19th century

Bodice (*k'taf* or *punta*) of white linen, with two applied panels in red velvet, and embroidery in silver-gilt thread. The bodice is square-cut, sleeveless and completely open at the back. It has a collar which is slightly open at the front and provided with a pair of silver-filigree buttons and buttonholes of silver-gilt thread. The pattern consists of rows of geometrical figures (hexagons and interlacing zigzig bands) and latticework diaper of lozenges of small quatrefoils. The garment is provided with two pairs of tying strings. It formed part of the costume of a woman from the Jewish community of Morocco.

Prov.: Gift of Miss F L Gilbard.

Notes: See cat. no. 83.

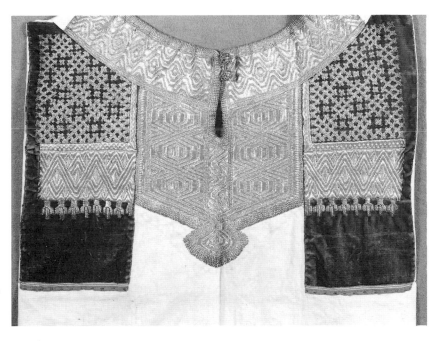

84 Bodice.
T175–1912

85 Veil

T176–1912 (Textiles)
Length (excluding fringes) 80 cm × width 24 cm
Moroccan (acquired in Tetuan): 19th century

A veil woven in silver-gilt thread and red and black silks, slightly pleated, with red silk fringes. The garment is of double thickness and is decorated with horizontal rows of thin wavy stripes, generally at wide intervals, in black upon a gold ground. There are also three bands of plain red silk. It is provided with a pair of tying strings of plaited crimson silk. Part of the costume of a woman from the Jewish community of Morocco.

Prov.: Gift of Miss F L Gilbard.

Notes: See cat. no. 83.

86 Girdle

T177–1912 (Textiles)
Length 240 cm × width 24 cm
Moroccan (acquired in Tetuan): 19th century

Girdle of brocaded silks, woven in coloured silks and silver-gilt thread, with long fringes of blue, green and red silks. The garment is of double thickness. The pattern is divided into compartments of different lengths, filled with geometrical devices, such as quatrefoils and lozenges, and floral designs partly in horizontal stripes. Part of the costume of a woman from the Jewish community of Morocco.

Prov.: Gift of Miss F L Gilbard.

Notes: See cat. no. 83.

87 Sash

T178–1912 (Textiles)
Length 84 cm × width 76 cm
Moroccan (acquired in Tetuan): 19th century

Sash, woven in crimson and yellow silk and silver-gilt stripes, with narrow fringes of crimson silk. The crimson ground is marked with three broad and 24 narrow yellow stripes, the latter in two sets of 12 each. The broad stripes are filled with a repeating pattern of cones and small leafy stems, and each of the narrow stripes is filled with interlacing ornament. Part of the costume of a woman from the Jewish community of Morocco.

Prov.: Gift of Miss F L Gilbard.

Notes: See cat. no. 83.

88 Oblong silk panel

T179–1912 (Textiles)
Length (excluding fringes) 57 cm × width
26.5 cm
Moroccan (acquired in Tetuan): 19th century

Oblong panel of pink and yellow silk plus silver-gilt strips, with fringes of twisted silver thread and silver-gilt thread. Part of the costume of a woman from the Jewish community of Morocco.

Prov.: Gift from Miss F L Gilbard.

Notes: See cat. no. 83.

89 Sash

T180–1912 (Textiles)
Length 126.5 cm × width 53.5 cm
Moroccan (acquired in Tetuan): 19th century

Sash(?) woven in plain red silk. Part of the costume of a woman from the Jewish community of Morocco.

Prov.: Gift of Miss F L Gilbard.

Notes: See cat. no. 83.

90 Pair of slippers

T181 & a–1912 (Textiles)
Both slippers are 25.5 cm long and 7.5 cm wide
Moroccan (acquired in Tetuan): 19th century

A pair of slippers of 'French Morocco', embroidered at the toes with silver-gilt wire; each has a red silk pom-pom. The toes are turned up and pointed. The embroidered pattern consists in each case of two conventional flower motifs on a ground of spreading foliage. Part of the costume of a woman belonging to the Jewish community of Morocco.

Prov.: Gift of Miss F L Gilbard.

Notes: See cat. no. 83.

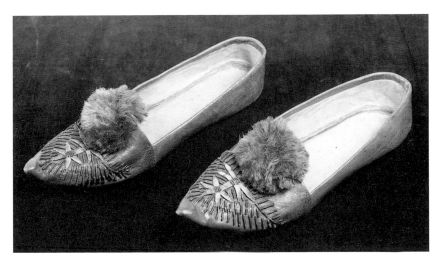

90 Pair of slippers. T181/T181a–1912

91 Necklace

T182–1912 (Textiles)
Length 50 cm; depth 5 cm
Moroccan (acquired in Tetuan): 19th century

A necklace made up of circular silver-gilt discs, with Arabic inscriptions on both sides, linked together. The discs are arranged in three rows, with the smallest at the bottom. Part of the costume of a woman belonging to the Jewish community of Morocco.

Prov.: Gift of Miss F L Gilbard.

Notes: See cat. no. 83.

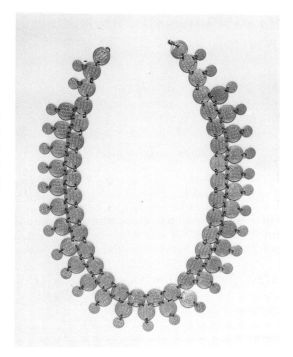

91 Necklace.
T182–1912

92 Necklace

T183–1912 (Textiles)
Length 70 cm × depth 5 cm
Moroccan (acquired in Tetuan): 19th century.

A necklace made up of plaited silver-gilt thread with a row of simulated coins of gilt-metal, with Arabic inscriptions on both sides. The necklace consists of an irregular loosely plaited net with a narrow braid above, and a single pendant row of discs. Part of the costume of a woman from the Jewish community of Morocco.

Prov.: Gift of Miss F L Gilbard.

Notes: See cat. no. 83.

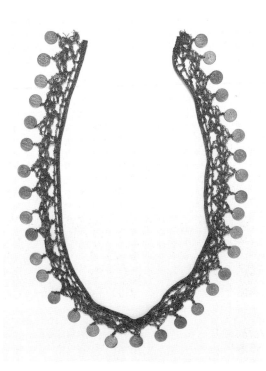

92 Necklace.
T183–1912

93 Robe (*am al-kasa*)

T439–1967 (Textiles)
Iraq: *c.*1870

An Iraqi dress (*am al-kasa*) made from white silk (*p'ta*) with a brocaded pattern of narrow alternating rows of gilt pine pattern motifs with green foliage. The garment is full length, fitted to the figure, with a low-cut neck and long sleeves widening towards the cuff, where they are slit. The skirt is slightly gathered at the centre back. There are rows of gilt braids around the neck, armholes, cuffs and front opening, and the neck and cuffs are edged with red and gold looped braid. The seam at the centre back is covered with gold braid, while the cuffs are trimmed with large diamond-shaped wound-gilt buttons. The garment fastens along its whole length with small self-covered buttons. The bodice (*zik*) is lined with white cotton; the front is laced with red silk. From the Jewish community of Iraq.

Prov.: Received from Mrs E Ramah-Judah, London.

Notes: This dress is similar to one belonging to the Iraqi Jews Traditional Culture Center, Or Yehuda, Israel (no. 426.85). This type of dress was known as *am al-kasa* or grandmother's dress, and often had long, deep pockets in which sweets for children could be hidden. The low-cut rounded neckline usually had a light chemise underneath, and the rectangular bodice allowed for easy breast-feeding; the style is similar to Turkish costume of the same period.

94 Woman's gown

T440–1967 (Textiles)
Iraq: *c.*1870

A woman's gown, from Iraq (material made in India), formerly owned by one of the Iraqi Jewish community, made from a material known to the Iraqis as *menarus*: black satin brocaded in gold with vertical floral trails, and floral feather sprays in between. The robe is full length, fitted to the figure, with a low-cut neckline and long sleeves widening towards the cuff, where there is a slit. The waist seam and the skirt are gathered at the centre back. Gilt braid is used to trim the cuffs and to create a diamond-shaped panel on the back of the bodice. Looped scarlet braid lines the neck of the garment, and the shoulder seams are piped in scarlet silk. There are buttonholes down the centre front and self-covered buttons from the waist to hem, with worked stud holes above. The skirt and cuffs are faced with scarlet silk, and the gown is lined from the waist with white cotton.

Prov.: Received from Mrs E Ramah-Judah, London.

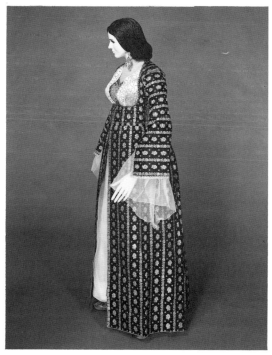

94 Woman's gown.
T440–1967

Notes: Similar to an Indian gown (no. 185.83) owned by the Iraqi Jews Traditional Cultural Center, Or Yehuda, Israel.

95 Woman's trousers

T441–1967 (Textiles)
Iraq (Kurdistan): *c*.1870

Woman's trousers, from the Iraqi Jewish community, made of shot green and golden-brown silk and gored to flare widely from waist to hem, where they have a patchwork border of triangular motifs made from green, red, yellow, purple and pale-blue silk. There is a red silk waistband through which is slotted a netted pale green girdle with a knotted tassel.

Prov.: Received from Mrs E Ramah-Judah, London.

Notes: Compare with a similar item illustrated in Israel Museum, *Jews of Kurdistan: daily life, customs, arts and crafts* (in Hebrew). Exhibition Catalogue 216. Jerusalem, Israel Museum, 1981, pp. 160–1.

96 Woman's bodice

T442–1967 (Textiles)
Iraq: *c*.1870

A woman's bodice from Iraq, formerly owned by one of the Iraqi Jewish community. Made from Indian embroidered muslin with a wide pointed neckline and short straight sleeves and extending to just below the bust. It fastens at the centre back with cords at neck and waist. The front panel is shaped to the breast and made from red satin, with an applied formal design of flowers and peacocks in gilt sequins and applied green and blue satin. Red cotton is used to bind the seams and to form the sleeve borders, and there is plaited gold braid around the neckline and sleeves.

Prov.: Received from Mrs E Ramah-Judah, London.

Notes: Similar to a bodice (no. 182.83) owned by the Iraqi Jews Traditional Cultural Center, Or Yehuda, Israel.

97 Woman's bodice

T443–1967 (Textiles)
Iraq (Baghdad): *c*.1870

A woman's bodice from Iraq (imported from India), formerly owned by one of the Iraqi Jewish community. Made from white tambour-embroidered net with a wide neckline and short straight sleeves and extending to just below the bust. It fastens at the centre back with cords at neck and waist. The front panel is shaped to the breast and made from green satin, with a gilt sequin and purl pattern of undulating floral trails and rosettes between diagonal lines. All the edges, including the sleeve border, are bound with scarlet cotton and there is black and red plaited braid stitched around the sleeves and neck. The lining of the bust is of red cotton.

Prov.: Received from Mrs E Ramah-Judah, London.

Notes: Similar to a bodice (no. 182.83) owned by the Iraqi Jews Traditional Cultural Center, Or Yehuda, Israel.

98 Woman's housedress (*dishdasha*)

T444–1967 (Textiles)
Iraq: *c.*1870

A woman's housedress (*dishdasha*), from the Iraqi Jewish community. Made from sheer muslin, ankle length, with straight-cut front, side panels gored from the under-arm and straight set sleeves which widen towards the wrist. The neck is low and round, and the centre front opening has a border pattern of applied white cotton flowers and circular motifs in a dentillated border. There are circular motifs at the corners of the neck.

Prov.: Received from Mrs E Ramah-Judah, London.

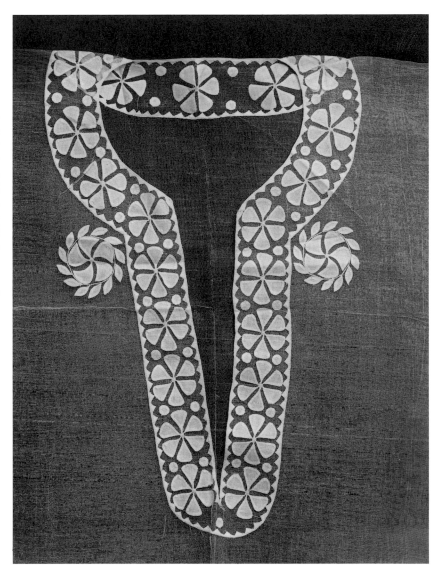

98 Woman's housedress (*dishdasha*). T444–1967

99 Man's jacket (*z'ikma*)

T445–1967 (Textiles)
Iraq: *c.*1870

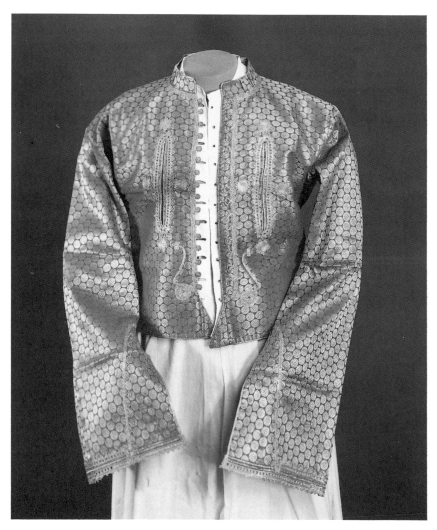

Man's jacket (*z'ikma*), from the Iraqi Jewish community. Made from pink silk with circular brocaded motifs. It is waist length with a narrow band collar and long sleeves which widen towards the split cuff. There are vertical pockets on the breast. The front fastens with loops and gilt wire buttons, and there are slits at the side seams and at the hips, and an obtuse angle at the bottom front corners. The jacket is lined with white cotton.

Prov.: Received from Mrs E Ramah-Judah, London.

Notes: A later form of this jacket, known as *sidre'e*, forms part of the collection of the Iraqi Jews Traditional Cultural Center, Or Yehuda, Israel (no. 157.82). An elderly informant (aged over 80) to the Cultural Center, formerly of Basra, identified the design of the V&A jacket as of the type known as *menes*.

99 Man's jacket
(*z'ikma*).
T445–1967

106

100 Man's waistcoat

T446–1967 (Textiles)
Iraq: c.1870

Man's waistcoat of white figured linen from the Iraqi Jewish community; waist length, sleeveless, with a round neck and tucked collar. It fastens down the centre front with stud buttons of which only the holes remain. There is a projecting angle at the bottom, and the pockets are welted and straight.

Prov.: Received from Mrs E Ramah-Judah, London.

101 Man's costume

T11, a–l–1963 (Textiles)
Silk sash: length (without fringe) 452 cm × with 97 cm; underpants: length (outer leg) 71 cm × width (at waist) 204 cm; tying cord for trousers: length (including tassels) 176 cm; short wooden stick: length 22.5 cm; purse: length (including tassel) 51 cm; waistcoat: length (centre back) 59 cm; jerkin: length (centre back) 54 cm; jacket: length (centre back) 51.5 cm; trousers: length (outside leg) 75 cm × width (at waist) 165 cm; *burnous*: length (centre back, neck to hem) 141 cm
Tunisia: 1890

Man's costume consisting of turban-scarf, waistcoat, sash, jerkin, jacket, trousers, cloak, underpants, purse and cotton stockings. The photograph (c.1890) shows the original owner wearing the costume. The 13 items which make up this gift are described below.

a A turban-scarf of yellow silk and fine white cotton woven in a pattern of checks and stripes, with a deep leaf and cone border pattern at each end, where there is also a short sparse fringe made from untwisted warp threads.

b Underpants of white cotton cut in the traditional style of Turkish breeches; see under *i* below. The waist is finished with a 1 in. wide hem, and there are openings in the front and back seam to take a drawstring. The narrow part of the leg is lined with a finer white cotton. The drawstring openings, the inner seams of the legs and the knee cuffs are trimmed with white cotton braid.

c Tying cord for trousers. Sprang woven in white cotton and divided at each end into two tassels.

d Short wooden stick, pointed at the top, slightly tapered and rounded at the bottom. Carved at the top and threaded on a cord loop. Said to have been used for threading the trouser cord.

e Purse of dark red silk made of a sprang woven band folded in half, joined at the edges and finished with a tassel.

The principal garments of the suit, consisting of a jacket, waistcoat, vest and trousers, are made of fine cream-coloured silk and wool cloth, lined with a biscuit-coloured cotton and extensively decorated with beige silk braid on the outside. The inner edges are trimmed with yellow silk braid with stripes patterned in red on white and red on blue.

f A sleeveless waistcoat, slightly shaped at the shoulders, with a vertical slit at the lower edge on each side. Trimmed on all edges and down the front with beige braid. The front edge has 23 pear-shaped buttons covered with silk thread. The corresponding loops on the left front are also made of braid but sewn down to form a decorative border; the buttons cannot be fastened. Braid ties hold the waistcoat edges together below the buttons. There are two patch pockets on the inside of the garment made of lining material and crimson damask. The inner front edges and pocket tops are trimmed with yellow striped braid.

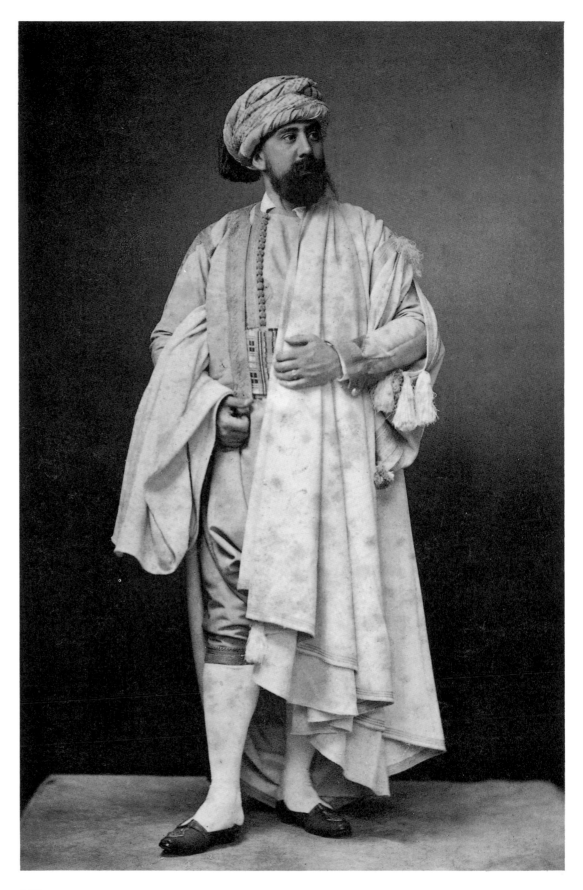

101 Man's costume.
T11, a – l– 1963

108

g Sleeveless vest, or jerkin, with a round neck, no front opening and a vertical slit at the lower edge on each side; fastened with two buttons on one shoulder. The garment is the same back and front and is, therefore, reversible. There is plain trimming of beige braid at the neck, armholes and lower edge. On the right breast on each side is a watch pocket with a crescent-shaped opening set in a small sharply pointed decorative panel.

h Sleeved collarless jacket with an unfastened edge-to-edge front opening. The sleeves are set straight to the shoulder with an underarm gusset. All edges and seams are heavily decorated with beige braid. There are also pointed decorative panels on the shoulders, the back of the arms and the centre back, together with rectangular areas of decoration on each side, between the front and back side seams. The cuffs are open, cut away at the underarm seam, and provided with ten metal buttons (originally covered with silk?) The opposite edge of the cuff has braid loops, sewn down as on the waistcoat front. The outside of the cuff is, in addition, decorated with gold braid, while the inside is lined with crimson silk damask and edged with gold and red braid. There are two patch pockets made of lining and red silk damask, inside the jacket. The pocket tops and all the inner edges are trimmed with yellow striped braid.

i The trousers are cut in the traditional Turkish manner. A very wide centre panel, folded at the bottom edge, forms the main part of the body, while narrower side panels, seamed to the selvages of this piece, form the legs. The openings at the lower corners reach the knees. A side waistband of lining cotton is slit front and back to allow for a drawstring, the slits being trimmed with braid. Two patch pockets of lining material are attached to the inside at each side. Access to the pockets is by a slit in the side panels, ornamented with beige braid. A short length of yellow striped braid attached to the pocket is visible behind the slit. All seams and kneecuffs are ornamented with braid. The trousers are lined in the lower half of the legs only, and the inside of the cuff is edged with yellow striped braid.

j A semicircular *burnous*, or cloak, of pink felted wool cloth, cut without a seam. There is a flat hood of the same material, attached at the neck. Trimmed on the hood, front edges and hem with pink silk braid. Pink tassels are attached to the two top corners of the hood and the two lower front corners of the cloak. A double triangular insertion trimmed with braid and bands of sprang forms a permanent join at the front opening at the neck, so that the cloak must be pulled over the head.

k,l A pair of biscuit coloured cotton stockings.

Prov.: Gift from Mr J Sassoon, London. The costume is said to have been given to the donor's grandfather, Gabriel Jacques von Rosenberg, by the Bey of Tunis in 1890.

Notes: This costume is remarkably similar to that worn by Mordecai as drawn on the Esther scroll (cat. no. 34) which was produced for the Sephardic community of Amsterdam in 1643.

PART V
Miscellaneous Items and Doubtful or Specious Objects

This section contains two categories of item. The first are art objects which have some bearing upon Anglo-Jewish social and art history but are not used for ritual purposes. The second group is composed of items about which there is some doubt; either about their use, their suitability for ritual purposes or their attributions. In only one case does an object appear to have been tampered with in what seems to have been a deliberate attempt to produce a fake (see cat. no. 107).

Into the first category fall two pieces of glasswork by the Jacobs family of Bristol, and three dummy board figures showing Jewish characters. The blue bowl (cat. no. 102) and the decanter (cat. no. 103) show that Jewish craftsmen were free to practise their trades by the late 18th century, whereas the dummy board images reveal the reverence felt towards the Jewish Patriarchs, Moses and Aaron. These (cat. nos 105 and 106) should be compared with cat. no. 104, which demonstrates the propensity to caricature contemporary Jewish figures, in this case a pedlar, in the early 1800s.

The most interesting item in the category of doubtful objects is the spice box/reliquary (cat. no. 107) This late 15th-century north Italian copper-gilt object manifests most of the characteristics of a spice box, except for the poorly formed decorative element approximating to the shape of a cross which surmounts the tower. The small piece has a conical spire-like cover surmounted by an orb with a crudely formed cross. Close inspection reveals brazing marks immediately below the orb on which the cross sits, indicating that the object has been repaired or altered; this cross is badly made in comparison with other detailing. The spire itself is only loosely fixed to the body of the piece by pins; a reliquary would surely have been more securely attached, probably even sealed. A spice box, on the other hand, would certainly require ease of access to the hollow interior, in this case by a removable lid. It seems likely that this object has, at some stage in its history, been altered to pass as a reliquary in order to enhance its selling price. It is only in comparatively recent times that Jewish ritual objects have started to command high prices in the salerooms.

The silver-filigree *yad*, or *Torah* pointer (cat. no. 108), which is almost certainly Italian, appears to have been adapted from a 17th-century pomander with late 18th- or 19th-century additions. This gives rise to some doubt about whether or not this is a bona fide pointer.

Finally, there is the gilt bronze panel (cat. no. 109), representing the figure of Moses in the Wilderness of Sinai. It presents an interesting museum mystery. It was purchased from J Sassoon in 1887 and, as can be seen in the early photograph reproduced in this catalogue, which is the only record of its original condition, contained two repoussé silver panels with the sacred name, the abbreviated form of the ten commandments and a border of foliage and grape clusters; it was, the records reveal, signed and dated 'P Cernezola [?] 1671'. The silver panels have been removed since the panel's arrival in the museum and, whether stolen or mislaid, are now unavailable for study. The bronze plaque and panel still remaining are from Italy and date from the late 18th or early 19th century. The photograph indicates that the craftsman used Sephardic letter forms, either from north Africa or the eastern Mediterranean, as his model.

The object was originally described as being a decorative plaque placed over an *Aron-ha-Kodesh* (Ark of the Law), in which *Torah* scrolls are stored in synagogues. Grooves have been cut into the back of the frame on the lower edges of the side struts and also on the bottom edge in order to fit the panel to a larger piece of furniture. The absence of the silver panels renders it impossible to verify whether they were originally intended for a Jewish ritual object. The gilt-bronze panel, however, was obviously intended for some other, non-Jewish, function; probably to decorate a church. The removal of the left-hand portion of the decalogue has revealed that the word and Roman numeral 'EXODE XX' have been engraved on the bronze panel. Although accepted into the museum as a bona fide Jewish item and possibly, judging by his surname, obtained by the vendor under the same misapprehension, it is most unlikely that it was ever used to decorate a synagogue.

102 Bowl

C49–1936 (Ceramics)
Height 10 cm
English (Bristol), made by Isaac Jacobs:
c.1805

Cylindrical blue glass bowl, with projecting lips on opposite sides of the rim, used at the table for rinsing wine glasses in the period before it became common to set a large number of different glasses. Around the rim is a broad meander or key pattern in gold, broken by a small festoon under each lip. Signed under the base 'I. Jacobs Bristol', in gold.

Prov.: Gift from J L Brodie, London, in memory of Eleonora T Brodie.

Lit.: Victoria & Albert Museum, *Catalogue of an exhibition of Anglo-Jewish art and history* [etc.]. London, Victoria & Albert Museum, 1956, no. 399, p. 58.

Notes: Described as a wine-glass cooler in the departmental register. Isaac Jacobs referred to a gilt coloured glass of this type in an advertisement of 1806. A stand for a finger-bowl, similarly decorated and marked, is in the collection of Bristol Art Gallery, and a second example is in the Peterborough Museum. Yet another blue glass bowl with a gold meander pattern, but of slightly different shape, is in the collection of the Aberdeen Museum and Art Gallery.

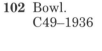

102 Bowl.
C49–1936

103 Decanter

C320–1926 (Ceramics)
Height 24 cm × diameter 10 cm
English (Bristol), probably by Lazarus Jacobs: late 18th century

Decanter of blue glass with cut and gilt decoration. The body is tapered, with a fluted base; the neck is cut in panels and flat rings. There is grape and vine decoration around the neck. It is inscribed with the word 'PORT' and traversed by bands of formal ornament. The stopper is missing.

Prov.: Bequest of Lieutenant-Colonel G B Croft-Lyons, FSA.

103 Decanter.
C320–1926

104 Dummy board figure

W89–1926 (Woodwork)
Height 173 cm × width 57 cm
English: about 1820

Dummy board figure: Jewish pedlar. Carved wooden outline of pedlar standing full face, holding an open box of trinkets; painted in oil colours. He wears a black hat, brown coat, green breeches and top boots.

Prov.: Purchased from Messrs Walpole Brothers, 15 Old Bond Street, Bath, for £20.

Lit.: Victoria & Albert Museum, *Catalogue of an exhibition of Anglo-Jewish art and history* [etc.]. London, Victoria & Albert Museum, 1956, p. 60, no. 433.

Notes: Compare with the similar example in the Jewish Museum.[1]

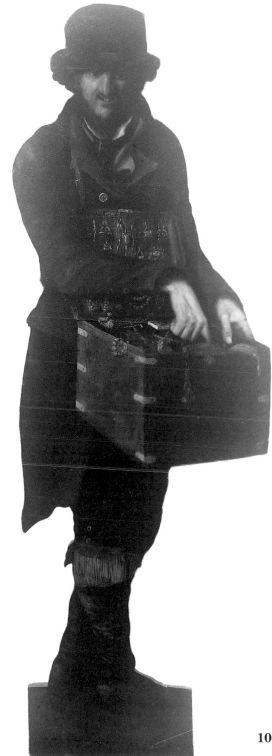

[1]Barnett, R D, *Catalogue of the permanent and loan collections* [etc.]. London, Jewish Museum, 1974, no. 699, p. 141, pl. clxxvii. This entry mentions another example in Hatfield House, Hertfordshire.

104 Dummy board figure. W89–1926

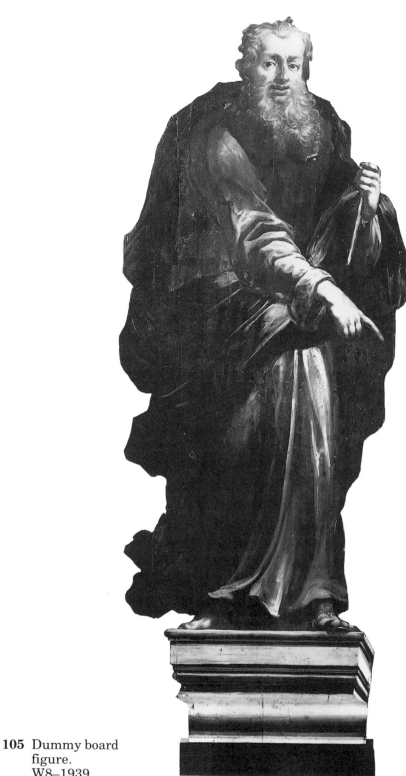

105 Dummy board figure

W8–1939 (Woodwork)
Height 232 cm × width 74 cm
English: late 18th century

Dummy board figure: Moses. Pinewood board of carved outline, painted in oil colours, the head facing front with a brown beard framing the face. The figure is depicted wearing a flowing blue cloak over a yellow robe. The right hand holds a spike, or possibly a staff, which has at some stage been broken. The feet, wearing sandals, are depicted upon a base which is painted to represent the moulded capital of a column, with a triangular section cut away at the bottom.

Prov.: Purchased from Miss Mary F Pattinson, Edgware. This figure and its companion (cat. no. 106), were formerly in St Swithin's London Stone, in a reredos from which they were removed some time towards the end of the 19th century.

Notes: It has been suggested that these figures were the work of Aaron de Chavez,[1] but this is unlikely even though they bear a marked resemblance to those supporting the Tablets of Law in the painting undertaken by Chavez on behalf of the Spanish–Portuguese synagogue (Bevis Marks) in Heanage Lane, London. Chavez undertook his commission for the Bevis Marks in 1675, whereas these figures were not made until the middle decades of the next century.[2]

[1] Aaron de Chavez was a painter of a family which took its name from the Portuguese town of Chaves. He worked in London during the late 17th century, died in 1705 and was buried in the Spanish-Portuguese graveyard in Mile End Road.
[2] For a brief account of the history of Moses and Aaron figures of this type, see Croft-Murray, E, 'A note on the painting of Moses and Aaron' In: Grimwade, A G (*et al.*), *Treasures of a London Temple* [etc.]. London, Taylor's Foreign Press, 1951, pp. 67–8.

105 Dummy board figure. W8–1939

106 Dummy board figure

W9–1939 (Woodwork)
Height 242 cm × width 56 cm
English: late 18th century

Dummy board figure: Aaron. Pinewood board of carved outline, painted in oil colours, the head facing to the right and surmounted by a jewelled turban-like head-dress; the face is framed by a flowing white beard. The figure is depicted wearing a blue over-tunic with a tasselled fringe along the lower edge, beneath which can be seen a white robe which reaches to the floor. The blue tunic decorated with gold embroidery is surmounted by a jewelled breastplate and a multi-coloured sash with gold tassels which is tied around the waist. The right hand is raised to shoulder height and in the left hand is a chain from which is suspended a censer. The feet stand upon a base painted to represent the moulded capital of a column, with a triangular section cut away at the bottom.

Prov.: As for the figure of Moses (cat. no. 105).

Notes: See notes on cat. no. 105.

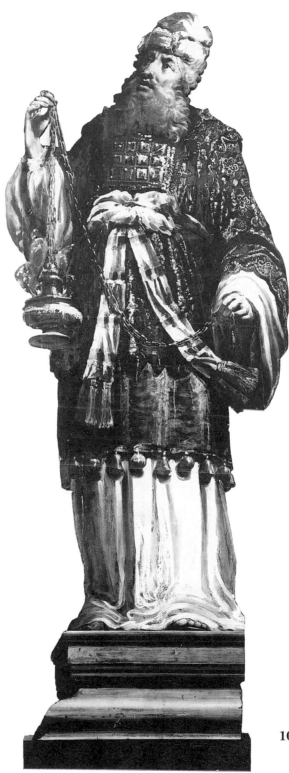

106 Dummy board
figure.
W9–1939

107 Spice box.
M40–1956

107 Spice box

M40–1956 (Metalwork)
Height 19 cm × diameter 5 cm
North Italian: late 15th century

Copper-gilt spice box. The tower is cylindrical with four elaborately pierced tracery windows, separated by twisted columns ending in spires. The conical spire-like cover is surmounted by an orb with a crudely formed cross. The stem is cylindrical with a ball-knop and spreading foot.

Prov.: Hildburgh Bequest (ex-Hildburgh loan 1192).

Notes: This piece manifests most of the characteristics of a spice box except for the poorly formed decorative element approximating to the shape of a cross, which is badly made in comparison with other detailing. Close inspection reveals brazing marks immediately below the orb on which the cross sits, indicating that the object has been repaired or altered. It is possible that this object has, at some stage in its history, been altered to pass as a reliquary in order to enhance its market value.

108 *Torah* pointer (*yad*)

M466–1956 (Metalwork)
Length 23.5 cm × diameter (of ball) 6 cm
Probably Italian: 17th century (with 19th-century additions?)

Silver-filigree *Torah* pointer (*yad*, hand). Central ball, hollow and pierced, engraved with foliage, having an elongated conical handle below and an elongated conical pointer terminating in a cast hand, with deep cuff, above. The whole piece, except the hand, is engraved with bands of foliage. The handle terminates in an eyelet to which a silver chain is attached. It appears to have been adapted from a 17th-century pomander.

Prov.: Hildburgh Bequest (ex-Hildburgh loan 5055).

Notes: The incorporation of a decorated ball in the handle, or at the end of a shaft, is not unusual – see Jewish Museum catalogue,[1] Gutmann[2] and examples from the Musée Cluny.[3] In this instance, however, the ball does seem rather large and it is possible that a 17th-century pomander has been utilised in the construction of a 19th-century *yad*, which in turn causes some doubt about whether this is a bona fide pointer.

[1]Barnett, R D, *Catalogue of the permanent and loan collections* [etc.]. London, Jewish Museum, 1974, nos 148, 149, 152, 153, 156, 169 and 170, pp. 33–5, pls lxvi and lxvii.
[2]Gutmann, J, *Jewish ceremonial art*. New York and London, Yoseloff, 1964, p. 33, figs 15 and 16.
[3]Israel Museum, *Jewish treasures from Paris* [etc.]. Exhibition Catalogue 226. Jerusalem, Israel Museum, 1982, nos 45, 46, 48, 49, 50, 51 and 52, pp. 31–3.

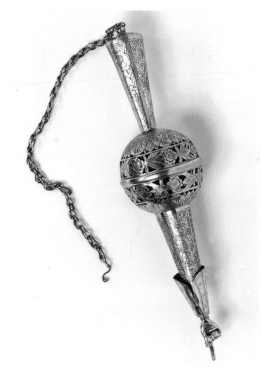

108 *Yad (Torah pointer).*
M466–1956

109 Gilt bronze panel

223–1887 (Metalwork)
Bronze panel and wooden frame (overall): height 26 cm × width 7 cm; silver panels: (est.) height 17 cm × width 7 cm
Gilt bronze plaques: Italian, late 18th or early 19th century; missing silver panels: Italian? 1671?

Oblong bronze panel, repoussé, with the figure of Moses in the Wilderness of Sinai, his hands resting upon the two Tablets of the Law. The latter were originally covered with two repoussé silver panels with the sacred name, the abbreviated form of the ten commandments and a border of foliage and grapeclusters; they were signed and dated 'P. Cernezola [?] *1671*'. These panels have been removed since the item's arrival in the museum and are now missing. They can be seen in an early museum photograph, reproduced here. In the upper right-hand corner of the panel is a smaller image of Moses receiving the tablets on the summit of Mount Sinai. The whole is contained within a black wooden frame, the pediment of which is decorated with a gilt-bronze festoon of fruit. The object was originally described as being a decorative plaque placed over an *Aron ha-Kodesh* (Ark of the Law) in which *Torah* scrolls are stored in synagogues. Grooves have been cut into the back of the frame on the lower edges of the side struts and also on the bottom edge in order to fit the panel to a larger piece of furniture.

Prov.: Purchased from J Sasson (*sic*), London, 15 July 1887.

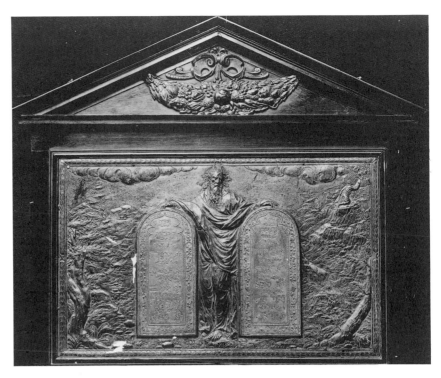

Notes: The absence of the silver panels makes it impossible to verify whether they were originally intended for a Jewish ritual object. The gilt-bronze panel, however, was obviously intended for some other, non-Jewish, function; possibly to decorate a church. The removal of the left-hand portion of the Decalogue has revealed that the word and Roman numeral 'EXODE XX' have been engraved into the bronze panel. It is most unlikely that it was ever used to decorate a synagogue.

109 Gilt bronze panel. 223–1887

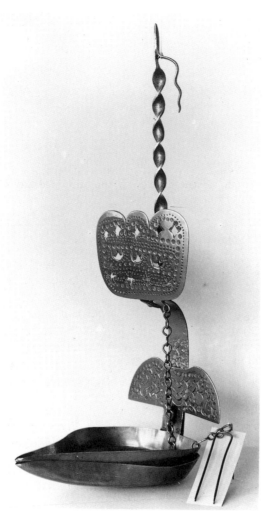

110 Sabbath/synagogue lamp

264 & a–1891 (Metalwork)
Height 35.5 cm × width 16 cm
Netherlands: 18th century

Brass lamp. The oil reservoir is flat and pear-shaped; the back is stamped and perforated, and there is a hook by which it can be suspended plus a pair of tweezers for trimming the wick.

Prov.: Given by Messrs Angus, Craibe & Son, Fine Art Dealers, 159 Queen Street, Glasgow.

Notes: This lamp was one of two given to the museum by the same Glasgow company in 1891, the other being 164–1891 (cat. no. 28), the donors being certain that both lamps had been used for Jewish ritual purposes. Both were originally listed as being *Ḥanukkah* lamps, in the case of the 164–1891 this was obviously the case, but this object is more likely to have been used as a Sabbath lamp, or perhaps to light a synagogue.

GLOSSARY

This glossary is a list of the foreign, mainly Hebrew, words contained in the text, and of certain other terms used.

Arba'ah minim See *etrog*.

AC Latin *anno creationis*, the year of creation. In the Jewish calendar, the reckoning of the date from the supposed day of creation.

Aravah See *etrog*.

Aron ha-Kodesh The Holy Ark. The recess, or cupboard, containing *Torah* scrolls in a synagogue. Also referred to as the *Aron, Aron ha-Brith* (Ark of the Covenant) and, among Ashkenazi communities, the *Hechal*.

Ashkenazim From the old Hebrew word for Germany. It is the name ascribed to the Jews of central, eastern and northern Europe who spoke Yiddish and adhered to the particular traditional liturgical forms and cultural patterns of those areas.

Azei Ḥayyim Trees of Life (sing. *Etz Ḥayyim*). The wooden rollers on which the *Torah* scroll is wound.

Bar Mitzvah The ceremony by which a 13-year-old boy is initiated into the Jewish religious community, signifying that he is thereafter expected to adhere to the precepts of the *Torah*. The central feature of the ceremony is the calling up of the boy to the *bema* in the synagogue to read from the Law.

Bema The reading platform in a synagogue.

Beth ha-knesset Meeting house; Hebrew name for a synagogue.

Beth ha-midrash House of study; alternative Hebrew name for a synagogue.

Beth tefillah House of prayer; another Hebrew name for a synagogue.

B'samim Spices, for the Havdalah ceremony. The spice box itself is often called a *b'samim*.

CE Jewish designation of the Christian calendar (abbreviation of Common Era).

Etrog A citrus fruit. One of the *arba'ah minim* (four species), the other three being the *lulav* (palm branch), *hadas* (myrtle) and aravah (willow) used in the sheaf (*'Omer*) carried during the *Sukkot* (q.v.) ceremonies. A name applied to the silver fruit-shaped container in which the *etrog* is carried.

Ḥadas See etrog.

119

Ḥad gadya	Traditional verses for *Pesach*, often illustrated in the most ornate *Ḥaggadot*. Also known as a kid for two *ẓuẓim* (farthings).
Ḥaggadah	Service recited in the home on Passover eve while the family is sitting at the *seder* (q.v.) table. The book or scroll on which this ritual is written or printed is also called a *Ḥaggadah* (pl *Ḥaggadot*).
Ḥallot	(Sing. *hallah*) Loaves used for Sabbath and festival meals. Often baked in elaborate plaited forms.
Ḥanukkah	Meaning: dedication. The Festival of Lights, extending over a week and culminating in a celebratory meal held on the 25th day of *Kislev* (mid- to late December) to celebrate the victory of Judas Maccabeus over Antiochus Epiphanes and the rededication of the Temple in Jerusalem in the year 165 CE.
Ḥanukkiyah	The *Ḥanukkah* lamp (pl *hanukkiyot*). An eight-nozzled lamp used during the eight days of *Ḥanukkah*. There are usually nine nozzles on these lamps, the ninth being the *shammash* or servitor lamp, from which the other lamps are kindled. See also *menorah*.
Havdalah	Meaning: separation. The ceremony which concludes the Sabbath on Saturday evening and which separates the sacred from the profane.
Ḥechal	See *Aron ha-Kodesh*.
Ḥuppah	The wedding canopy.
Keter Torah	Crown of the Law. A crown-like decorative silver-gilt or silver cap which fits over the *Azei Ḥayyim* (q.v.) when the *Torah* is not in use. Sometimes referred to simply as the *Keter*.
Ketubbah	Marriage contract (pl *ketubbot*).
Kiddush	The prayer recited over the ritual Sabbath wine, hence *Kiddush* cup.
Kodesh	Holy.
Kodesh ha-K'odeshim	Holy of Holies. Originally the inner chamber of the Jerusalem Temple which only the high priests were allowed to enter on *Yom Kippur* (q.v.).
Ladino	The lingua franca of the Sephardim (q.v.), also known as Spaniolit, which is based on medieval Spanish with Hebrew and Arabic additions.
Lulav	See *etrog*.
Mappa	(pl *mappot*) See *wimpel*.
Mazzah	The unleavened bread (pl *mazzot*) eaten during the *seder* (q.v.), which is the Passover meal eaten to commemorate the exodus from Egypt.

Megillah	The scroll on which the Book of Esther (*Megillah Ester*) is written (pl *megillot*).
Menorah	The eight-branched candelabra used during *Hanukkah* (q.v.). One of the oldest symbols of Judaism. See also *hanukkiyah*.
Ner tamid	Eternal light. The lamp kept burning in the synagogue.
'Omer	See *etrog*.
Parochet	The curtain which hangs in front of the *Aron* in the synagogue.
Pesach	Hebrew name for Passover.
Purim	Religious festival held to celebrate the events described in the Book of Esther.
Rimmonim	Meaning: pomegranates. Used to decorate the *Torah* finials.
Rosh ha-Shanah	The Jewish New Year, which is held on the 1st two days of the month of *Tishri* (mid-September to early October).
Seder	Meaning: order. The ritual meal held on the eve of Passover in every Jewish household.
Sephardim	Derived from the old Hebrew name for Spain, *Sepharad*. The Jews of the Iberian peninsula and, following the expulsion of 1492, their descendants who settled the Mediterranean littoral. Their lingua franca was a form of Spanish known as Ladino. The Sephardim adhere to their own particular liturgical forms, and their own cultural patterns which they inherited from their Spanish forebears.
Shabbat	The Sabbath (Ashkenazi pronunciation: *Shabbes*). *Shabbat* lasts from sunset on Friday evening until nightfall on Saturday.
Shaddai	Almighty. Another name for God.
Shammash	The ninth, servitor, lamp on a *hanukkiyah* from which all the other lamps are lit.
Shanah Tovah	Good New Year. The traditional New Year greeting.
Shevu'ot	Pentecost. The Festival of the First Fruits, commemorating the giving of the Law.
Shofar	Ram's horn trumpet (pl *shofartot*) which is sounded in synagogues on New Year's Day.
Simchat Torah	Festival of the Rejoicing of the Law.
Sofer	Scribe.
Sukkah	The temporary booth or tabernacle, covered with or made from leafy branches, in which the pious spend the eight days of the *Sukkot* festival.
Sukkot	Festival of the Tabernacles, celebrating the Israelites' wanderings in the wilderness; also a celebration of harvest.

121

Tallit	Prayer shawl (Ashkenazi pronunciation: *tallis*). Shawl with fringes (ẓiẓit) at each of its four corners, worn by adult males.
Tas	The shield or breastplate with which the *Torah* is decorated.
Tik	The hinged and decorated box placed in the *Aron* in which the Sephardic communities in the Middle East and north Africa house their *Torah* scrolls. A word derived from the Greek *théké*, box.
Tishri	The first month of the Jewish calendar (end of September to the Beginning of October).
Torah	The Law. The five books of Moses: Genesis, Exodus, Leviticus, Deuteronomy and Numbers. Also known as the *Sepher Torah*, Book of Law.
Wimpel	Torah binder used for the *Bar Mitzvah* ceremony. Also known as a *mappa* (q.v.).
Yad	Meaning: hand. *Torah* pointer.
Yiddish	The lingua franca of the Ashkenazim. Mainly German with Hebrew, Polish and Russian additions.
Yom Kippur	Day of Atonement, held on 10th *Tishri*.

Select Bibliography

Books

Abrahams, I, *Festival studies*. London: Goldston, 1906.

Barnett, R D, *Catalogue of the permanent and loan collections* [etc.]. London: Jewish Museum, 1974.

Bury, S, *Jewellery Gallery summary catalogue*. London: Victoria & Albert Museum, 1982.

Cherbuliez, B, *Guide à la collection des dentelles Salle Amébe Piot*. Genève: Musée d'Art et d'Histoire [1930].

Christie & Manson, *Catalogue of...works of art...of that distinguished collector, Ralph Bernal [to be]...sold by auction,...at the Mansion, No. 93, Eaton Sq.* [etc.], London: Christie & Manson, 1855.

Davidovitch, D, *The Ketuba: Jewish marriage contracts through the ages*. Tel-Aviv: Lewin-Epstein, 1968.

Eis, R, *Ḥanukkah lamps of the Museum*. Berkeley: Judah L Magnes Museum, 1977.

Eli Gera Gallery, *Eli Gera*. Jaffa: Eli Gera Gallery [1978].

Encyclopaedia Judaica, 16 vols. Jerusalem: Encyclopaedia Judaica, 1971.

Grimwade, A G (*et al.*), *Treasures of a London Temple: a descriptive catalogue of the ritual plate, mantles and furniture of the Spanish and Portuguese Jews' synagogue in Bevis Marks. Published by authority of the Wardens and Elders on the occasion of the 250th anniversary of its opening*. London: Taylor's Foreign Press, 1951.

Grossman, G C, The Maurice Spertus Museum of Judaica. Text by G C G. Chicago: Maurice Spertus Museum of Judaica, 1974.

Gutmann, J, *Hebrew manuscript painting*. London: Chatto & Windus, 1979.

Gutmann, J, *Jewish ceremonial art*. New York and London: Yoseloff, 1964.

Hausler, W, & Berger, M, *Judaica: Die Sammlung Berger*. Wien; Munchen: Jugend und Volk, 1979.

Israel Museum, *Architecture in the Ḥanukkah lamp: architectural forms in the design of Ḥanukkah lamps from the collection...at the...Museum*. Exhibition catalogue 186. Jerusalem: Israel Museum, 1978.

Israel Museum, *Bezalel, 1906–1929*. Exhibition catalogue 232. Jerusalem: Israel Museum, 1983.

Israel Museum, *Jewish treasures from Paris: from the collections of the Cluny Museum and the Consistoire*. Exhibition catalogue 226. Jerusalem: Israel Museum, 1982.

Israel Museum, *Jews of Kurdistan: daily life, customs, arts and crafts*. Exhibition catalogue 216. Jerusalem: Israel Museum, 1981.

Israel Museum, *Towers of spice: the tower-shape tradition in Havdalah spiceboxes*. Exhibition catalogue 224. Jerusalem: Israel Museum, 1982.

Israel Museum, *Treasures of the Israel Museum*. Jerusalem: Israel Museum, 1981.

Kanof, A, *Jewish ceremonial art and religious observance*. New York: Abrams, 1969.

Kayser, S, & Schoenberger, G, *Jewish ceremonial art*. Philadelphia: Jewish Publication Society of America, 1955.

Narkiss, B, *Hebrew illuminated manuscripts*. Jerusalem: Keter, 1969.

Narkiss, B, & Yaniv, B, *Index of Jewish art: I. The Gross family collection.* Jerusalem: Hebrew University (Centre for Jewish Art), 1985.

Narkiss, M, *[The Ḥanukkah lamp.]* Jerusalem: National Bezalel Museum, 1939.

Roth, C (ed.), *Jewish art: an illustrated history.* Revised ed. London: Valentine Mitchell, 1971.

Royal Albert Hall, *Catalogue of the Anglo-Jewish exhibition.* Publications of the Committee, IV. London: Royal Albert Hall, 1887; de luxe ed., 1888.

Shachar, I, *Jewish tradition in art: the Feuchtwanger collection of Judaica.* Jerusalem: Israel Museum, 1981.

Somers-Cocks, A, *The Victoria & Albert Museum: the making of a collection.* London: Victoria & Albert Museum, 1980.

Victoria & Albert Museum, *Anglo-Jewish silver: an exhibition of Jewish ritual silver and plate associated with the Jewish community in England.* London: Victoria & Albert Museum, 1978.

Victoria & Albert Museum, *Catalogue of an exhibition of Anglo-Jewish art and industry.* London: Victoria & Albert Museum, 1956.

Whitworth Art Gallery, *Jewish art treasures from Prague: the State Jewish Museum...and its collections.* Exhibition catalogue. Manchester: Manchester University, 1980.

Wigoder, G (ed.), *Jewish art and civilization.* 2 vols. Fribourg: Office du Livre, 1972.

Zedner, J, *Catalogue of Hebrew printed books.* [3rd ed?] London: British Museum, 1867.

ARTICLES

Barnett, R, 'A group of embroidered cloths from Jerusalem'. In: *Journal of Jewish art*, 1975, II, pp. 28–41.

Cohen, S, 'A 17th century parochet'. In: *Jewish Chronicle*, 10 July 1953.

Croft-Murray, E, 'A note on the painting of Moses and Aaron. In: Grimwade, A G (*et al.*), *Treasures of a London Temple* [etc.] London, Taylor's Foreign Press, 1951.

Doery, Ludwig, Baron, 'Silbernes Altgerat von 1749 aus Frankfurt'. In: *Chronik Pfarrer Sankt Crutzen zu Weisskirchen aus Taunus*, 1963.

Frauberger, H, 'Verzierte Hebräische schrift und Judischer Buchschmuck'. In: *Mittelungen der Gesellschaft zur Enforschung Judischer Kunstdenkmäler zu Frankfurt-am-Main*, October 1909, V.

Gross, W L, 'Catalogue of catalogues: bibliographical survey of a century of temporary exhibitions of Jewish art'. In: *Journal of Jewish art*, 1978, VI, p. 133.

Namenyi, E, 'La miniature juive au XVIIIe et au XVIIIe siècle'. In: *Revue des études Juives*, 1957, XVI (new series).

Wilbusch, Z, 'An ornamental Sabbath cloth in the Museum's collection'. In: *Israel Museum news*, 1975, X.

Index